BONNARD

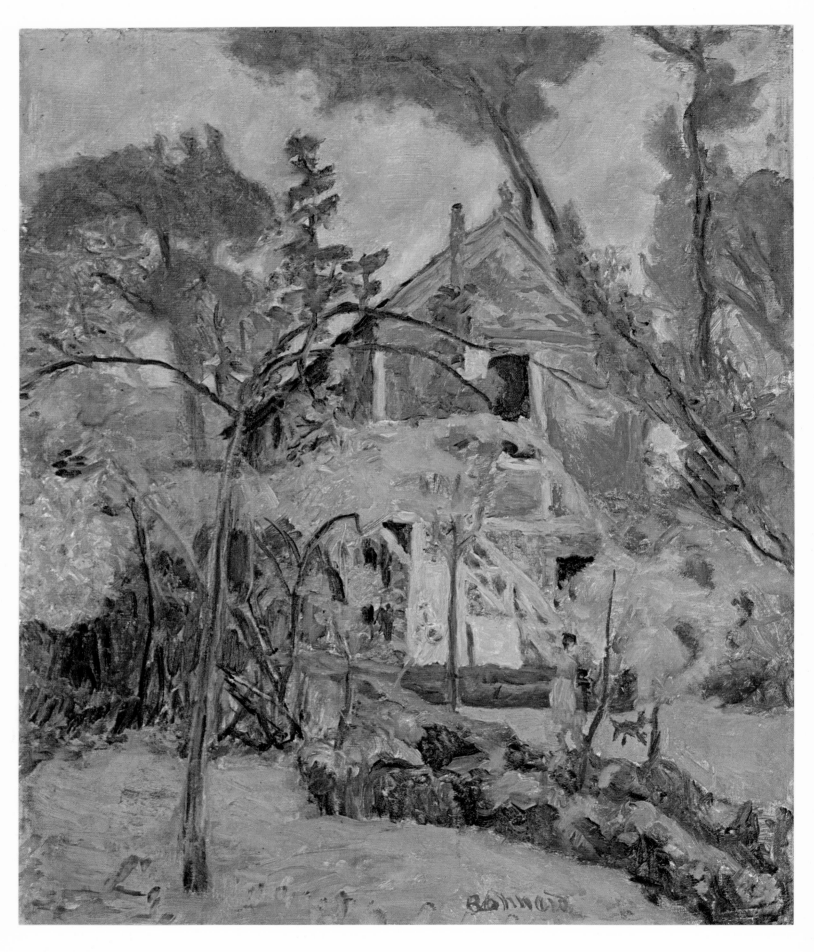

LIFT PICTURE FOR TITLE AND COMMENTARY

PIERRE
BONNARD

TEXT BY

ANDRÉ FERMIGIER

THE LIBRARY OF GREAT PAINTERS

HARRY N. ABRAMS, INC. *Publishers* NEW YORK

Standard Book Number: 8109-0041-6
Picture reproduction rights, where applicable, reserved by S. P. A. D. E. M.
Library of Congress Catalog Card Number: 69-12442
All rights reserved. No part of the contents of this book may be
reproduced without the written permission of the publishers
HARRY N. ABRAMS, INCORPORATED, *New York, N.Y.*
Printed and bound in Japan

CONTENTS

PIERRE BONNARD *by André Fermigier*
BIOGRAPHICAL OUTLINE
GRAPHIC WORKS AND DRAWINGS

COLORPLATES

BONNARD

Bonnard

"A delightful anarchism," wrote Élie Faure of Bonnard. But though Bonnard's generation was quite fond of tossing bombs—or at any rate firecrackers—at the various political, literary, and artistic forms of the established order, Bonnard has nothing of the anarchist about him. He wanted neither to simplify nor to destroy painting; nor was he bent on reforming current notions about space and the object. He made light of those problems and theories that have stirred the history of contemporary art into a feverish tale of successive palace revolutions and more or less deeply experienced "agonizing reappraisals," holding himself resolutely, even ironically, aloof from such dramatics. To some his work has in fact seemed so redolent of a bygone era, so given to the sweetness of living and the simple pleasure of painting what he liked and what he saw that they have accounted him the best behaved and most innocently Epicurean of Impressionism's successors, the last poet of bourgeois sensibility.

One should not be misled. If it is true, as is often told, that Picasso one day exclaimed before a painting by Bonnard: *"Piddling! That's piddling work!"* his reaction exhibited perhaps not so much scorn as exasperation with an artist, possibly the only one of his time, who had not submitted to the Cubist master's influence and whose pictorial expression Picasso had not succeeded in integrating with his own; which, in itself, was no small merit. Bonnard may indeed have been a man of the nineteenth century, but the pictorial syntax that he brought to maturity in the early twentieth century, taking his departure from Symbolism, Art Nouveau, Gauguin,

and Monet, has shown itself so cohesive and so rich in new potential that it appears now but lightly marked by its period; whereas the work of the other Nabis seems long since to have subsided into a past which is touching, perhaps, but irrevocably faded and even a trifle ridiculous. We have realized since

Photograph of the young Bonnard, taken by Alfred Natanson c. 1892

9

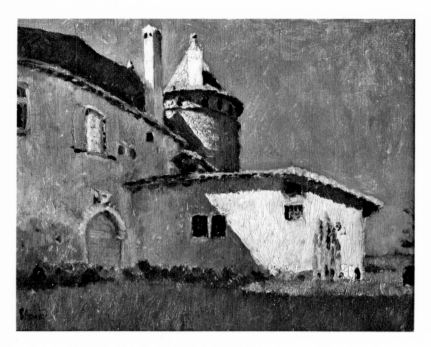

HOUSE WITH A TOWER (NEAR LE GRAND-LEMPS). C. 1889.
Oil on canvas, 7 1/4 × 9″. *Collection Charles Terrasse, Paris*

desire to be an artist. Their material well-being enabled Bonnard to live comfortably during the first years of his career as a painter. Pierre was the second son of Eugène and Élisabeth Bonnard; soon after him came a daughter, Andrée, who in 1890 was to marry the composer Claude Terrasse. Like most Parisians, the Bonnards belonged only by adoption to the city, and the family clung to its country roots, especially on the paternal side. Pierre's father was from the province of Dauphiné, in the southeast quarter of France, between Savoie on the north and Provence on the south. The property at Le Grand-Lemps, near Grenoble, where the painter spent his vacations as a child and as a young man, furnished the themes central to Bonnard's early works: the big house overflowing with children's shouts and games; the gentle family presences which Bonnard evokes with a great deal of tenderness and some

World War II that Bonnard with his *petits tons* reached out toward and perhaps surpassed what is most modern in painting. In an article significantly titled *Pierre Bonnard and Abstraction* that appeared soon after the artist's death, the English critic Patrick Heron wrote that Bonnard was at least as "contemporary" as Picasso, and noted that his art was drawing intense interest from some of the "leading exponents of the various schools of new non-figurative painting." In 1944 André Lhote had already written that Bonnard's "late works were moving toward abstraction; that is to say, toward an emphasis on pure painting values at the expense of immediate reality." These evaluations might be disputed, and it is hardly necessary to see in Bonnard a precursor of lyrical abstraction in order to allow one's self to like him; but that his art could have given rise to such statements is evidence of its complexity and richness and of the unique nature of the painter's development.

Pierre Bonnard was born in 1867 (one year before Vuillard and two before Matisse) at Fontenay-aux-Roses, then a green and amiable Parisian suburb. His father was an official in the Ministry of War, his family a bourgeois one, very liberal in spirit and accepting without too great dismay the young man's

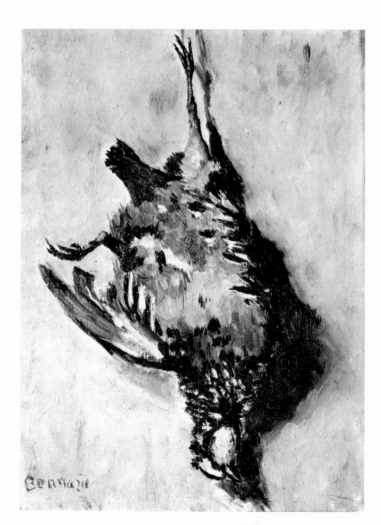

STUDY OF A RED PARTRIDGE. 1889. Oil on canvas,
8 3/4 × 6 1/4″. *Collection Raoul de Ricci, Paris*

10

irony (*Grandmother and Turkey*; *Children at the Pool*; *The Terrasse Family*; *L'Après-midi bourgeoise*); the region's characteristic light that had already so appealed to Jongkind. In both geography and sentiment, Le Grand-Lemps was Bonnard's first landscape; Paris, Normandy, and the coast of the Mediterranean were to be the other three.

Like all good bourgeois youths Bonnard went to the lycée where, it is worth noting, he excelled in literature. There is nothing of the self-taught man or of the savage in Bonnard. His spirit is that of a cultivated and intellectually sophisticated man, familiar with his classics, loving books, an intimate of writers and poets—in this respect resembling those other Parisian bourgeois, Manet and Degas, rather than Renoir or Pissarro. In 1886 Bonnard, his baccalaureate behind him, embarked on the study of law. Bonnard a magistrate, a government official? That seems to have been out of the question. He decided to become a painter, and settled himself in Paris at his grandmother's, in the Batignolles section at the foot of Montmartre (where Vuillard also lived). Three years later he succeeded in being rejected not only in the competitive examination for the bureaucracy for which his father had intended him, but also for the Prix de Rome. So depressing was the atmosphere in that stronghold of official painting, the École des Beaux-Arts, that Bonnard had also signed up at the privately run Académie Julian where, if the teaching was just as mediocre, the pupils nonetheless enjoyed more freedom. It was there that he met several young painters with whom he became friends and who were to make up the Nabi group: Paul Ranson, H. G. Ibels, Maurice Denis (the group's theoretician), soon to be joined by Vuillard and K.-X. Roussel, and later by Maillol and Félix Vallotton.

"The boldest among the young artists who around 1888 frequented the Académie Julian," wrote Maurice Denis, "were almost entirely unaware of the great art movement which, under the name of Im-

THE PEIGNOIR. C. 1890. Oil on velvet, 60 5/8 × 21 1/4".
Musée National d'Art Moderne, Paris

11

pressionism, had just revolutionized the art of painting." And in fact Bonnard's first efforts, as shown in *Study of a Red Partridge* or *House with a Tower*, make it clear that at that time he knew nothing of French painting after Corot. To be sure, he must soon have made the acquaintance of the Impressionists' art, and must certainly have seen the important exhibitions that Durand-Ruel devoted to Pissarro, to Monet, and to Renoir during the winter of 1892; but the influence of Impressionism does not appear in Bonnard's work until about 1910, while the style of his youthful work shows a quite clear and conscious reaction against the aesthetic notions of those whose most brilliant successor he was to seem in later times. The Nabis and their friends criticized what they felt to be the Impressionists' intellectual and poetic poverty ("They are a little low in the 'ceiling,' " said Odilon Redon), their lack of mystery, the rather prosaic and restricted visual approach to which their basic naturalism condemned them. Their paintings, according to Maurice Denis, were nothing but "windows opened on nature"; and in an article of 1892 in the *Revue Encyclopédique*, Albert Aurier wrote: "On every side we are again demanding the right to dream, the right to pasture in the azure, the right to soar toward the forbidden stars of absolute truth. Myopic copying of social anecdote, idiotic imitations of nature's warts, flat observation, *trompe-l'oeil*, the glory of being as faithfully, as banally accurate as the daguerreotype no longer satisfy any painter or sculptor worthy of the name." Painful though its prose is, the quotation clearly reveals the chief end upon which most of the young painters were bent: to find a plastic equivalent for the refinements of literary Symbolism, for "that aristocratic love for the rare word, for the soul's uncharted states and for the obscure in poetry" (Maurice Denis) that young writers were enthusiastically discovering in Verlaine, Jules Laforgue, and Mallarmé. Of Mallarmé, Thadée Natanson tells us that "Bonnard read and reread him, verse by verse, line by line, abandoning himself, letting himself be carried away, even in his extreme old age."

It was Gauguin who furnished them with the key. Maurice Denis, again, writes: "It was on our return to the city in the fall of 1888 that the name Gauguin

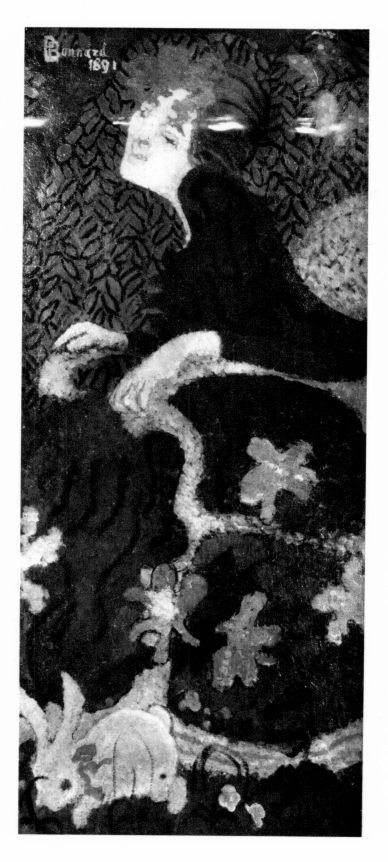

WOMAN WITH RABBIT. 1891. Oil on canvas, 37 3/4 × 17". *Collection W. S. Rubin, New York*

12

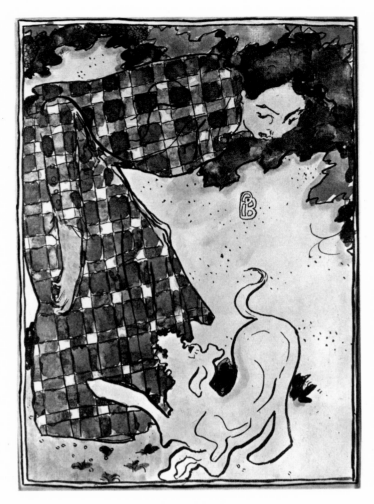

WOMAN WITH DOG. C. 1892. Watercolor, 10 1/8 × 7 1/4″.
Museum of Fine Arts, Springfield, Massachusetts

in hue and rimmed with brutal strokes, worked in cloisonné, it might have been said, because *cloisonnisme* and again *Japonisme* were words that were then in the air.''

"The distortions in drawing, the semblance of caricature, the flat-laid colors—all that seemed scandalous,'' and in effect pointed toward Maurice Denis' famous definition, formulated the following year: "One should remember that a painting, before being a warhorse or a nude woman or an anecdote, is essentially a flat surface covered with colors assembled in a certain order.''

Gauguin's influence on Bonnard is not easy to pin down; nor could two men be imagined who were more dissimilar in character, intellect, sensibility, and taste. Furthermore, in 1891, when a Paris newspaper undertook an inquiry into the state of the new painting, Bonnard refused to acknowledge any master: "I belong to no school. I want only to do something of my own and I am at present unlearning what I took a lot of trouble to learn during four years at the Beaux-Arts.''

Yet when in the course of the same interview Bonnard declared: "Painting must above all be decorative. Talent shows itself in the way in which

was revealed to us by Sérusier, just back from Pont Aven, who, not without mystifications, showed us a cigar box cover on which one could make out a landscape deformed by its artificial formulations in terms of violet, vermilion, Veronese green, and other pure colors, just as they had come from the tube, without admixture of white.''

"How do you see that tree?'' Gauguin had said. "It is green, no? Then put green, the most beautiful green in your palette. And this shadow? On the blue side? Don't be afraid to paint it as blue as possible.''

That little painting was *The Talisman*, and it became just that for the painters of the new generation. Their enthusiasm burst its bounds when, in 1889, Gauguin exhibited in Paris seventeen of his paintings from Brittany, Arles, and Martinique: "What a dazzlement, first; and then what a revelation! Here were heavily decorative surfaces, powerful

THE CROQUET GAME. 1892. Oil on canvas, 50 3/8 × 63 3/8″.
Private collection, Paris

13

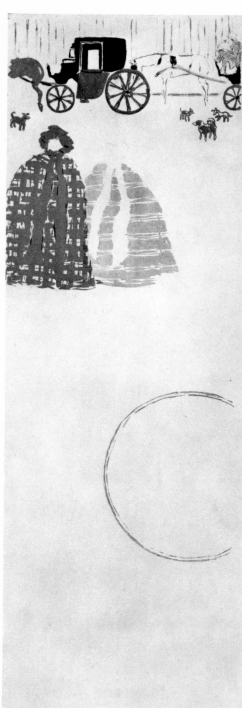

FOLDING SCREEN WITH FOUR PANELS. 1899. Color lithograph, each panel 53 1/2 × 18 1/4″.
Collection Rex de C. Nan Kivell C.M.G., London

the lines are distributed," he implicitly avows his debt to Gauguin. Granting first that in most cases Gauguin's influence was to appear intermingled with that of others, to be discussed later, we shall here try to determine as briefly and clearly as possible what Gauguin, or, to be more precise, Gauguin as the Nabis viewed him, taught Bonnard.

First, like Gauguin, Bonnard shows a preference for expression in terms of color rather than in terms of light. There is no vibration of light in Gauguin's work; and in Bonnard's, until 1909–10, hardly any save that artificial light blooming from city street lights or the unreal glow of lamplight in an interior. Color, for Bonnard, was an end in itself. Exploiting

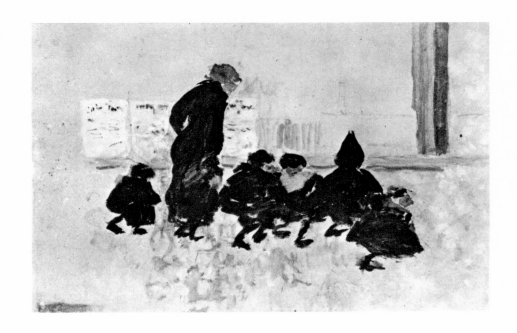

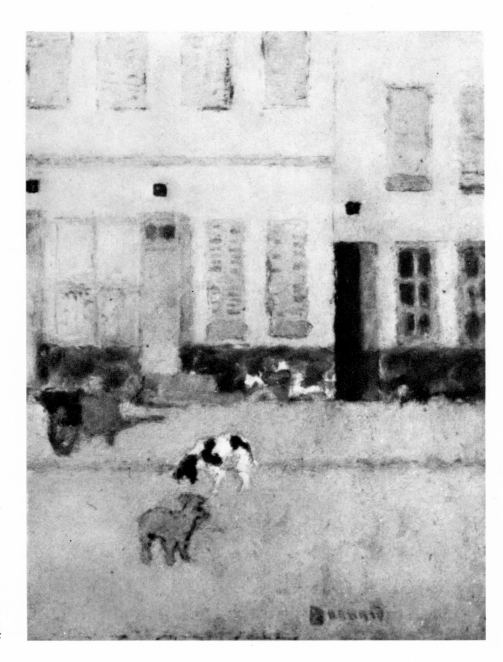

above right:
CHILDREN LEAVING SCHOOL. C. 1893.
Tempera, 11 3/8 × 17 1/2″.
Collection Mrs. Mellon Bruce, New York

right:
STREET IN ÉRAGNY. C. 1894.
Oil on canvas, 13 1/2 × 10 1/2″.
Collection Mrs. Mellon Bruce, New York

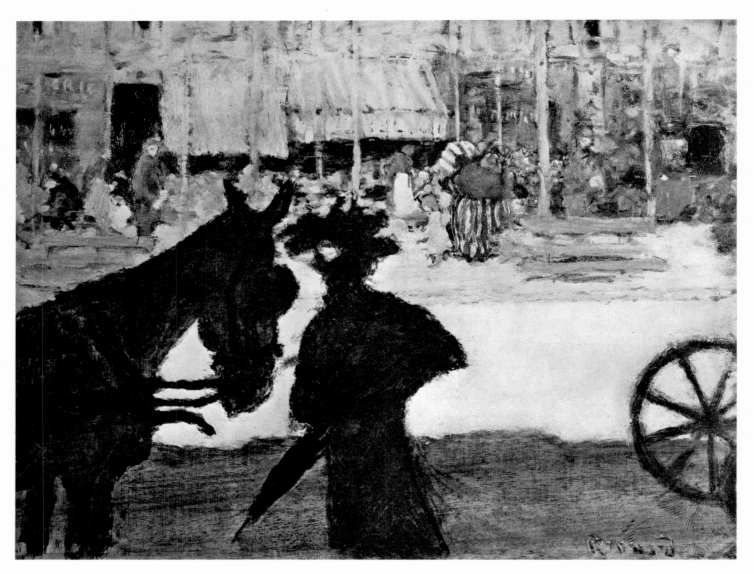

THE CAB HORSE: BOULEVARD DES BATIGNOLLES. C. 1895. Oil on canvas, 11 3/4 × 15 3/4".
Collection Mrs. Mellon Bruce, New York

its decorative value, its strength or poetic charm, he conceived of it in an arbitrary fashion, unconcerned with literal accuracy in respect to local colors. Even in the later landscapes executed out of doors Bonnard, though not entirely neglecting the suggestion of atmospheric light, painted and even thought, it seems, in terms of color and for the sake of color; color always as it exists in itself or in its relation to other colors in the composition, rather than with any fidelity to received visual impressions of it. As Charles Sterling said: "Bonnard's mode of seeing differs from that of the Impressionists. It unites with a ubiquitous light the Symbolists' expressive and arbitrary color . . . color so despotic that every object appears as a colored patch before allowing of recogni-

tion in its customary aspect." In an Impressionist painting a shadow may appear violet because the painter truly saw it, in reality, thus violet; but when Bonnard paints a lilac-hued face, a mauve horizon line, it is because that face or horizon had to be lilac or mauve by virtue of the picture's logic and poetic intention.

"The order of the day, the common principle [among Gauguin's pupils]," writes Maurice Denis, "is to exalt color and simplify form." To the primacy of color over light must be added in effect that of line over modeling and of the flat surface over depth. In this respect the influence of Japanese art was at least as important as Gauguin's; and we know that Bonnard's friends had nicknamed him the *Nabi très*

16

japonard, "the very ultra-Japanese Nabi." Since the middle of the century Japanese prints had been much in vogue with European artists and art lovers, and the extent to which painters as diverse in style as Whistler, Degas, and Van Gogh borrowed from the masters of Ukiyo-e has often been subjected to analysis. *Japonisme* was the rage of Paris in the nineties and played a role in the artistic life of the time comparable to that played by African art during the Cubist epoch: in 1881 the dealer Bing, who specialized in handling art objects from the Far East and who published a magazine called *Le Japon Artistique*, had organized a "historical exhibition of the art of engraving in Japan"; in 1890 a very important exhibition of Japanese prints was held at the Ecole des Beaux-Arts; in 1891 Edmond de Goncourt published a volume devoted to Utamaro.

What seems to have struck Gauguin, Bonnard, and their friends most strongly in Japanese prints, besides the expressive and decorative role played by color applied in broad, homogeneous areas, was first of all the use of linear arabesques intended to suggest volume, and secondly the rigorously flat character of the colored surface. No more modeling —a view that enchanted Maurice Denis, who was particularly irritated by the academic adage that "it becomes art when it appears round." No more modeling—hence, no more deep space and no more aerial perspective. The canvas was reduced to an ensemble of colored areas arbitrarily arranged on a two-dimensional surface with no concern at all for symmetry or for constructive geometry. The compositions appear consciously decentralized, voids play as important a part as solids, shadows and chiaroscuro disappear: all becomes rhythm and silhouette. The painting is now but a white page to decorate and illuminate.

All this may be seen in Bonnard, too, though he shared but little in the accompanying taste of certain among his friends for the violent distortions and harsh colors that charmed them in primitive arts or folk images. Breton Calvaries, for instance, never really interested Bonnard. If at this time he cultivated a kind of witty and refined awkwardness (*The Laundry Girl; Woman with Umbrella*), perhaps distilled out of the general sentimental atmosphere

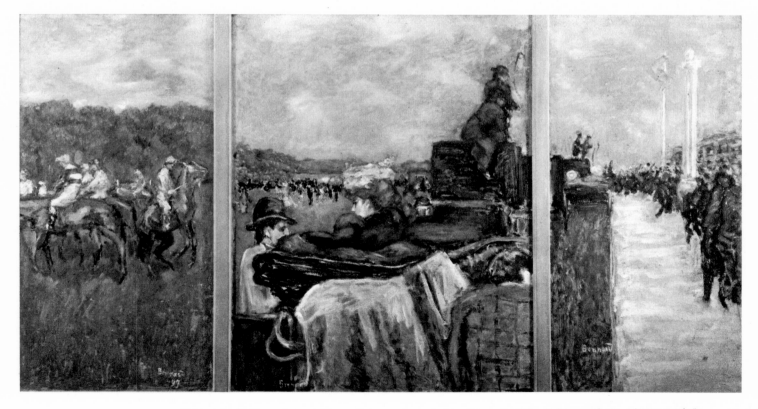

THE RACES. 1891. Triptych: left panel, 21 1/4 × 11"; center panel, 21 1/4 × 16 1/2"; right panel, 21 1/4 × 10 5/8".
Collection Fernand Javal, Paris

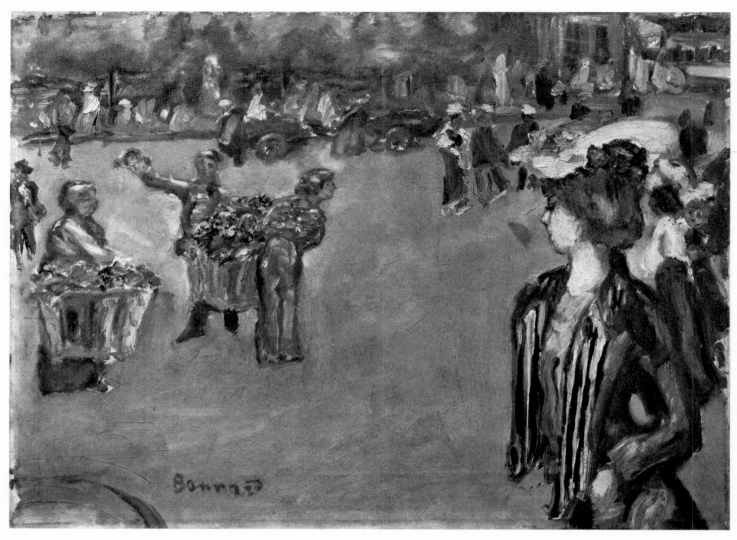

of the 1890s when "naïveté" was much in fashion, he certainly never dreamed of following Maurice Denis' advice to "return to childhood," "return to baby talk," "behave like a simpleton," even though at the time that would be the most intelligent thing to do. All his life, to be sure, Bonnard would stammer a bit. His figures' feet would always rest a little uneasily on the ground; their faces would be possessed of a kind of mysterious vacuity, a curious indifference to their surroundings, even at times of an unreadable expression of "tenuous rapture," as André Lhote would have it. Such overtones represent, of course, a translation within Bonnard's intimate and familiar universe of the Symbolists' reveries and languors. Bonnard's feminine subjects, even when they are having their *café au lait* or eating cherry tarts, are in many respects the mute and unpretentious sisters of those faraway princesses and solitary

women of the 1890s. There is a strong undertone of melancholy and disenchantment in Bonnard, and for a long time even his landscapes were to float immobile and weightless in a world of decorative unreality. All this represents his own particular manner of "becoming a simpleton" and "rediscovering childhood at will."

Though other artists of the time like Mary Cassatt or Henri Rivière exploited the print masters with a fidelity verging on pastiche, Bonnard's "*Japonisme*," like that of Vuillard, is characteristically allusive. It does make its appearance, however, in all the work of the years 1890–95: in paintings (*The Checkered Blouse*; *The Croquet Game*); in watercolors (*Woman with Dog*); in decorative panels (*Woman with Rabbit*); and especially in color lithographs. Among these last are some of the youthful artist's most delicious masterpieces: the *Family*

18

Scene of 1892 and a like subject executed in 1893, and the famous screen composed of four lithographed panels printed in 1899, in which are summed up with brilliant virtuosity all the stylistic diversifications of a painter already come to maturity. The very development of the color lithograph and poster that took place during this period is in fact clearly bound up with the Japanese influence. The first work that Bonnard was able to sell was a poster commissioned in 1889, *France-Champagne*, which drew Toulouse-Lautrec's attention to him. In style it is still close to Jules Chéret's posters: but what charming originality is already manifest in the frankness of his flat color zones and in the flittering caprice of his line, which evokes all the fantasy and gaiety of contemporary Paris!

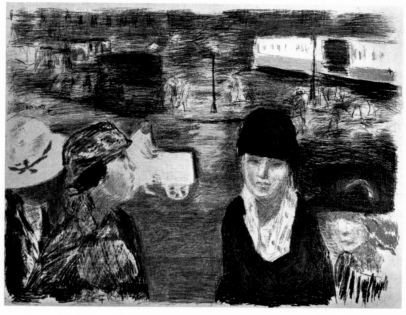

PLACE CLICHY. 1923. Color lithograph, 19 5/8 × 25 5/8"

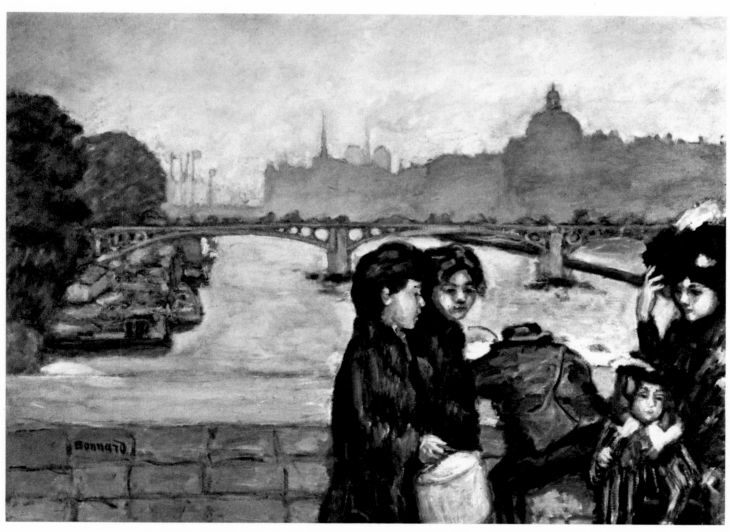

THE BRIDGE (LE PONT ROYALE). c. 1908. Oil on canvas, 27 × 38".
Collection Mr. and Mrs. Sidney F. Brody, Los Angeles

19

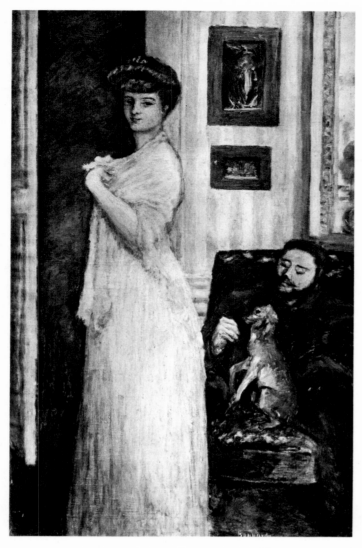

MISIA AND THADÉE NATANSON. C. 1902. Oil on canvas,
51 1/8 × 33 7/8″. *Musée Royaux des Beaux-Arts, Brussels*

for observing the unimportant spectacles and minor dramatis personae of everyday life *(Cab Horse; Street in Éragny; Children Leaving School*—the children's spidery little legs and crooked silhouettes seeming straight out of Hokusai's *Mangwa)*; it also lent to his manner of composing scenes a decided orientation toward a taste for unexpected ways of arranging things on canvas. He could crop his scenes abruptly (in this perhaps owing as much to Degas as to Japan), so that only the truncated arm or face of a figure appears at the edge; or he could take up the composition's whole foreground plane with a figure seen from the back *(The Parade Ground)*, a tree *(The Terrace at Vernon)*, a dog whose reason for being there is not quite clear, or with some other such unimportant detail.

Few paintings give the impression at first sight of being less consciously composed than Bonnard's, of being more freely born out of visual happenstance or the spontaneities of recollection. People and objects appear to have met on the canvas without benefit

For many years Bonnard was to devote a considerable part of his activity to prints and illustrations. Especially worthy of note are the twelve color prints titled *Quelques Aspects de la vie de Paris (Aspects of the Life of Paris)*, published in 1899 by Vollard, and several sets of illustrations: those of 1893 for the *Petites Scènes familières pour piano* and the *Petit Solfège illustré* of his brother-in-law Claude Terrasse; those of 1896 for the Danish novelist Peter Nansen's *Marie*, of 1900 for Verlaine's *Parallèlement*, of 1902 for Longus' antique tale of *Daphnis and Chloe*, of 1903 for Jules Renard's *Histoires naturelles* (published 1904), and of 1907 for Octave Mirbeau's tale of his auto trip in Flanders and Germany, *La 628 E 8* (published 1908).

The Japanese mode not only stimulated his taste

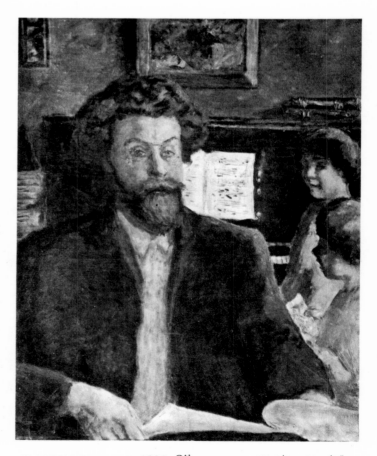

CLAUDE TERRASSE. 1902. Oil on canvas, 37 3/8 × 30 3/8″.
Collection Charles Terrasse, Paris

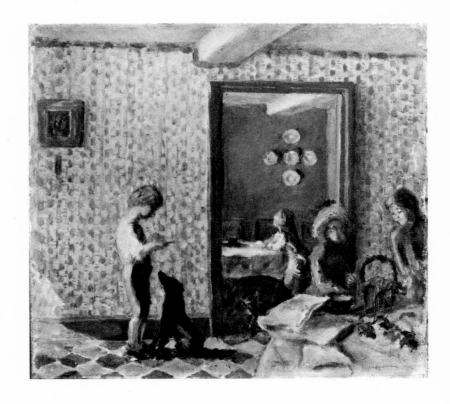

of the painter's intervention, indifferent to the laws of academic composition, under no other compulsion than that responsible for the flight of moments and hours that ceaselessly make and unmake the movement of the world. Like the Japanese, too, Bonnard abolishes any hierarchy among his objects. A kitchen pot may well occupy the center of a painting (*The Red-Checkered Tablecloth*), and Bonnard all his life was to construct his most finished and, if the term may be applied here, most ambitious works around a simple ornamental detail: the patterns in a dress or the stripes on a blouse, the scattered flowers in a wallpaper, a tablecloth's checks, the tiles in a bathroom.

Finally, it is also in some measure to Far Eastern art 'that Bonnard owes his peculiar conception of space. He occasionally presents a scene frontally, giving an impression of depth and distance (*The Bridge*); but how much more he seems to prefer the oblique view that Degas already knew, the diagonal perspective or the view looking down from above. A table top may spread up toward the top of the picture plane, or seem ready to tip out of the picture; the central group of objects is often tilted nearly vertically so that all sense of depth disappears; horizon lines are placed extremely high, are often even absent; and his very treatment of the French window, through which in 1912 he begins to cast a timid but relishing eye toward a more broadly conceived landscape, is certainly of Japanese origin.

But most of all, in the *Nabi très japonard*, the Oriental influence reinforced a determinedly decorative conception of the art of painting. The taste for decoration was common to most of the artists of the 1890s. At that time, wrote Verkade, one of the Nabis, in his memoirs (*Le Tourment de Dieu*), "the battle cry rang out from one studio to the next: No more easel pictures! Down with useless furniture! Painting must not usurp a liberty that isolates it from the other arts. The painter's work begins at that point where the architect considers his finished.

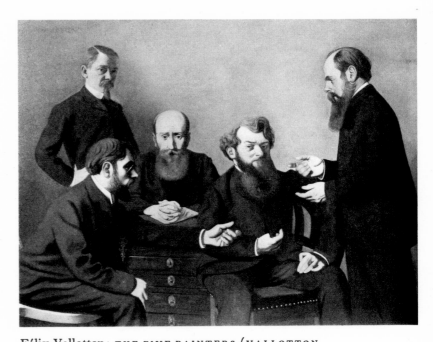

Félix Vallotton: THE FIVE PAINTERS (VALLOTTON, BONNARD, VUILLARD, COTTET, ROUSSEL). 1903.
Oil on canvas, 56 1/4 × 73 5/8".
Kunstmuseum, Winterthur, Switzerland

Walls, walls to decorate! Down with perspective! The wall must remain a surface, must not be spoiled by a representation of distant horizons. There are no pictures; there is only decoration!"

The desire to reconcile painting with architecture

and the applied arts and to conceive their pictures in terms of decorative surfaces clearly relates the Nabis to those artists who were taking part in the international art movement variously known as Art Nouveau, Modern Style, or Jugendstil. The Art Nouveau note is relatively muted in Bonnard's work, but between 1890 and 1910 he did a number of paintings, some among which overtly display that style's rather acid and mannered grace, and all of which share its ornamental quality, seeming like decorative panels or even like tapestries, with the same decided predilection for long vertical formats and for supports other than canvas—velvet, for instance, in the famous *Peignoir* in the Musée National d'Art Moderne, Paris. The most interesting among these works are the portrait of Andrée Terrasse painted in 1890; the four whimsical panels of 1891–

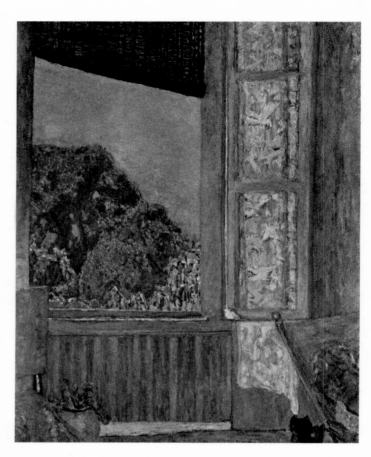

THE OPEN WINDOW. C. 1921. Oil on canvas, 46 1/2 × 37 3/4″. *The Phillips Collection, Washington, D.C.*

92; the triptych of *The Races* of 1891; and the two large ensembles, the four big panels painted for Misia Godebska's apartment and the other three panels painted for the Russian collector Ivan Morosoff. These two groups were exhibited respectively in the Salon d'Automne of 1910 and 1911.

Through these same years Bonnard evinced a lively interest in the decorative arts themselves. In 1895, for the American glassmaker Louis Tiffany, he made a design for a stained-glass window (*Maternity*) and, for Thadée Natanson, a most "Nabic" desk, in which, according to François Jourdain, he provided a cutout intended to accommodate its owner's prominent stomach. In about 1904 he sculpted a big bronze table centerpiece, a joyful round of children, women, dogs, and a bearded old man. He painted settings for Paul Fort's Théâtre d'Art and for Lugné-Poë's Théâtre de l'Oeuvre. Lugné-Poë, a longtime friend of Bonnard's, was not only an important producer of Symbolist and Scandinavian drama, but also an ardent Nabi partisan. It was at

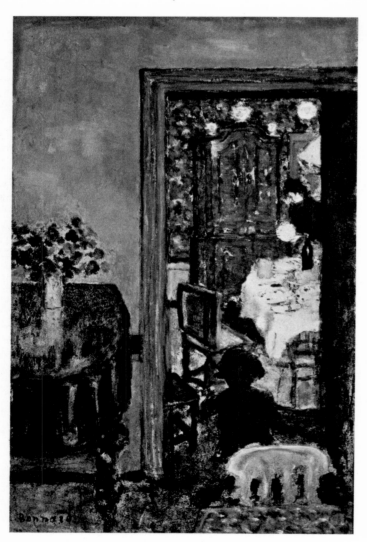

INTERIOR. C. 1898. Oil on canvas, 20 1/2 × 13 3/4″. *Collection Mr. and Mrs. Norton Simon, Los Angeles*

22

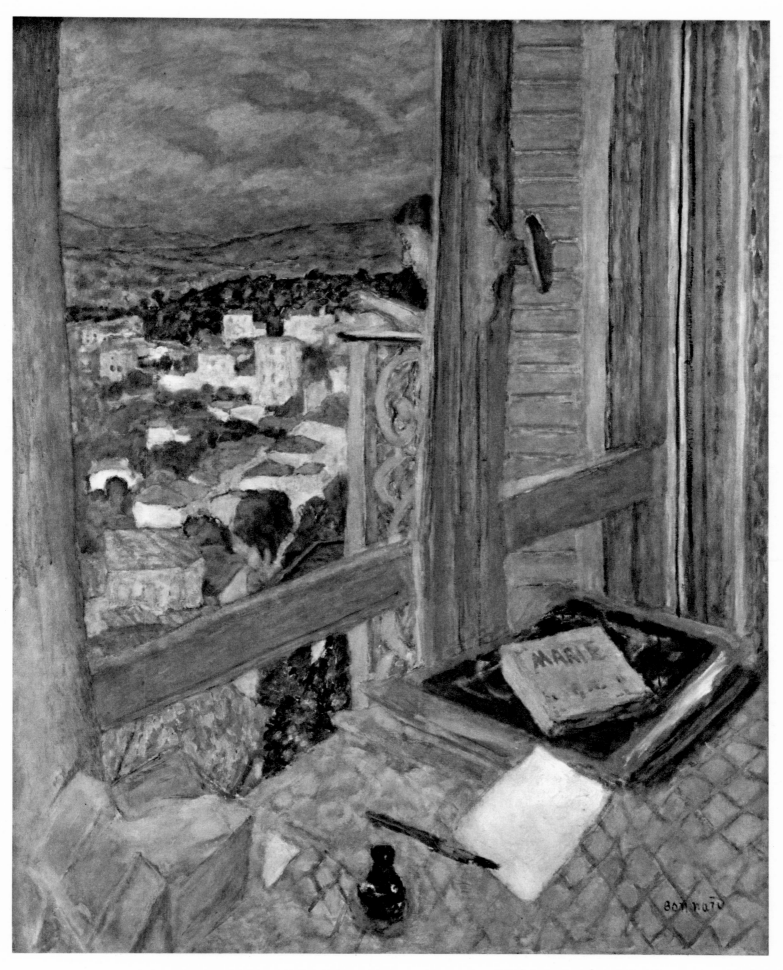

WINDOW AT LE CANNET. C. 1925. Oil on canvas, 42 3/4 × 34 7/8″. *The Tate Gallery, London*

the Théâtre de l'Oeuvre, in a setting designed by Bonnard and Sérusier, that he put on the first performance, amid furious uproar, of Alfred Jarry's *Ubu roi*, on December 10, 1896. Bonnard designed several programs for l'Oeuvre, one of them being *La Dernière Croisade*, and busied himself with the Théâtre des Pantins, a marionette theater founded in 1896 by Franc-Nohain, Claude Terrasse, and Jarry in a studio in the Rue Ballu. A set of sheet music, published by the *Mercure de France* between 1890 and 1898, has Bonnard-designed covers for songs composed by Franc-Nohain and Claude Terrasse for their marionette plays, including *La Berceuse obscène* and *La Malheureuse Adèle*. Bonnard portrayed himself in the Rue Ballu studio together with Claude Terrasse, Franc-Nohain in a bowler hat, and the irrepressible Jarry attired, as was his custom, in a cyclist's outfit.

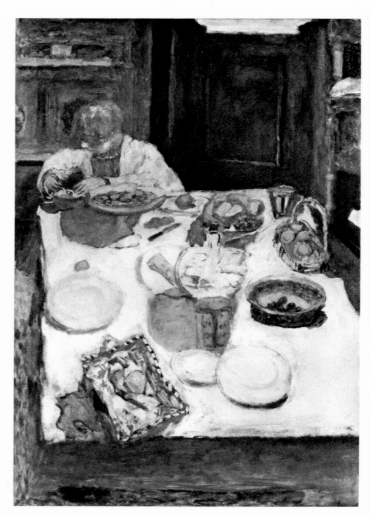

THE TABLE. 1925. Oil on canvas, 40 1/2 × 29 1/2″. *The Tate Gallery, London*

INTERIOR. 1925. Drawing heightened with pastel, 13 3/4 × 9 7/8″. Whereabouts unknown

Bonnard also contributed to the little journals and reviews, such as *La Vie Moderne* and *Escarmouche* (edited by the anarchist Georges Darien, author of that libertarian novel, *Le Voleur*), for which he did a very nice young girl in her chemise, with dreadful black stockings, and a big lithograph across which promenaded a horse-drawn cab and a whole litter of those engaging, hairy, floppy Parisian dogs whom the painter apparently already at that time counted among his best friends. Bonnard also worked for the more respectable journals, as witnessed by two fine posters for *Le Figaro*. Still, the real Bonnard must be sought for in the spiritual climate surrounding Darien, Franc-Nohain, Jarry, or Toulouse-Lautrec rather than in that of Sérusier or Maurice Denis.

Indeed, Bonnard seems to have been a rather sardonic and skeptical Nabi. He must have smiled at the sentimental and religious mysticism current

among certain of his comrades, or at the solemn theories of neotraditionalism so dear to Maurice Denis. Bonnard never seems to manifest the slightest religious or political convictions; and though Vollard may once have talked him into illustrating a Life of Saint Monique (not, in any case, among Bonnard's most succesful endeavors), yet while Maurice Denis was painting virginal Franco-Florentine Annunciations, Bonnard was illustrating the highly irreverent *Almanachs du Père Ubu* (1899, 1901), or Jarry's *Soleil de printemps*, wherein one may read such disrespectful propositions as: "The spring sun shines even for the bourgeois; even for the curate. The curate's blackness sets off the color of the sun." And, on the next page, Bonnard depicts the "Repopulator" in the guise of a satyr of particularly enterprising shape and deportment. Bonnard no doubt preferred the comedies of his friend Tristan Bernard to the dramas of Maeterlinck; his smile, his sense of humor, were always those of the Paris *gamin*.

It is with this in mind that we should evaluate Bonnard's association with the *Revue Blanche*. From 1891 to its demise in 1903, the Natanson brothers' *Revue Blanche* was unquestionably the best of its time: it was the most independent in spirit, the most indifferent to literary quarrels and coteries, the most open to all talents. Welcoming Symbolists equally with Naturalists, it had among its contributors Verlaine and Mallarmé, Maeterlinck, Jules Renard and Octave Mirbeau, André Gide and Romain Coolus, and, in their first endeavors, Proust and Léon Blum. In the artistic area, Thadée Natanson took an interest in all facets of modern art: he published Gauguin's *Noa-Noa* and Signac's essay *D'Eugène Delacroix au Néo-Impressionisme*. But his own taste leaned to Lautrec, Bonnard, Vuillard, and Vallotton, all of whom he asked to do illustrations for his review. Bonnard in particular was for him the painter of painters, and to Bonnard he devoted a book of engaging perceptivity and tenderness: *Le Bonnard que je propose*.

In 1894 Bonnard designed the *Revue Blanche* poster, a masterpiece of Parisian elegance and poetry, but of a Paris quite unlike that evoked by *France-Champagne*. It is less bright, less luminous, all gray,

LE MENU. 1925, Lithograph, 11 3/4 × 10 1/4"

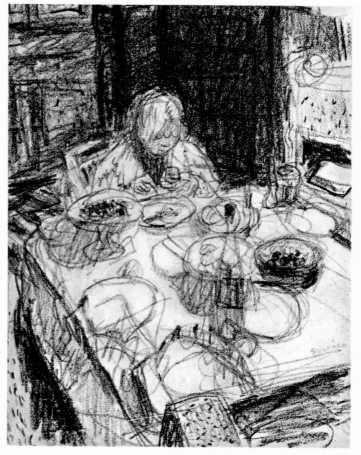

THE BREAKFAST TABLE. 1926. Crayon, 12 1/4 × 9 7/8".
Formerly Collection Georges Rehns

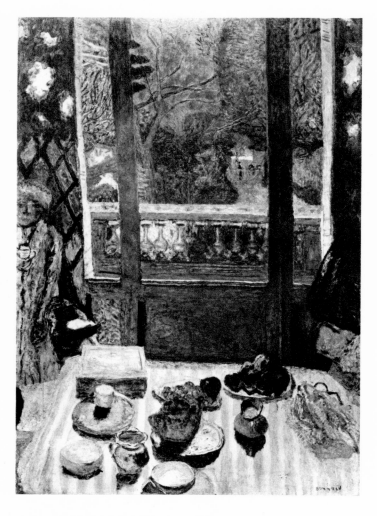

THE BREAKFAST ROOM. C. 1930–31.
Oil on canvas, 63 1/4 × 44 1/8".
The Museum of Modern Art, New York. Anonymous gift

chilly, and reserved—the color of high walls and winter. In it, the gesture of the impertinent *gamin* is still drawn in a somewhat "ultra-Japanese" fashion, in contrast to the appealing melancholy in the eyes of the young woman enveloped in her huge cape— certainly the strangest "sell" ever devised for any publication, even an avant-garde review. The young woman is perhaps Marthe, the model whom Bonnard had just met, who was to be his life's companion, and whom he was to marry in 1925. The *Revue Blanche* poster was quite characteristic of the year 1894, for then Bonnard's palette, formerly an array of vivid colors, began to take on the somber hues he would soon employ to express the poetry of nighttime or intimate indoor scenes. The transformation of mood was not yet by any means complete, however, for the cover of the *Album de La Revue Blanche* and the engravings published in the *Revue Blanche* in 1895 are still the gay and witty Bonnard.

Bonnard's gaiety is in fact charged with a kind of extravagance in the illustrations that he made to poems by Romain Coolus and Tristan Bernard in *Nib*, a supplement published for the *Revue*. Though the overtones of delirium in these suggest that Bon-

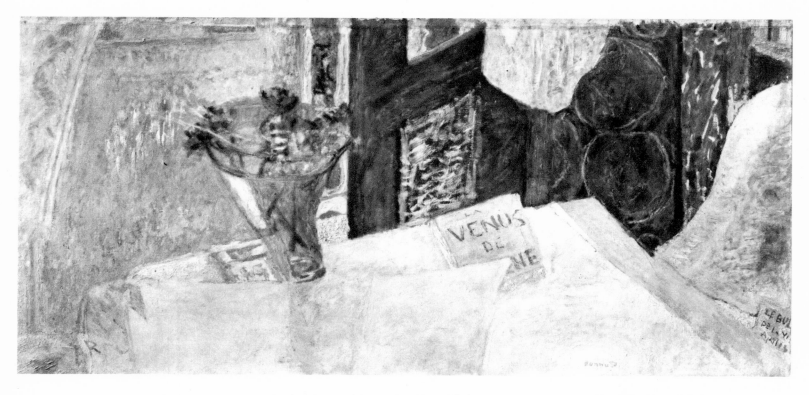

STILL LIFE WITH A BOUQUET OF FLOWERS. C. 1932. Oil on canvas, 23 5/8 × 51 1/8". *Kunstmuseum, Basel*

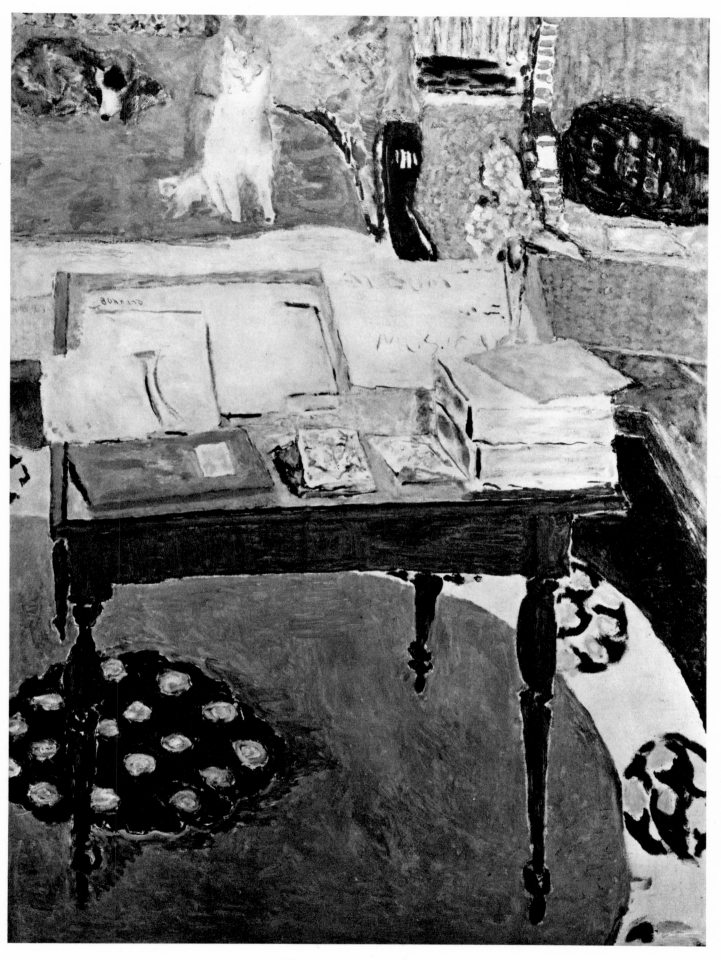

TABLE WITH MUSIC ALBUM. 1926–32. Oil on canvas, 48 × 36″. *Collection Mr. and Mrs. Paul Mellon, New York*

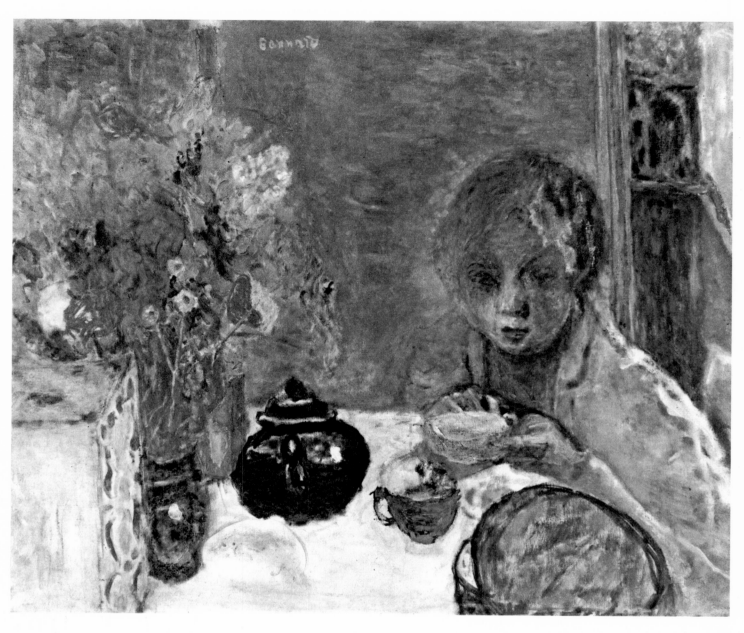

THE LUNCH. C. 1932. Oil on canvas, 26 3/4 × 32 5/8″. *Musée du Petit Palais, Paris*

nard may have been looking at James Ensor, the spirit of the texts themselves may have been sufficient to inspire the unconstrained nature of Bonnard's contribution.

Bonnard's interest in decoration and illustration did not take him away altogether from painting. In the years following 1891 he exhibited at the Salon des Indépendants, at Le Barc de Boutteville's, at Durand-Ruel, and with the Vienna Secession; he sent work to the Salon d'Automne in the year of its founding, 1904, and in 1906 had his first one-man exhibition at Bernheim-Jeune's, thereafter his principal dealers, though he never bound himself to them by

contract. Frequenting Vollard's circle of friends, he attended the dinners Vollard organized in the famous Rue Lafitte *cave*, and in an amusing painting Bonnard shows Vollard serving liquid refreshment to several guests, among them Forain, Misia Godebska, and himself. He often saw Vuillard, whose sister married Roussel in 1893, and often went to work at Roussel's house at L'Étang-la-Ville before he himself rented a little house at Marly-le-Roi. In the spirit of his art, however, he remained faithful to the Batignolles and Montmartre, to all of that animated, vivid, petit-bourgeois Paris of flowersellers, young clerks, and pretty children centering on the Place Clichy: this,

despite occasional sorties to the banks of the Seine or to the Champs-Élysées, was Bonnard's Paris.

The charm of these street scenes has often brought Verlaine to mind: "Verlaine, his friend, his companion, his brother in existence," wrote Gustave Geffroy in January, 1896, when Bonnard exhibited at Durand-Ruel. Geffroy continues: "No one better captures the look of the street, the colored patch seen through the Parisian mist, the passing silhouettes, a young girl's frail grace. A searching hand moving with simian pliancy seizes the passing gesture, the evanescent faces of the street, born and vanished on the instant. It is the poetry of life that is gone, a remembrance of things, of animals, of human beings." Bonnard was now *peintre gris, a* "gray" painter, an artist of half-tones. Before his slight, indefinite world, out of plumb and a trifle unstable, we think perforce of Verlaine's *chanson grise* and of the admonitions scattered in his *Art poétique:* "nuance" preferred to color; the determination not to make the choice of words (or to pin down a form, with Bonnard) "without some ambiguity"—the cult, in sum, of the uncertain:

> More shapeless and soluble in the air,
> With nothing in it that is weighty or settled.

Looking at these paintings it becomes clear how far Bonnard had now traveled from the Nabi circle. Gauguin, the Japanese, the practice of lithography

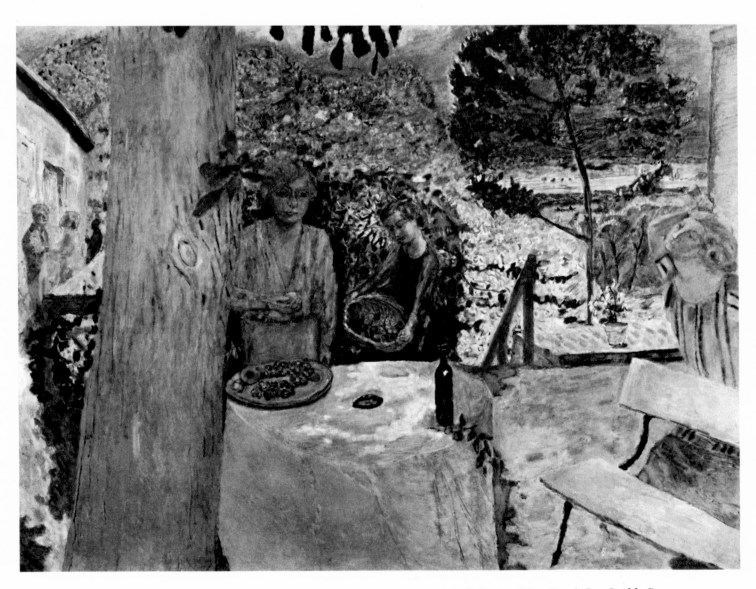

THE TERRACE AT VERNON. C. 1930–38. Oil on canvas, 58 × 75 1/2″. *Collection Mrs. Frank Jay Gould, Cannes*

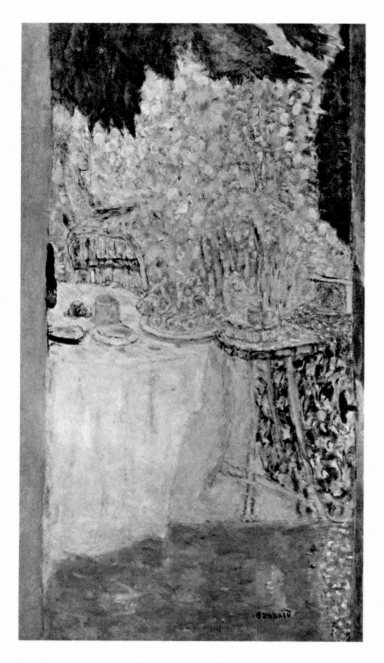

MORNING. 1940–46. Oil on canvas, 49 1/4 × 28".
Collection Bowers, Paris

had given him the taste for a clear line and for frank colors reduced to their simplest terms; now, however, his drawing is misty, his colors blended, occasionally touched by vivid accents. It may be that in this Bonnard reflects such Impressionist Parisian cityscapes as Pissarro's *Place du Théâtre Français* of 1898; but the influence remained limited. Bonnard's Paris is much more somber, less joyful and pleasing in atmosphere, almost always wintry; and, instead of seeing the street as a distant spectacle glinting with light and reflections, Bonnard prefers to isolate a few figures on the foreground plane against a limit-

ed depth. The Impressionists painted the panorama of the streets; Bonnard saw only from one sidewalk to the other. The streets of his Paris have not the breadth and exuberance of those in the Impressionists' paintings and for him the great, spectacular city shrinks to a homely setting.

It is in fact during these years (1898–1910) that Bonnard begins to reveal himself as the intimist he was to remain to the end of his life. Apart from a few garden scenes, a few excursions into mythology probably inspired by Roussel, Bonnard was now to be, like his friend Vuillard, the poet of the nocturnal or of the domestic scene, of cozy rooms, evenings spent in the lamplight. Children play with a dog, a young woman sets the dinner table, a plump-cheeked little boy eats his cereal, a grandmother cradles a baby on her lap. Now, too, in works first exhibited at Bernheim's in 1904, appear the charming young female figures, slender of body and with round, slightly childish faces, for whom Marthe was to be the most frequent model. Whether he saw them standing beside a bed, seated on a chair, near a dressing table (bathrooms were still suspect in France at this time), Bonnard was never to tire of noting down their unsophisticated, sometimes awkward gestures. Often a mirror or a looking glass, indispensable accessories to the female toilette, ingeniously complicate the perspective, and by embracing the familiar in a network of luminous reflections reinforce that impression of intimacy, of "luxurious exclusion of everything without," as Mallarmé said, which is the essence of this tender, insulated little universe.

Bonnard's nudes are so personal as to be almost unique in the history of the genre. There can be no question here of influence by Renoir or Maillol, whose self-sufficient, robust females are clearly of another flesh than Bonnard's delicate young women with their remarkably unemphathic hips and breasts. Bonnard is concerned hardly at all with modeling and anatomy; only the shimmer of light over the body seems to interest him, and his nudes are characterized by an almost total lack of sensuality. To be sure, a few black stockings appear in some of the canvases around 1900, and one might sense here and there, if bent upon it, a slightly more congested

atmosphere, a nuance of eroticism (*Man and Woman*), but it does not go far. One is more likely to find in Degas, who in 1886 exhibited a "Suite of nudes, of women bathing, washing, drying, rubbing down, combing their hair or having it combed," the possible sources or parallels for the almost disconcerting simplicity of Bonnard's nudes—with this difference: that Degas in his misogyny seeks out the least graceful attitudes and the meagerest shoulders, while Bonnard is all softness and tenderness.

In 1910 Bonnard went to work in the South of France, where he was to go again often, to Antibes, Cannes, Saint-Tropez, and where he was to meet Manguin, Signac, and Renoir. In 1912 he bought Ma Roulotte, a little house at Vernonnet near Giverny, the home of Monet, whom he often visited. (In 1925 he was to settle definitively at Le Cannet.) From this time on the pattern of his life, as of his work, is set. His palette brightens, light and landscape enter into

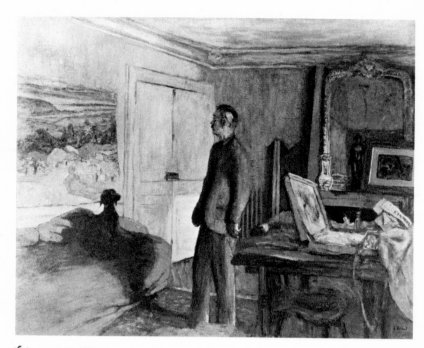

Édouard Vuillard: STUDY FOR THE PORTRAIT OF BONNARD. 1935. Distemper on paper, 45 × 56 1/4". *Musée du Petit Palais, Paris*

his work, never to leave it. Landscape in particular, save in the decorative compositions, loses its tapestry-like appearance in favor of a freer and more vividly accented freshness of notation recalling Boudin and the Impressionists.

To say that his life was set is perhaps an overstatement. Despite his origins, Bonnard was the least bourgeois of men. He lived more or less anywhere, according to the chance displacements that the health and rather capricious temperament of his wife imposed on him. The barest hotel room was enough for him, and no matter where he was he camped rather than settled. Photographs showing him in his surroundings at Le Cannet give the impression of an almost ascetic simplicity and a total indifference to money and comfort. His only luxury was a bathroom; his wife seems to have spent her life in a bathtub, as witnessed by a great number of paintings (reassuring documents, too, of the development of hygiene in France between the two world wars). Sometimes he hired a boat, and as long as the state of his eyesight allowed him to drive he owned an automobile in which he toured the byways; there was also his bicycle, upon which, said Thadée Natanson, "he took himself into the very folds of the

Bonnard at Deauville. Photograph by Rogi André, 1937

31

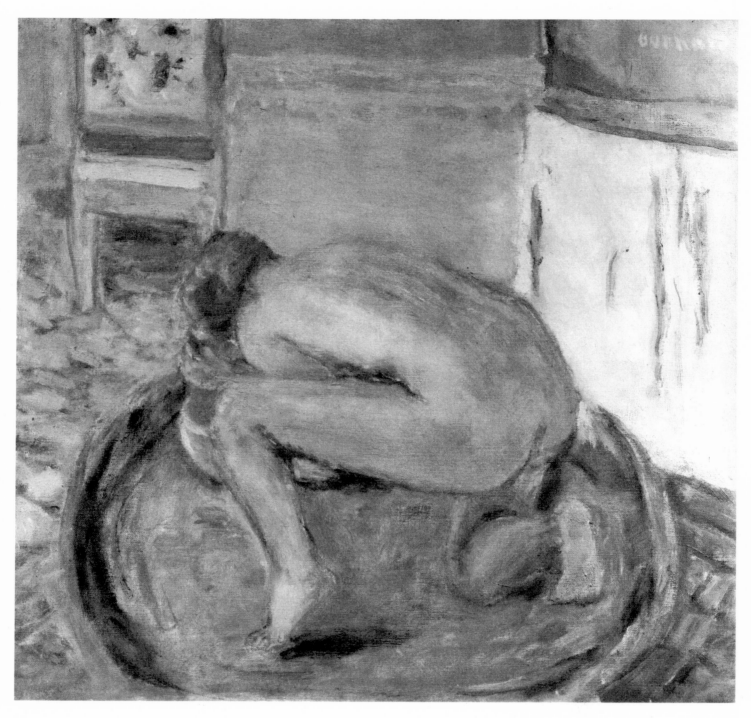

WOMAN WASHING HERSELF. C. 1916. Oil on canvas, 16 × 16 7/8". *Galerie Bernheim-Jeune, Paris*

landscape.'' His favorite amusement was walking; from his daily walks in Normandy or in the Provençal countryside he returned with his pockets stuffed with sketches, which he remembered when the time came to paint. For though he never painted anything that he had not had before his eyes, he never painted on the spot, but in his studio, or rather in what served him as such. ''His working conditions were incredible,'' wrote Georges Besson in 1943.

''Bonnard no doubt always had a studio in Montmartre; but his true studio was elsewhere and everywhere, in the unlikely settings of hotel rooms or furnished villas. Often, on the ceiling, the overhead light bulb of the retired government clerk; always, on the wall, the flowered wallpaper that his tacked-up canvases little by little covered over. . . . He had no easel; his only equipment was a little bamboo table on which were strewn the paintbrushes and a chipped

32

plate on which he set out his colors. His canvases, fixed to the wall with thumbtacks, he sometimes left for months without finishing, then one day added to them a little color smeared on with his finger. On more than one occasion, visiting friends, he touched up a canvas sold them perhaps ten years earlier. One of his companions even tells us that 'at the museum at Grenoble, or the Luxembourg, it happened that he would watch until the guard moved from one room to the next, take out of his pocket a minuscule box holding two or three tubes of paint and a sawed-off brush, and furtively, with a few touches, "improve" a detail that bothered him. Then, his *coup* complete, he would disappear, radiant as a schoolboy who has told the world off with a scathing scrawl on the blackboard.' "

He always signed but hardly ever dated his pictures: hence the peculiarly trying nature of attempts

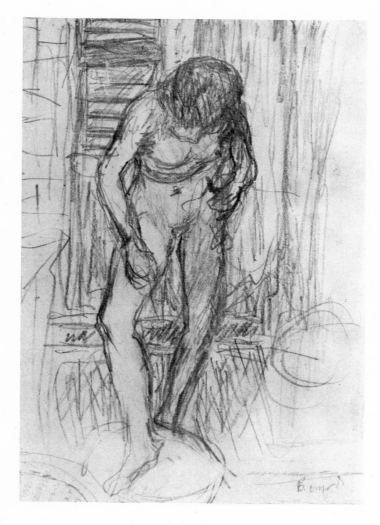

WOMAN IN A TUB. 1922. Crayon, 9 × 7 1/8".
The Louvre. Gift of Georges Besson, the donor retaining life interest

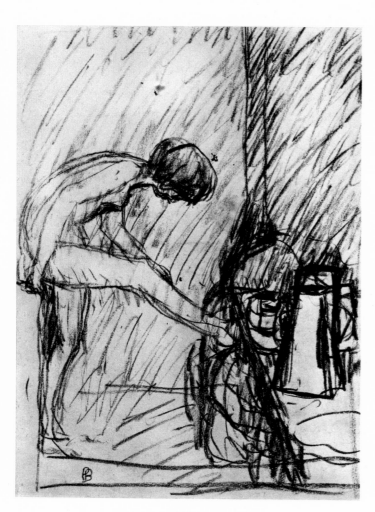

THE TOILETTE. C. 1920. Pencil, 13 × 8 5/8".
Whereabouts unknown

to establish a chronology for them. The prices that his pictures fetched toward the end of his life scandalized him: "All those zeros get on my nerves," he said. What he wanted was not so much glory or fortune as independence and freedom, just to live alone with his wife, his paintings, and his dogs Ubu and Poucette. As Thadée Natanson put it, "A dog was always part of his person."

Here he is in his maturity: "This thin, active man seems big even though he is a little bent over and sunk in on himself, as though this very pose were meant to be a considered thing. His complexion is bronzed by his master the sun. He caresses a short beard that grows freely around a determined chin. The lenses of his glasses multiply the brilliance of his glance. Two thin lips show his teeth, to mark, perhaps, that the witty mouth neither wants nor

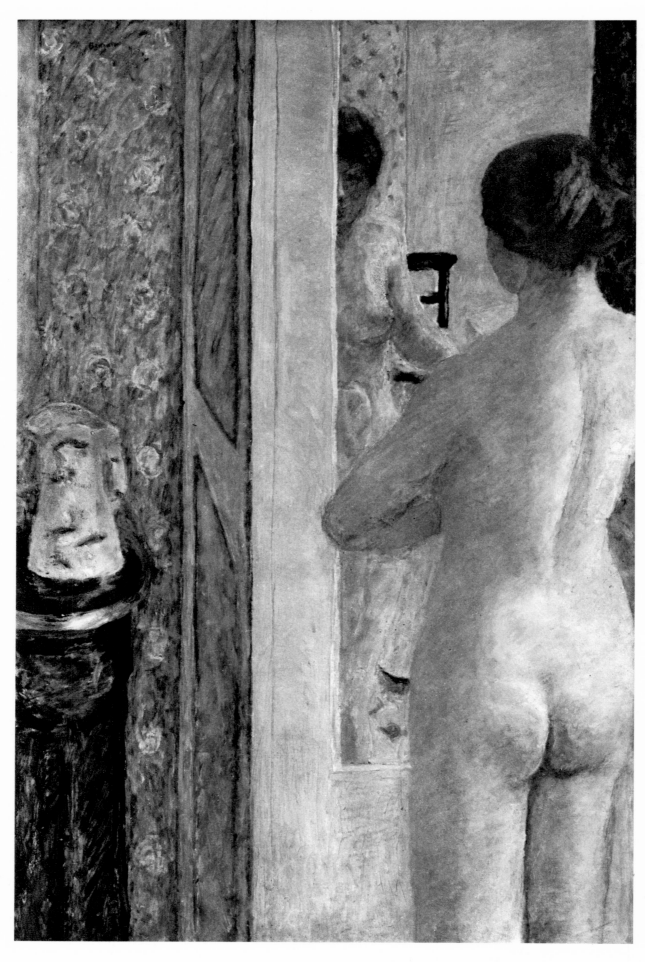

THE TOILETTE. C. 1922. Oil on canvas, 47 1/4 × 31 1/2". *Musée National d'Art Moderne, Paris*

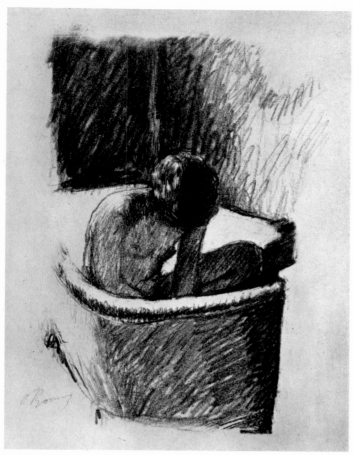

THE BATH. 1925. Lithograph, 13 × 8 7/8″

bound by friendly mutual esteem, but with whose painting his has little in common except a certain remove (*Table with Music Album*, finished 1932). However, it is certain that the crisis and the "years of anguish" that Charles Terrasse describes in the beautiful book he devoted to his uncle must have arisen as a consequence of the atmosphere surrounding painting in Paris and its special concerns in the years just before the war: "He realized that he had decidedly to start all over again. Yes, relearn everything. 'I have gone back to school. I have tried to forget what I knew; I am seeking to learn what I don't know. I am studying again, from the basics, from A,B,C . . . and I am on guard against myself,

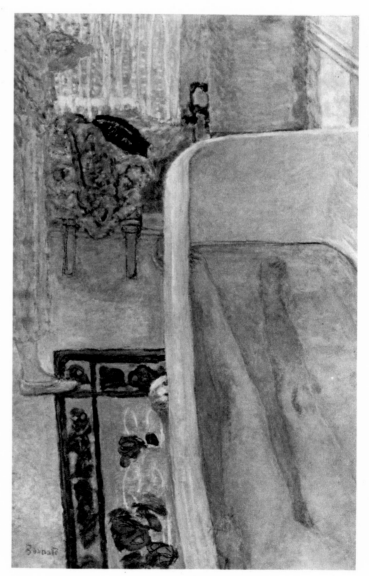

NUDE IN THE BATH. 1935. Oil on canvas, 51 1/8 × 25 1/4″. *Collection R. T., France*

knows how to dissemble. . . . He has not grown fat, nor will he, despite his propensity to laughter; not so much because he refuses himself leisure but because one grows fat only by staying put, and he dislikes above all else letting himself be held by anyone, bound or enclosed anywhere. . . . He appears a man who likes his ease, is happy to live informally. . . . His myopia is that of an observer, which frees him from unimportant detail. Under the glasses a rare vivacity in his pupils seems to linger over or spy out objects, always able to seize on them. His seriousness, his timidity ask only to give way to a smile when not jumping at the chance to burst into laughter. And that is why one so clearly remembers Bonnard's teeth: regular, white, and frankly revealing themselves completely" (Natanson, *Peints à leur tour*).

The return of color to Bonnard's art after 1911 may perhaps be explained in part by the climate of the period and more particularly by the influence of the Fauves. Not that Bonnard owes anything very precise to them—not even to Matisse, to whom he is

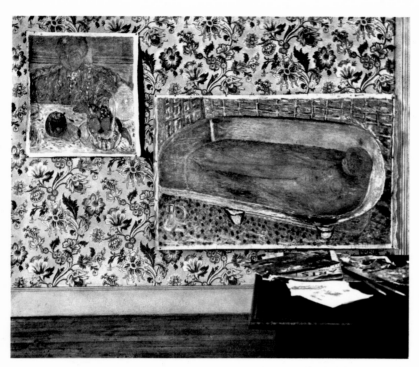

Wall of a room in Deauville, showing a partly finished
NUDE IN THE BATH. Photograph by Rogi André, 1937

detracted from his respect for Cézanne. We know, through the publisher Tériade, that "he approved of collages at the time when artists were experimenting with them," and one day he told the critic Pierre Courthion, "I am trying to give painting more coherence, more unity. I thought for a long time that it was enough to make one tone sing out a little more vividly in a muted range. It was an experiment; but the picture has to be sustained, you understand. There must be no holes. From that point of view Cubism and the painters of the new generation have done a good thing. But they are tough, these young ones."

Difficult though this experience may have been for Bonnard, it recalled to him the need for drawing, construction and composing. The famous *Dining Room in the Country* (1913) in the Minneapolis Institute of Arts is the first witness to this desire to build the painting around a precise and rigorous network of horizontals and diagonals, of clearly drawn

against all that I loved, against the color that drives you crazy.' "

In Paris in 1914 the talk was all of drawing, form, construction, and the return to Ingres. "The fashion then was," writes Léon Werth, "for order and construction. Painting drew inspiration from Euclid and the Blacks. . . . We begged for crumbs of rationality wherever we could suppose it to have gained sway over gratification of impulse; wherever the permanent seemed to have vanquished the immediate. . . . The doctrine of imperative construction and of a new classicism became a tenet of faith. . . . Monet was denounced as a frivolous butterfly of Impressionism, and Bonnard as the bearer of the taint of Post-Impressionism and degeneracy." Bonnard, says Jacques-Émile Blanche, "went through a bad moment at that time." It must have been a short moment, for in 1918 the Groupement de la Jeune Peinture Française chose him, along with Renoir, as honorary president.

However that may be, Bonnard had been capable of "going back to school" and, in his very personal way, taking advantage of the investigations of the new painting. His admiration for Monet in no way

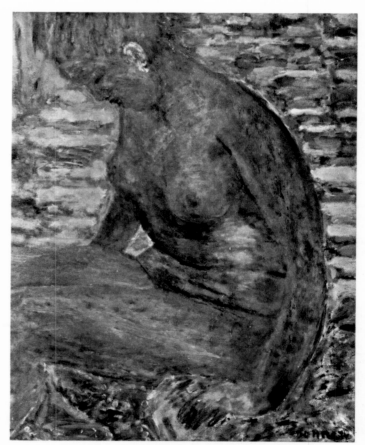

DARK NUDE. 1942. Oil on canvas, 31 1/8 × 24 3/4".
Collection Charles Terrasse, Paris

36

curves, which is to be found in Bonnard's work up to the eve of World War II. The motif of the window or French window (*The Open Window*, 1921; *Window at Le Cannet*, 1925) is exploited as a kind or architectural scaffolding inserted between the atmospheric freedom of the landscape and the charming disorder of the domestic setting, insuring that the painting will have balance and monumentality. The planes are clearly established and always somewhat flattened, and in Bonnard's reluctance to stress depth and perspective it cannot but seem that the Cubist influence has worked in harmony with, rather than in contradiction to, the earlier decorative aesthetic of the Nabis and Maurice Denis.

Without attempting to distinguish specific Cubist influences in Bonnard, which would clearly be absurd, one can still compare the Cubists' manner of disassembling objects to Bonnard's manner of dispersing his forms and masking their contours. There are few modes of vision more complex than Bonnard's, few pictures so difficult to read as certain of his still lifes. Some are almost indecipherable, like the curious *Still Life with a Bouquet of Flowers* in the Basel Museum, in which, further, it would not be hard to see a kind of Cubist accent in the way in which the vase to the left of the composition is distorted and silhouetted. Whether out of coquetry, malice, or the desire to keep our minds on the painting's color composition, Bonnard rarely presents an object in a simple descriptive fashion, and he is not averse to enigmas and riddles. If he shows a book in one of his interiors, he never allows us to read more than a fragment of the title. His art is one of allusion and poetic recollection, and it could be said that in many respects Bonnard was an artist of very conscious aesthetic refinements: not affected, but aware of aesthetic elegance as were Mallarmé and Proust.

Similarly, if the painter's vision must be allusive, it must also, according to Bonnard's statements to Charles Terrasse, be "mobile and variable." We do not really see faraway panoramas, but only close objects; distances are flat; roundness or volume exist only in the foreground. When an object is nearby the glance of the eye tends to be perpendicular to it,

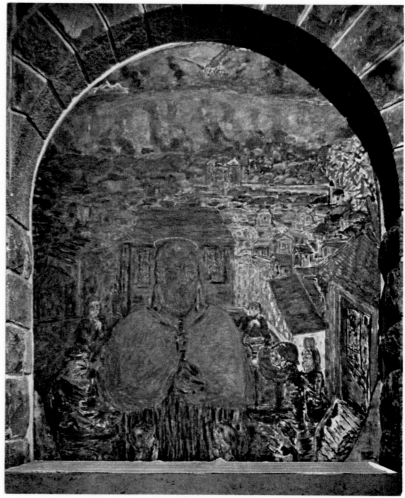

SAINT FRANCIS OF SALES BLESSING THE SICK. 1942–45. Oil on canvas. *Church of Assy, Haute-Savoie*

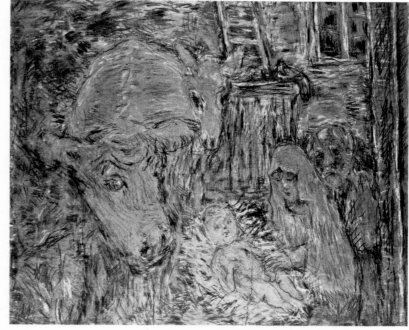

NATIVITY. 1943. Pencil and pastel, 23 1/4 × 29 1/8″. *Collection Charles Terrasse, Paris*

37

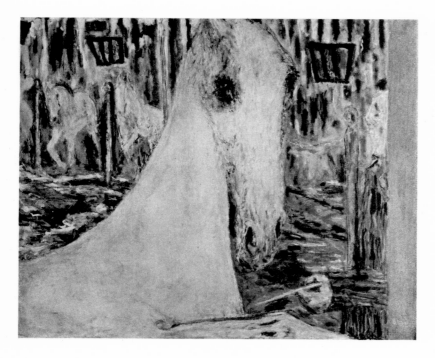

CIRCUS HORSE. 1938–46. Oil on canvas, 36 5/8 × 46 1/8". Collection Charles Terrasse, Paris

but Bonnard, far from placing the elements of the composition in perspective, likes to tilt his table tops up toward us, like Cézanne or even Picasso, and to show us objects in the same picture as though they were seen from different viewpoints. In *The Table*, the fruit dish in the background appears as an oval, a plate in the foreground altogether circular, while the front part of the composition and the wicker basket are presented more or less vertically.

In Bonnard, such manipulations are clearly not in the intellectual or speculative vein that might have characterized them in the work of contemporaries

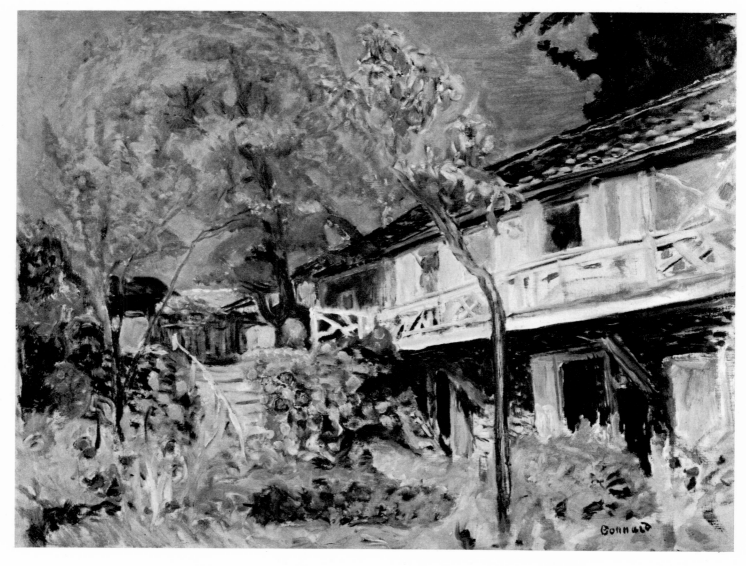

MA ROULOTTE. C. 1915. Oil on canvas, 22 1/2 × 29 1/8". Whereabouts unknown

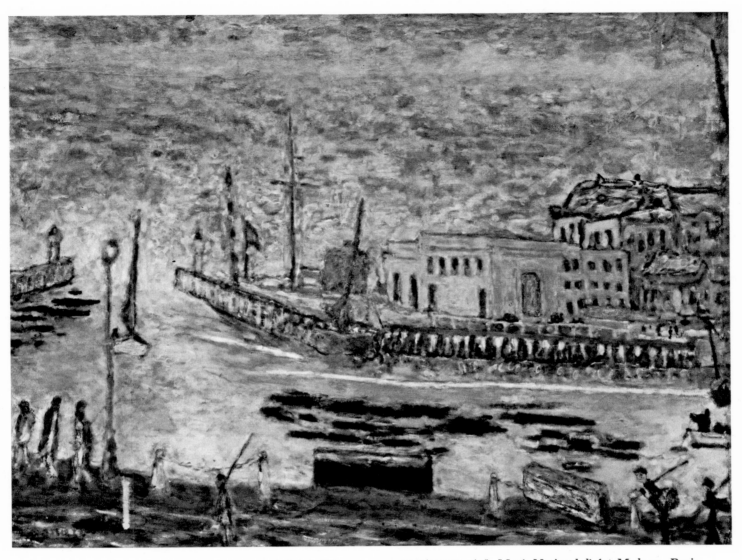

TROUVILLE: LEAVING THE HARBOR. 1938–45. Oil on canvas, 30 1/4 × 40 1/2″. *Musée National d'Art Moderne, Paris*

such as the Cubists or Matisse. Even so, certain of the painter's critic friends have overemphasized the freedom, the insouciance, the careless spontaneity that they imagine in his work. A contemporary of Malherbe, irritated by classical rules, wrote that "casualness is the greatest artifice" of the true poet. Casualness often does seem Bonnard's greatest artifice; but his nonchalance is strongly calculated and his liberties have their laws. Foremost of these laws is the very strict notion of composition that, as we have seen, disciplines the coloristic profusion on his canvas from 1913 up to the eve of World War II, except for certain landscapes. There is always a geometric form—the rungs of a chair, a wall, the rectangular shape of a city square, the edge of a terrace—to stabilize the picture and define a

limited space. Often the play of horizontal or vertical bands at the painting's edge keeps Bonnard's eye from plunging into depths and distant perspectives, a remnant of the Nabi in him.

Bonnard can thus exploit color according to his own understanding of it, separating it from the requirements of form, if need be, though he rarely indulges in what, in the wake of Cubism, had become one of the clichés of Parisian painting. From 1930 on he uses color with a surprising boldness and freedom. The local color of objects disappears, along with the conventional drawing of their forms. Bonnard transposes reality entirely into the color range which for so long had been his favorite, one abounding in mauves, lilacs, oranges, pinks, and violet-blues. The hues sharpen more and more, until they

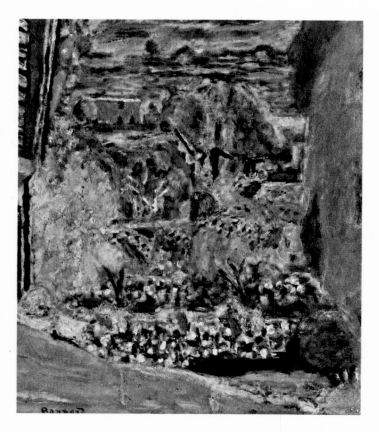

bathe in an atmosphere of magical, dreamlike un-reality, recalling some of the most beautiful pages of Proust. It is in fact surprising that Bonnard's interpreters, so abounding in lyrical passages about him, have never compared him to the author of *Remembrance of Things Past.* "Let others," wrote André Lhote in 1944, "paint metaphysically the crumbling of old principles, the great anguish of the present-day world. Bonnard, chilly, aristocratic, skeptical, steeped in meditations full of wisdom, draws us into those impossible regions we all dream of, from which violence and fear are excluded."

From 1940 to 1947, in spite of age, misfortunes, and the solitude so movingly evidenced by certain of the self-portraits, especially after Marthe's death

verge upon dissonance. The sea may be yellow, clouds red; nudes are enveloped in a quite unreal and arbitrary light; the tiles of one and the same bath-room become the pretext for almost unlimited chro-matic variations and, in a series of pictures, range through all the colors of the painter's palette. On the canvas color is no longer a reference to reality but an ensemble of modulations justified only by their reciprocal relationships; for "color," said Bonnard, "has a logic as severe as form. . . . To retouch an accent makes it discordant with the neighboring tone; they must then be reharmonized; but the second tone now seems to clash with its neighbor; they must be reharmonized. And, from one to the next, they all jostle each other."

It was at this time that Bonnard created some of his most splendid masterpieces, like the *Bathtub* series, wholly transfiguring the small, familiar universe that had always been his. This is no longer even that poetry of daily life with its sweet indolence, its graceful leisure, its charming and furtive little pleasures, but a world in which trees, fruits, bodies

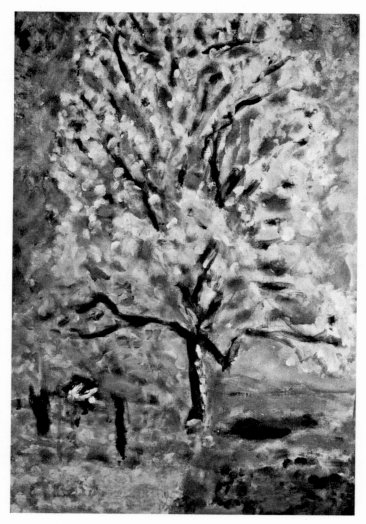

in 1942, even in spite of the sorrows of the occupation of France, Bonnard's activity in no way faltered. His old age, like that of Matisse and Braque, was a glorious twilight. The last works show us what rebirths his art was still capable of. Gorged with light in their least crevice, his pictures, especially the landscapes, become a sort of resonant and humming surface, an "all-over painting" in which forms and planes are strongly confounded, eccentricities of drawing and composition accentuated with a quite Expressionistic violence. The nudes, the still-life groups, even the portraits stand out with remarkable vigor against backgrounds hatched with rapid brush strokes and colored patches in which the elements of any real setting are no longer recognizable. "He saturates his late works with ever richer tones," wrote André Lhote, "ceaselessly adding new touches to those of the day before and at the same time suppressing elements of banal resemblance." It must not be thought, however, that Bonnard intended these late paintings as abstractions: when he resumed work in 1946 on the *Circus Horse* of 1938, it was to insert in the right side of the composition a horseman, albeit a very odd-looking one, in appearance a kind of puppet; and the last canvas he painted before his death on January 23, 1947, was *Flowering Almond Tree*. Prodigal as these late works are, they exercise no soft blandishments. The eye is still sure, but the hand trembles perhaps a little, setting down the forms on the canvas with a kind of slightly confused awkwardness; the tonal relations are sometimes strident to the point of acidity; the colors, whether dull or sharp, seem crushed, leaden; and Bonnard, who in any case had never loved glossy surfaces or alluring transparencies, never painted surfaces so matte and dry as those of his last works. An old man's painting, it has been said. Yes, in the sense that such classics as Rousseau's *The Reveries of a Solitary* and the *Life of the Abbé de Rancé* are the writings of old men.

We must not attribute to old age, and still less to an inclination for religious conversion, Bonnard's *Saint Francis of Sales*, his only religious painting, done for the church of the Plateau d'Assy in Haute-Savoie. Such commissions were common at the time

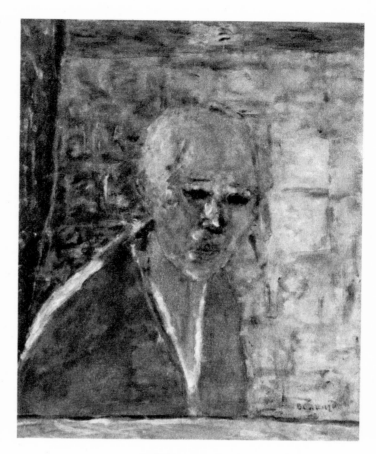

SELF-PORTRAIT. 1945. Oil on canvas, 22 × 18 1/8".
Collection Mr. and Mrs. Donald S. Stralem, New York

and Bonnard in his manner, like Léger, Matisse, and others in theirs, took part in the revival of religious art current in France, though briefly to be sure, at the end of the war. Bonnard himself looked on it as merely an assignment. It is a true Bonnard, however, with its little silhouettes crowding around the saint, the blue and mauve background hues, the principal figure set on the foreground plane, his head crowned with a small halo placed all askew, and a sumptuous violet robing the shoulders. In fact, one might imagine it to have been for the sake of painting this violet that Bonnard undertook the commission, though perhaps the subject interested him at that time, for we do have a fine drawing of a Nativity from 1943.

At the conclusion of his book, Thadée Natanson writes that he should have liked "to be able to express the power and diversity of this considerable body of work; or at least to offer an explanation that should embrace the whole of it. But Bonnard's gifts might as well have burst forth as naturally as

the song of birds at dawn. From the first lines of this attempt I have not ceased asking myself whence came these gifts, for to say that he is 'other' than we is not to explain him but simply to restate the question. Though I have sought, I have found nothing. Nothing valid. I shall no longer try to explain his painting. Nor from whom Bonnard derives. But is he the only inexplicable one? Do we know whence Watteau springs; or, any better, the ancestry of Chardin's art?" Let us put aside Watteau and Char-din, and not speculate too much about the birds and the bees, for Bonnard, after all, as much as Matisse or even a little more so, is the product of a culture. Although in ending this essay it would be presumptuous indeed not to accept as our own Thadée Natanson's conclusion, we may also recall the words of Stendhal: "The beautiful is a promise of happiness." For no body of work in the twentieth century appears to us to have kept that promise better than Bonnard's.

BIOGRAPHICAL OUTLINE

1867 OCTOBER 3: Birth of Pierre Bonnard at Fontenay-aux-Roses, near Paris, of a bourgeois family in comfortable circumstances. Childhood spent at Fontenay and in the house of his paternal grandmother at Le Grand-Lemps, in the Dauphiné.

1868 Birth of Vuillard.

1869 Birth of Matisse.

1870 Birth of Maurice Denis.

1874 First Impressionist exhibition.

1875 Bonnard enters school.
Death of Corot.

1886 Passing his baccalaureate, Bonnard enters the Faculté de Droit (law school) in Paris, where he later obtains his *licence*. Simultaneously works at the Académie Julian, where he meets Sérusier, Maurice Denis, H. G. Ibels, Paul Ranson.

Eighth and last Impressionist exhibition. Degas shows a series of pastels entitled: "Suite of nudes, of women bathing, washing, drying, rubbing down, combing their hair or having it combed." Jean Moréas publishes the *Symbolist Manifesto*.

1888 At the École des Beaux-Arts Bonnard forms friendships with Vuillard and K.-X. Roussel. Begins painting landscapes of the Dauphiné.

Sérusier returns from Pont-Aven with *The Talisman*.

1889 Turned down for the Prix de Rome. Succeeds in selling a design for a poster, *France-Champagne*, and settles in Paris in his first studio. The Nabi group is formed under the aegis of Sérusier.

Exhibition of the Impressionist and Synthetist group (Gauguin and his friends). Toulouse-Lautrec exhibition at the Salon des Indépendants. Verlaine publishes *Parallèlement*.

1890 Moves into a new studio near the Place Pigalle, with Vuillard and Denis; they are soon joined by the actor Lugné-Poë.

Founding of the *Mercure de France*.

Exhibition of Japanese prints at the École des Beaux-Arts. Gauguin in Paris, participating in Symbolist and Nabi gatherings.

1891 Makes the acquaintance of Toulouse-Lautrec, who had noticed his poster. Exhibits for the first time at the Salon des Indépendants, takes part in an exhibition of the Nabi group at Saint-Germain, and in December at Le Barc de Boutteville's.

La Revue Blanche published by the Natanson brothers.

Gauguin leaves for Tahiti.

1892 Exhibits at the Salon des Indépendants and in the second Nabi exhibition at Saint-Germain. In November, exhibits at Le Barc de Boutteville's with Vuillard and Denis.

The critic Gustave Geffroy mentions, in referring to Bonnard, a "violent Tachisme."

Exhibitions of Pissarro, Monet, Renoir, and Degas at Durand-Ruel.

1893 Illustrates *Petites Scènes familières pour piano* and *Petit Solfège illustré* by his brother-in-law, the musician Claude Terrasse. Does lithographs for *Escarmouche* and the *Revue Blanche*.

Mallarmé publishes *Vers et prose*. Vollard opens a gallery in the Rue Laffitte. Lugné-Poë founds the Théâtre de l'Oeuvre and presents Maeterlinck's *Pelléas et Mélisande*.

1894 Designs the poster for *La Revue Blanche*. Does a portrait of one of his models, Marie Boursin, who calls herself Marthe de Méligny; she becomes his life's companion, and marries him in 1925. Series of Parisian landscapes. More somber palette.

Odilon Redon exhibition at Durand-Ruel.

1895 Executes a design for a Tiffany stained-glass window. Designs the cover for the *Album de La Revue Blanche*.

Cézanne exhibition at Vollard's.

1896 First one-man show at Durand-Ruel. Exhibits in Brussels at the Salon de la Libre Esthétique. Poster for Vollard's exhibition of painter-printmakers.

Death of Verlaine. Premiere of Alfred Jarry's *Ubu roi* at the Théâtre de l'Oeuvre, with sets by Bonnard and Sérusier.

1897 Executes color lithographs for the albums of work by painter-printmakers published by Vollard. Exhibits at Vollard's with the Nabi group.

André Gide publishes *Les Nourritures terrestres (Fruits of the Earth)*.

1898 Publication of Peter Nansen's *Marie*, illustrated by Bonnard.

Death of Mallarmé.

1899 Vollard publishes a series of twelve of Bonnard's color lithographs: *Quelques Aspects de la vie de Paris*. Works for the Théâtre des Pantins. Group exhibition at Durand-Ruel.

1900 Exhibits with the Nabis at Bernheim-Jeune. Rents a small house at Marly-le-Roi. Vollard publishes Verlaine's *Parallèlement*, with illustrations by Bonnard.

1901 Exhibits at the Salon des Indépendants. Death of Toulouse-Lautrec.

1902 *Daphnis et Chloe* published by Vollard, with 151 lithographs by Bonnard. Exhibits at the Salon des Indépendants and at Bernheim-Jeune.

Maillol exhibition at Vollard's.

1903 Exhibits at the Salon des Indépendants, at Druet's, at the first Salon d'Automne (three paintings, including *The Family: L'Après-midi bourgeoise*), and at the Vienna Secession.

Final issue of the *Revue Blanche*. Death of Gauguin.

1904 Exhibits scenes of interiors and nudes at Bernheim-Jeune. Illustrates Jules Renard's *Histoires naturelles*.

Cézanne exhibition at the Salon d'Automne.

1905 Exhibits at the Salon des Indépendants and at the Salon d'Automne. Fauves' "scandal" at the Salon d'Automne.

1906 One-man exhibition at Bernheim-Jeune, which becomes his permanent gallery.

1907 Exhibits at Bernheim-Jeune, at the Salon d'Automne, and at the Munich Secession.

Picasso's *Demoiselles d'Avignon*.

1908 Publication of *La 628 E 8* by Octave Mirbeau, with marginal sketches by Bonnard. Trip to England, Spain, and North Africa.

1910 Works in the Midi, to which he will henceforth often return. His painting becomes brighter.

1911 Exhibits at Bernheim-Jeune twenty-seven paintings and the three decorative panels executed for the Russian collector Ivan Morosoff. The panels are also shown at the Salon d'Automne.

Cubist exhibition at the Salon des Indépendants and at the Salon d'Automne.

1912 Buys a house, Ma Roulotte, at Vernonnet, near Giverny. Refuses the Légion d'Honneur, together with Vuillard, Vallotton, and Roussel.

1913 Exhibits *Dining Room in the Country* at the Salon d'Automne. Exhibition at Bernheim-Jeune.

Marcel Proust publishes *Du Côté de chez Swann (Swann's Way)*.

1914–18 Years of crisis and uncertainty. Bonnard becomes, with Renoir, an honorary president of the Groupement de la Jeune Peinture Française. Takes part (1916) in the exhibition of French art at Winterthur, Switzerland.

1920 Illustrates André Gide's *Promethée mal enchaîné (Prometheus Misbound)*.

1924 Important Bonnard retrospective exhibition at Galerie Druet.

1925 Buys Le Bosquet, a villa at Le Cannet, near Cannes, which will be his real home until the end of his life.

1926 Member of the Carnegie International Exhibition prize jury. Trip to the United States. One-man exhibition at Bernheim-Jeune.

1927 Vollard publishes Octave Mirbeau's *Dingo*, illustrated with twenty-seven etchings by Bonnard.

1928 Exhibits forty paintings at De Hauke & Co., New York.

1929 Participates in the Exposition de l'Art Français in Brussels.

1930 Illustrates Claude Roger-Marx's *Simili*. Vollard publishes the *Vie de Sainte Monique*, illustrated by Bonnard. Represented by seven paintings in the exhibition *Painting in Paris* at the Museum of Modern Art, New York.

1932 Bonnard-Vuillard exhibition at the Zurich Kunsthaus.

1933 Exhibition of portraits at the Galerie Braun.

1934 Exhibition at Wildenstein's in New York. Frequent stays at Deauville and Trouville until 1938. His paintings show more and more vivid color, drenched in a yellow-orange light.

1936 Wins second prize at Carnegie International Exhibition. Exhibition at Galerie Rosenberg, Paris.

1937 On the occasion of the Exposition Universelle in Paris, exhibits with the group of the Maîtres de l'Art Indépendant.

1938 Exhibition in Amsterdam (*Parijsche Schilders*), in Stockholm, and in Paris at Durand-Ruel and J. Rodrigues-Henriques (pastels, watercolors, and drawings).

1940 Retires to Le Cannet; remains there until the end of World War II.

Death of Vuillard. German occupation of France.

1942 Exhibition at the Weyhe Gallery, New York. Death of Marthe. Canvases more and more free and surcharged with color.

1943 Bonnard-Vuillard exhibition at Paul Rosenberg, New York. Exhibition in Paris at the Galerie Petridès.

1944 *Verve* publishes Bonnard's *Correspondances*, with his own illustrations. *Le Point* devotes a special issue to him. Exhibition of graphic work at Pierre Bérès in Paris.

Liberation of France.

1945 Makes a short stay in Paris. Exhibits gouaches, pastels, watercolors, and drawings at J. Rodrigues-Henriques.

1946 Retrospective at Bernheim-Jeune. Exhibits twelve canvases at the Salon d'Automne and at the Bignou Gallery in New York. Agrees to plan for a large exhibition of his work at the Museum of Modern Art, New York.

1947 JANUARY 23: Death of Bonnard at Le Cannet. Retrospective exhibitions in Copenhagen, Amsterdam, London, Stockholm, and the Musée de l'Orangerie, Paris.

1948 Retrospective exhibition at the Museum of Modern Art, New York.

1949 Exhibition at the Zurich Kunsthaus.

1954 Exhibition in Lyons.

1955 Exhibitions at the Maison de la Pensée Française. Exhibition at the Musée National d'Art Moderne, Paris: *Bonnard, Vuillard et les Nabis*.

1964 Exhibition *Bonnard and His Environment* at the Museum of Modern Art, New York.

1966 Exhibition at the Royal Academy of Arts, London.

GRAPHIC WORKS
AND
DRAWINGS

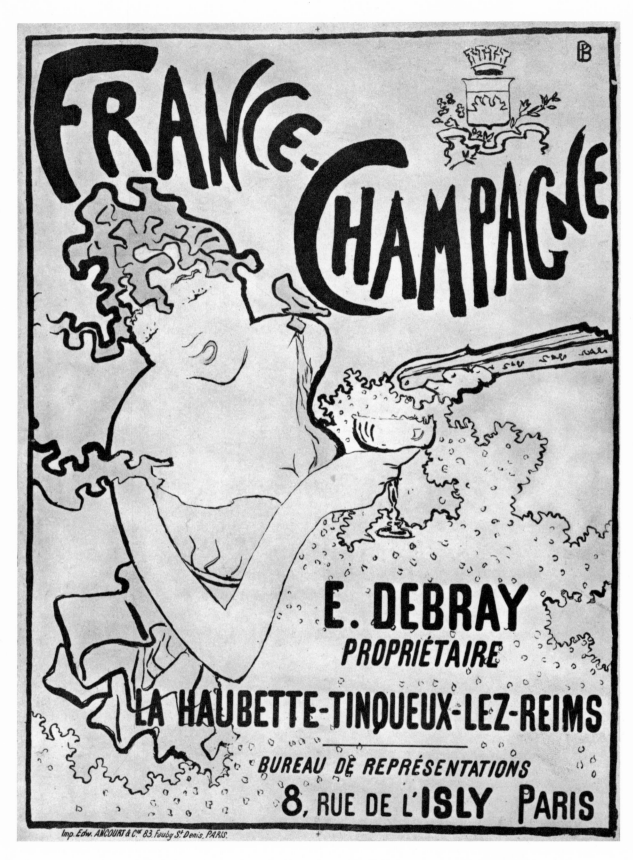

FRANCE–CHAMPAGNE. 1890. Poster, color lithograph, 30 3/4 × 19 3/4″

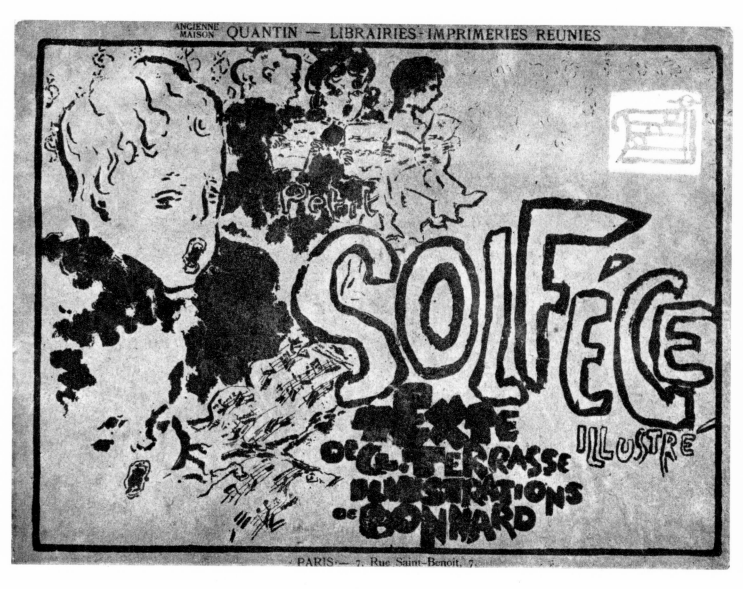

Cover of *Petit Solfège illustré.* 1893

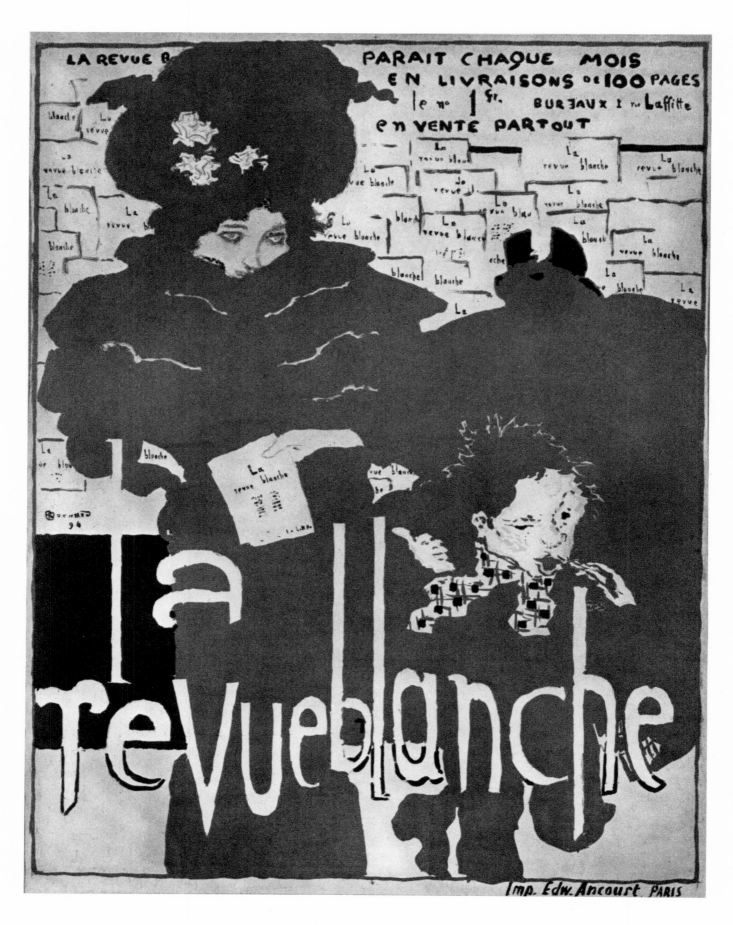

Poster for *La Revue blanche*. 1894. Lithograph, 30 3/4 × 23 7/8"

LA DERNIÈRE CROISADE (program for the Théâtre de l'Oeuvre. Proof printed before text).
c. 1896. Lithograph, 11 7/8 × 19 1/2″

Cover for *L'Album d'estampes originales*. 1897. Color lithograph, 22 1/4 × 33 1/2″

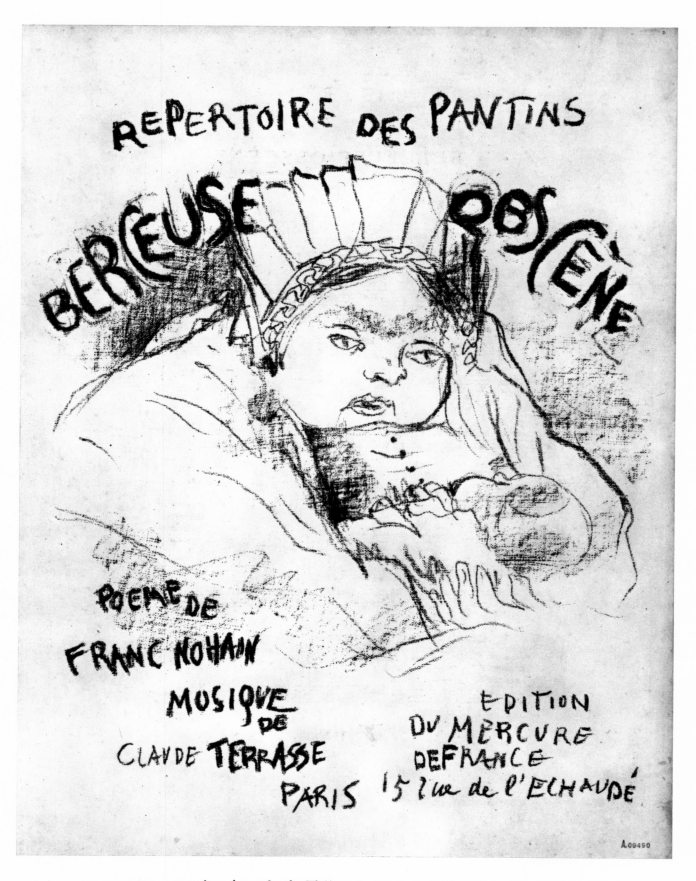

LA BERCEUSE OBSCÈNE (song for the Théâtre des Pantins). 1898. Lithograph, 12 1/4 × 9 7/8"

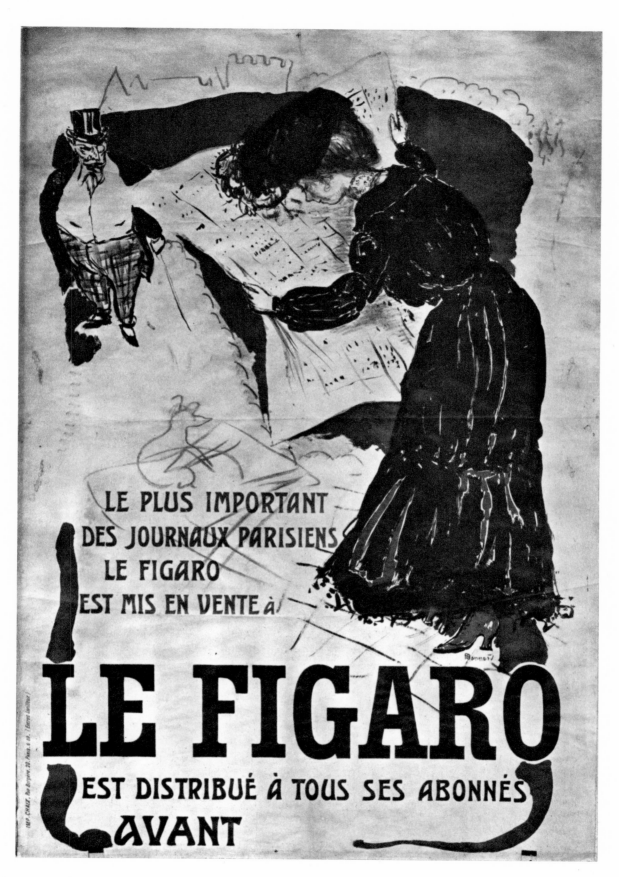

Poster for *Le Figaro.* c. 1904. Color lithograph, 50 × 32 5/8″

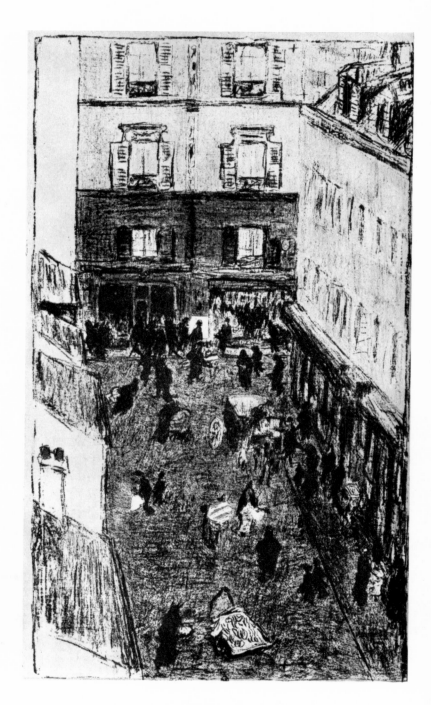

YOUNG GIRL WITH BLACK STOCKINGS.
1893. Lithograph, 11 1/2 × 5″

CORNER OF THE STREET SEEN FROM ABOVE
(from *Quelques Aspects de la vie de Paris*).
1895. Color lithograph, 14 1/8 × 8 1/4″

54

NIB CARNAVALESQUE.
1895. Lithograph, 13 × 19 3/4"

DOGS
(published in *L'Escarmouche*). 1893.
Lithograph, 14 1/2 × 10 1/4"

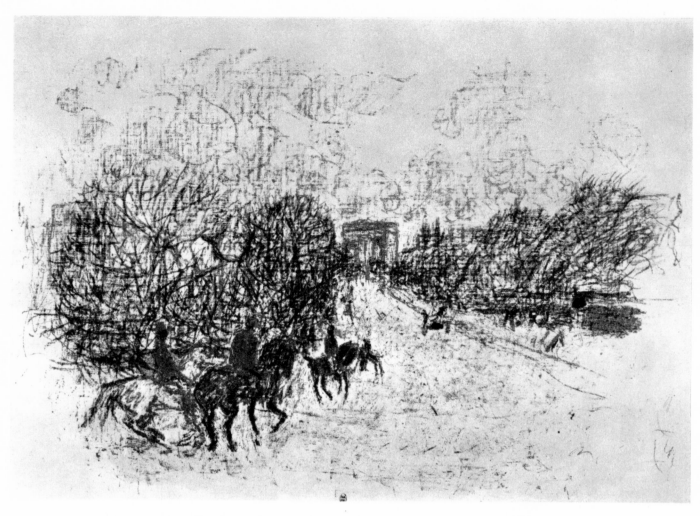

ARC DE TRIOMPHE (for *Quelques Aspects de la vie de Paris*). 1899. Color lithograph, 12 5/8 × 18 1/2″

THE COUPLE, study for *Parallèlement*. 1899.
Brush and ink, 8 1/2 × 10 5/8″. *Collection Hans R. Hahnloser, Berne*

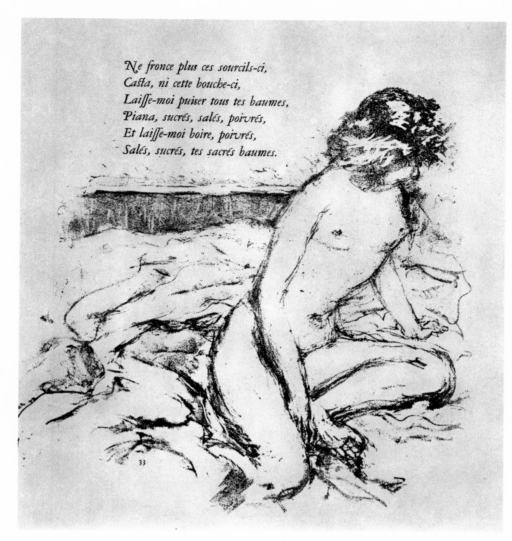

Ne fronce plus ces sourcils-ci,
Casta, ni cette bouche-ci,
Laisse-moi puiser tous tes baumes,
Piana, sucrés, salés, poivrés,
Et laisse-moi boire, poivrés,
Salés, sucrés, tes sacrés baumes.

Page from *Parallèlement*. 1900.
Color lithograph,
page size 9 7/8 × 12"

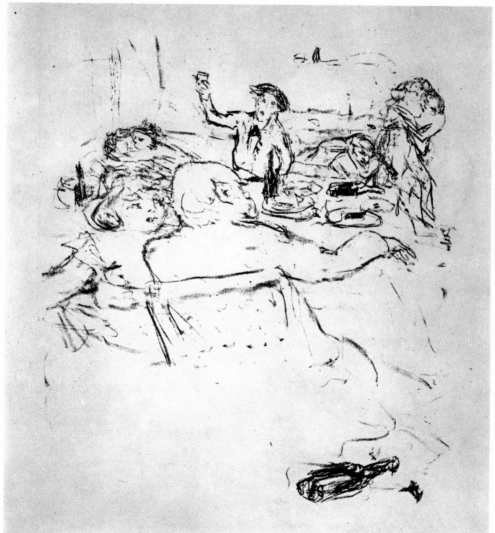

Page from *Parallèlement*. 1900.
Lithograph,
page size 9 7/8 × 12"

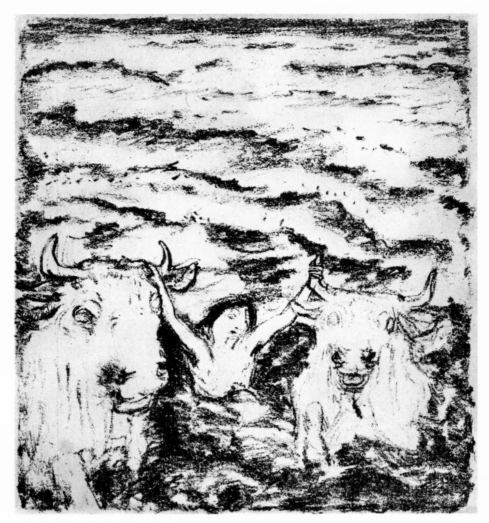

DAPHNIS ET CHLOE. 1902. Lithograph, 5 7/8 × 5 1/2″

CAT, illustration for Renard's *Histoires naturelles*.
1903. Brush and ink, 11 3/4 × 4 1/2″.
Collection Hans R. Hahnloser, Berne

SWAN, illustration for Renard's *Histoires naturelles*.
1903. Brush and ink, 12 1/4 × 8″.
Collection Hans R. Hahnloser, Berne

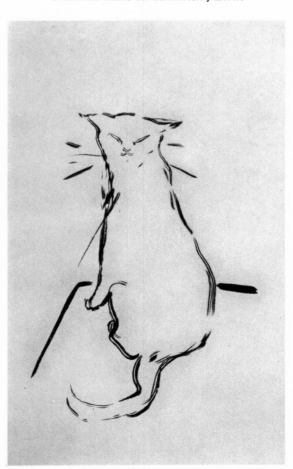

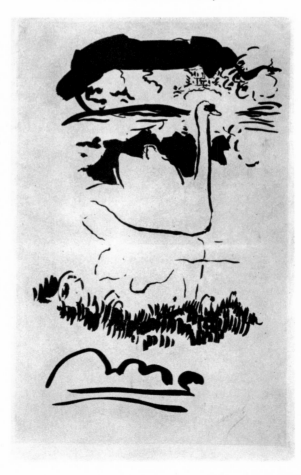

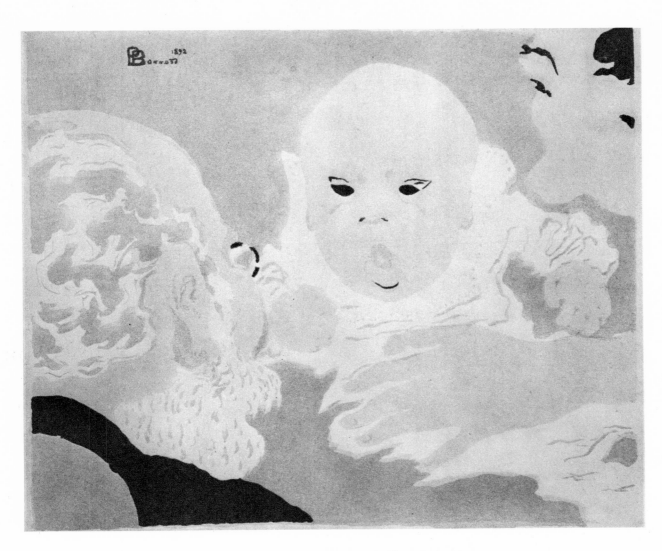

FAMILY SCENE. 1892. Color lithograph, 8 1/2 × 10 1/2"

WOMAN WITH UMBRELLA. 1895. Lithograph, 17 3/8 × 8 5/8"

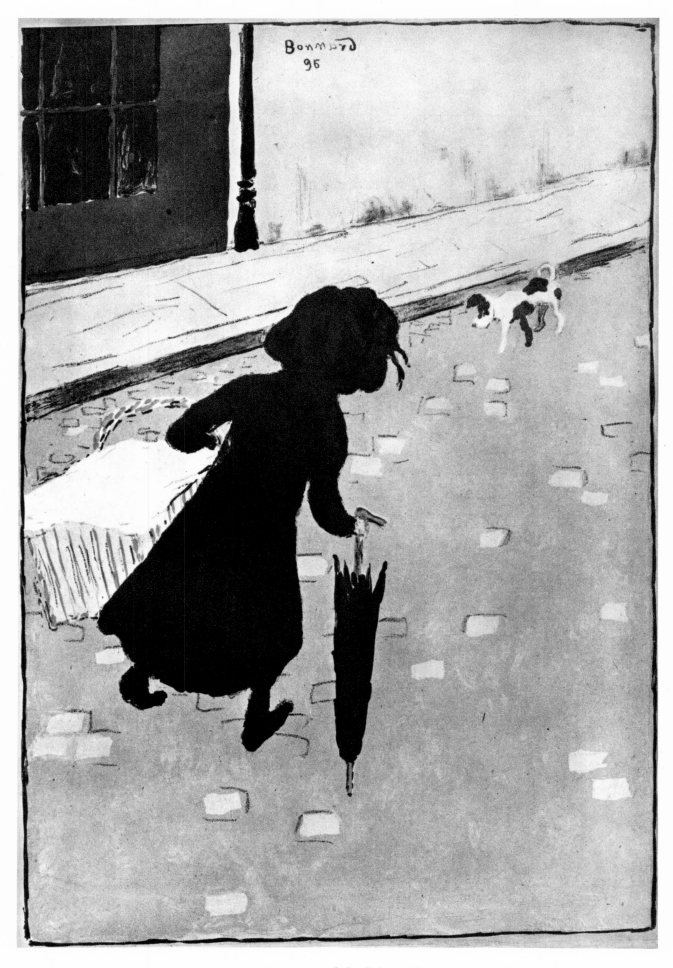

THE LAUNDRY GIRL. 1896. Color lithograph, 11 3/4 × 7 1/2″

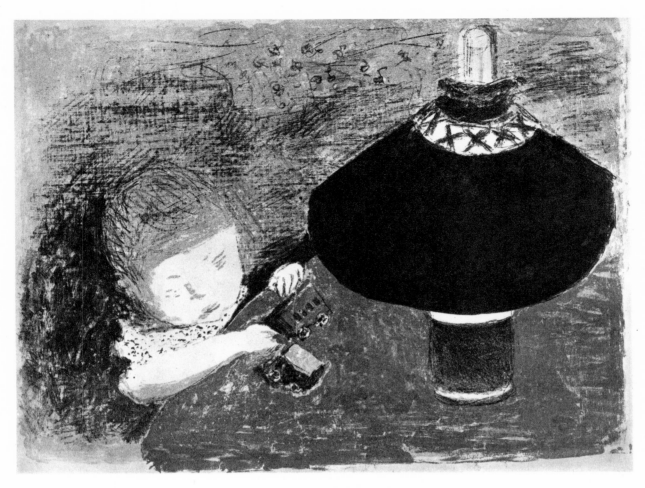

CHILD WITH LAMP. 1896. Color lithograph, 13 1/8 × 18 1/8″

IN THE STREET. 1900. Color lithograph, 10 1/4 × 5 1/8″

61

THE PARADE GROUND. 1890. Pen and ink, 7 7/8 × 11 3/4″. *Collection Roland Balay, New York*

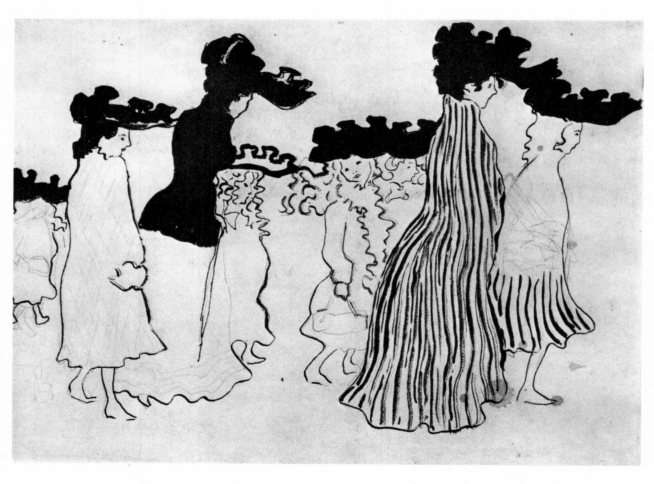

GIRLS. C. 1893. Pen and ink, 10 × 14″. *Collection Mr. and Mrs. Joseph Ansen, Beverly Hills*

STUDY. 1896. *Musée National d'Art Moderne, Paris*

PARIS STREET IN THE RAIN. 1898. Pastel. *Bibliothèque Nationale, Paris*

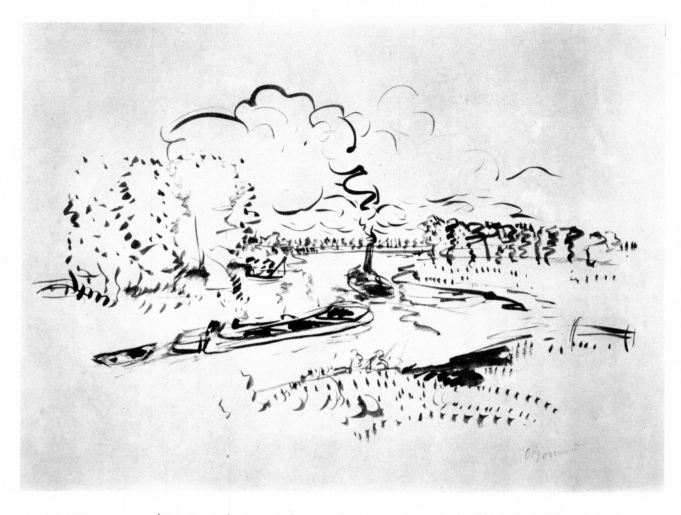

LE REMORQUEUR (LA SEINE À VERNON). 1907. Drawing, project for the illustration of Octave Mirbeau's
La 628 E 8. 7 1/2 × 12″. The Louvre. Gift of Georges Besson, the donor retaining life interest

WOMAN OPENING A DOOR. 1941.
Pencil, 25 1/2 × 19 3/4″.
Collection Bowers, Paris

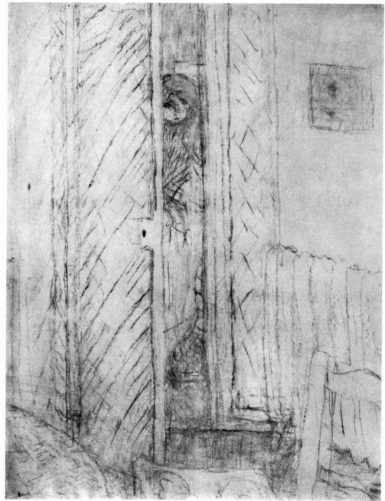

64

COLORPLATES

Painted 1890

THE PARADE GROUND

Oil on canvas, 8 5/8 × 11 3/4"
Private collection, Paris

This charming picture, one of the first in which Bonnard's personality is manifest, is a recollection of the painter's military service, which he performed in 1881 at Bourgoin. The humor with which Bonnard sees the scene suggests that to him military glory was a matter of some indifference, and the size of the soldier's pack in the foreground is evidence that Bonnard's army experience left him with rather unpleasant memories. Depth in the picture is but barely indicated, and the ground plane, rising vertically, is treated in a purely decorative manner. The ingenious and unexpected cropping of the scene, the dissymmetry of the composition, the taste for flat areas of color freely spaced over the picture surface, the blocking of the foreground by a figure seen from the back, the importance given to so trivial a thing as the rucksack, and the stylization of the straps fastening it to the soldier's back—all this reveals the influence of Japanese prints. Like Gauguin and most of the Nabis, Bonnard felt the attraction of Japan, especially after the exhibitions organized by the dealer Bing and the important one held at the École des Beaux-Arts in 1890. But, unlike some of his contemporaries, his borrowings were always indirect and were interpreted in a very personal manner. This little picture remains clearly French in manner, closer to Tristan Bernard and Courteline and their farces than to the masters of the Ukiyo-e.

Strongly reminiscent of Japanese prints is the monogram, not simply a signature but an important decorative element whose form relates to the picture's total composition. Bonnard was soon to relinquish this monogram, but he was always to use a signature (though seldom, unfortunately, a date), for which he chose place and color so that it contributed to the effect of the whole rather than looking like a superimposed element.

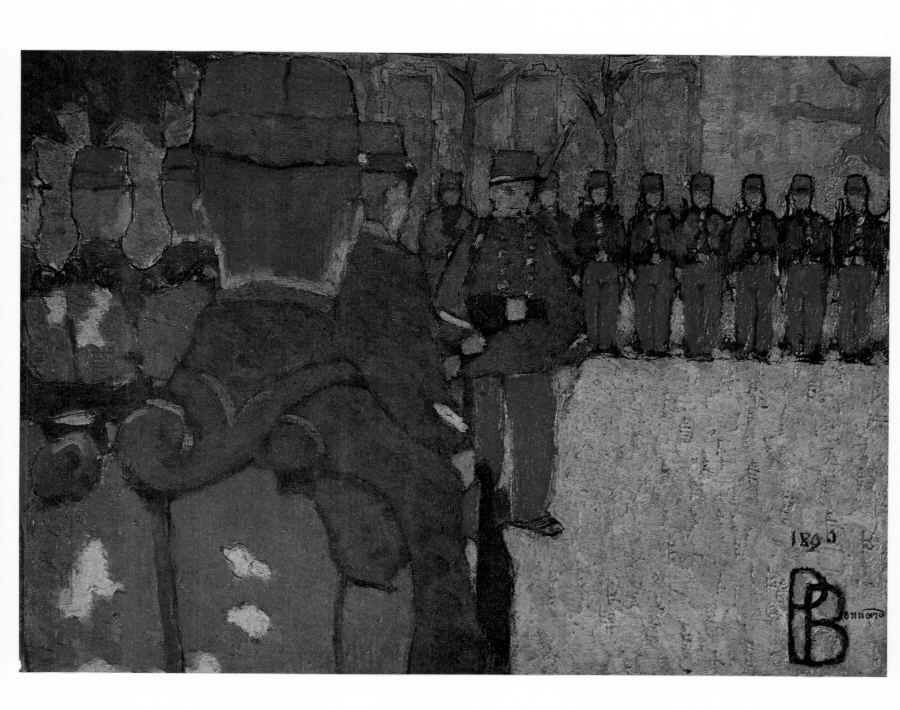

Painted 1891–92

FOUR PANELS FOR A SCREEN

Oil on canvas, each 63 × 18 7/8″
Collection Mrs. Frank Jay Gould

At the beginning of his career Bonnard was more interested in decoration than in painting proper. The concern with decoration was indeed common to most of the young painters of the years around 1890–1900, and occupied a major place in the thinking of Maurice Denis and the Nabis. Rather than easel paintings, then, Bonnard executed lithographs, posters, designs for furniture or stained glass, illustrations for reviews, theater sets. During these years, he showed a special predilection for tall, decorative panels, sometimes conceived as individual compositions, sometimes intended to make up a folding screen like those from Japan.

These panels clearly show how Japanese influences drew Bonnard toward a style neighboring on Art Nouveau, though he remains quite free of the somewhat morbid and decadent literary hypersentimentality that characterized the *fin-de-siècle* atmosphere. Here there are neither depth nor receding planes, neither shadow nor modeling. The forms are delineated by a clearly drawn outline, space is entirely arbitrary, the lines swell freely into capricious and somewhat mannered arabesques; the stylization of fabric patterns and leaves is carried to an extreme, the composition and color elements distributed in a purely decorative manner. Comparing these panels to works done by Bonnard's friends at about the same time—by Maurice Denis or Paul Ranson, for example—it becomes clear how much Bonnard clung to his individual freedom while remaining in the Nabi fold. Considerable grace and delicacy, a notable fantasy, a charming humor, a certain tendency to caricature—all these are characteristic of Bonnard and, though the aesthetic means vary, continue to manifest themselves in his work. Decorative subjects lend themselves to all kinds of inventions and caprices and, if some among these works seem a little superficial, they are nonetheless striking for the *brio*, the vivacity of execution, and the sensitivity to color which Bonnard already displays. They offered him the means to liberation from the conventions and restraints of "great painting," enabling him to engage freely upon the working out of his own personal style.

Painted 1892

THE CHECKERED BLOUSE

Oil on canvas, 24 × 13"
Collection Charles Terrasse, Paris

It becomes evident in this picture that Bonnard's friends were not without justification in dubbing him the *Nabi très japonard*, or "very ultra-Japanese Nabi." Although the head is beautifully done (the sitter is Andrée, the artist's sister), the real subject of the composition is clearly the pattern on the blouse, the decorative aspect of which Bonnard has underlined at the expense of all anatomical verisimilitude. The checks of the blouse are laid flat upon the picture plane, with no kind of modeling, and thus conform to one of the aesthetic principles of the Nabis. The sinuous, linear drawing of the shoulders, the highly elaborated coiffure (already a trifle Art Nouveau with its charming and very Parisienne curl on the forehead), and the apple in the foreground all contain a very pronounced Far Eastern accent. Bonnard even playfully adopts a procedure current in Japanese woodcuts: he does not fold the material of the blouse, but simply superimposes the folds in a few sinuous lines. Finally, even the painting's format, almost twice as high as it is wide, is Japanese in origin.

Japanese prints revealed to Bonnard, as to Vuillard, one of the decorative motifs that were to enchant him until almost the end of his life; the regular squares in this checkered blouse were to return later in his rendering of tablecloths and bathroom tiles, though with far more complex optical and luminous effects.

70

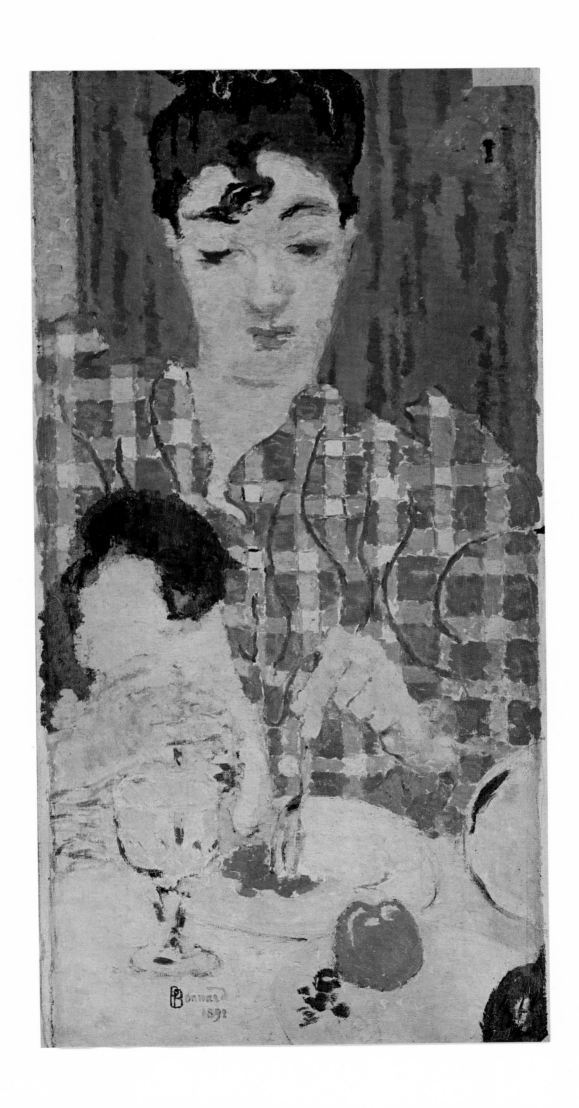

Painted c. 1896

THE BRIDGE AT CHATOU

Oil on canvas, 12 5/8 × 23 1/2″

Private collection, New York

This is one of the rare works of Bonnard's youth in which Impressionism's direct and almost literal influence can be felt. It seems in particular to reflect Monet: the Monet of the *Bridge at Argenteuil* (1874) or the *Railroad Bridge at Argenteuil* (1875). The kind of subject is exactly parallel, and Chatou, where Renoir lived and worked and where he painted his *Luncheon of the Boating Party*, was, like Bougival and Argenteuil, one of the prime settings of Impressionism. Yet this is altogether a Bonnard, and in some respects a very "Nabi" painting despite the Nabis' violent distaste for the out-of-doors. The bridge appears much closer, the scene is much less broad, the atmospheric impression less intense, the weather less fine than in any Impressionist painting. In adopting one of their preferred motifs Bonnard darkens his palette and completely suppresses the sky: it was often said at the time that there was too much sky in Impressionism. The foliage is almost black and the blobs of color that make up the figures' clothing would perhaps be more suitable to the mood of an interior than to a landscape. The composition on the left is very crowded, the drawing vague almost to the point of caricature, the figures are piled one above the other in order to limit the sense of space and depth. This taste for dark-hued painting and the rather arbitrary manner of manipulating forms and colors evince Bonnard's remoteness from the basically naturalistic tradition of Impressionism.

72

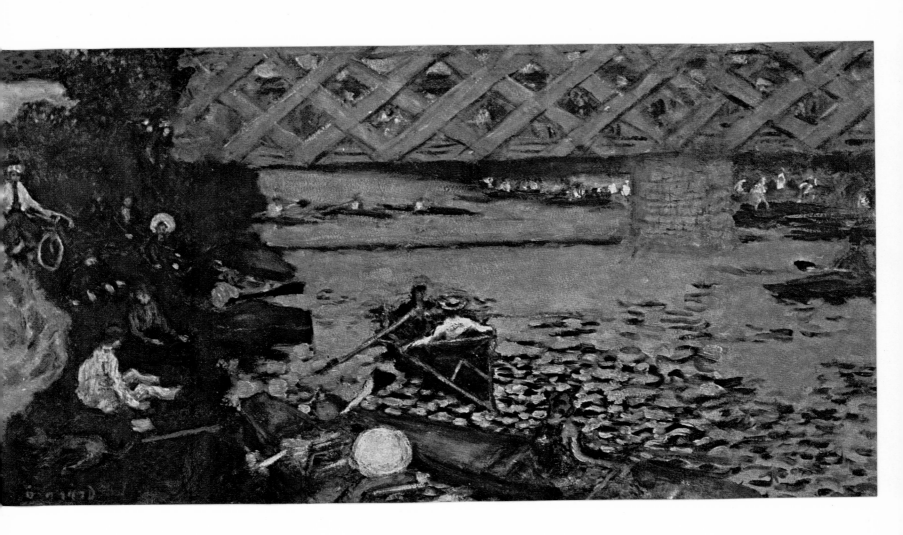

Painted c. 1898

ICE SKATERS

Oil on paper, 39 3/8 × 29 1/2"
Collection Professor Hans R. Hahnloser, Berne

This painting probably is the most striking of those in which Bonnard evokes the amusements and pleasures of *fin-de-siècle* Paris. It represents the Palais de Glace which, with the Alcazar d'Été, the Olympia, and the Jardin de Paris, was one of the gathering-places most fashionable at the time. Professor Hahnloser has with some justification compared the painting to a poster done by Toulouse-Lautrec in 1895 for *La Revue Blanche*, and it is perhaps just as clearly related to two of Jules Chéret's posters for the Palais de Glace, one of 1894 and the other of 1896, the latter of which must have suggested to Bonnard at least the pose and placement of the skating couple.

It was with the poster and the color lithograph that Bonnard's real career began, and through them he learned his craft as a painter. This work in many ways recalls a poster: its very dynamic composition offering the element of visual shock (the young woman's dress), its broad, flat areas of bright-hued color, and its simplified forms. In respect to these qualities Bonnard, who remembers the lessons of Japanese prints, goes further than Chéret or Toulouse-Lautrec. To be noted also is the painting's flatness— in conformity, this, with the Nabi aesthetic—and the great importance that Bonnard already attaches to a seemingly secondary or even meaningless element: the skating rink itself (the form of which forecasts those tablecloths and table tops which in later paintings seem to climb up, as does the rink's surface, to cover more than two-thirds of the height of the composition).

Bonnard avoids showing the feet of the central figures, who move directly out toward the spectator, almost as though they were going to tumble out of the canvas—a treatment he was often to use later and which here assumes a specially humorous note. The gentleman seems altogether absorbed in the task of keeping his partner on her feet, while her charming and vaguely stupid smile suggests in turn that it is coquetry that has made her forget the elementary rules of caution. Nothing could be more amusing than this genre scene in which Bonnard has gathered up an assortment of humorous details: the young woman's enormous sleeves, extravagant hair-dress and hat, not at all in the sporting style, and the ludicrous, disjointed silhouettes in the background. Here he does indeed show himself a worthy successor to the Impressionists in the painting of *la vie moderne* and even, as suggested in the face of the male figure, in technique.

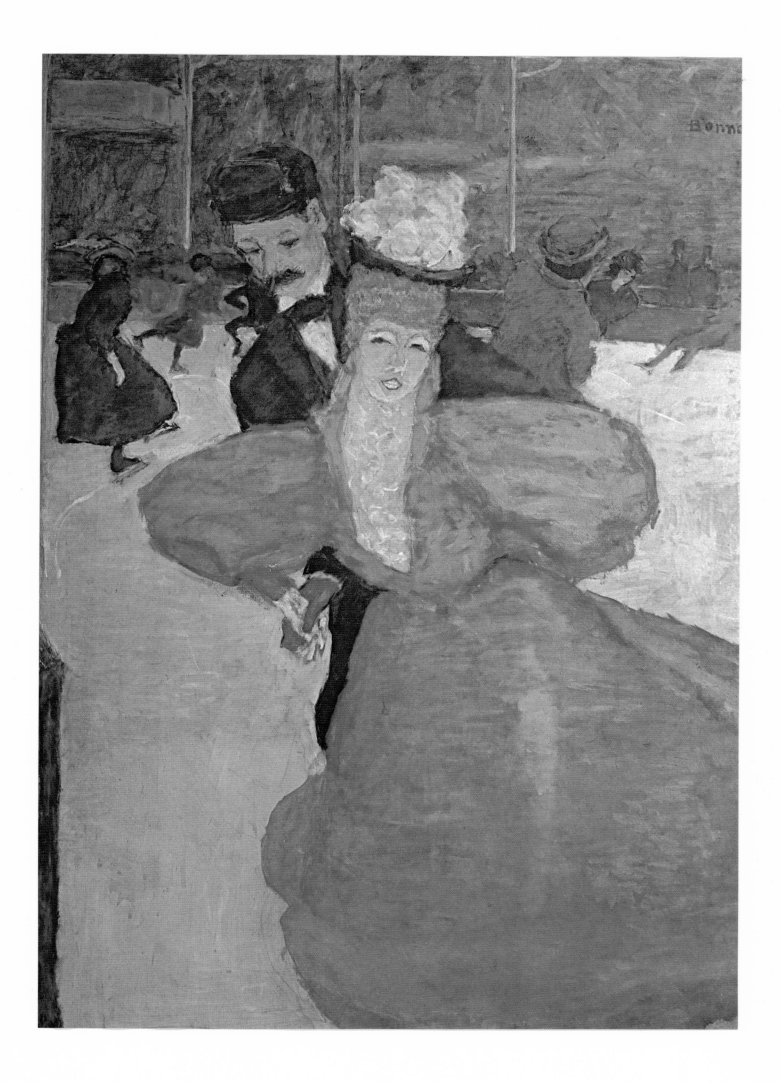

Painted 1899

L'INDOLENTE

Oil on canvas, 37 3/4 × 41 3/8"
Musée National d'Art Moderne, Paris

In this, one of his first nudes, Bonnard verges on an eroticism unusual in a painter whose nudes are in general characterized by their innocence. Around 1900 Bonnard did several paintings of like inspiration, among them a *Nude with Unmade Bed* (National Gallery, Melbourne) and *Man and Woman*. In considering these works, Denys Sutton has suggested a possible influence of Edvard Munch. This is plausible, but there is no definite evidence of such an influence and it would seem more fruitful simply to think of them as sharing in the mood of Bonnard's own lithographs for Verlaine's *Parallèlement*, published by Vollard in 1900. In any case, this uneasy, post-Baudelairean sensuality in the work of a contemporary of Huysmans, Octave Mirbeau, and Zola is hardly surprising.

A very "Naturalistic" flavor arises from the young woman's pose and placement, the almost excessive expanse of the bed, which suggestively fills the whole composition, and the presence in the right foreground of a tub which seems like a reminder of Degas. But the floating curves of the disordered sheets and the tumbled covers show Bonnard at his nearest approach to Art Nouveau, and the whole atmosphere is entirely *fin-de-siècle*.

In the catalogue published for the sale of his collection in 1908, Thadée Natanson described the painting: "On her low, unmade bed, a nude woman lies in the full light, head resting on one raised arm, the other arm lying between her breasts. One leg is propped against the other thigh, gripping it with the big toe; the right leg hangs down from the bed, toward a readied tub. A cat, ribbon around its neck, rubs against the sleeper's neck. On the marble top is a clay pipe. The over-all tone of the painting is blond. There appear, however, green, blue, brown hues toned down as far as black, setting off the bright pinks and yellows; and the color ranges as far as golds and emerald greens. Violent contrasts in value result from the lamplight." Natanson had the discretion not to point out that the pipe suggests a nearby masculine presence, nor that this little clay pipe was Bonnard's. *L'Indolente* subsequently belonged to Alexandre Natanson, then to Félix Fénéon.

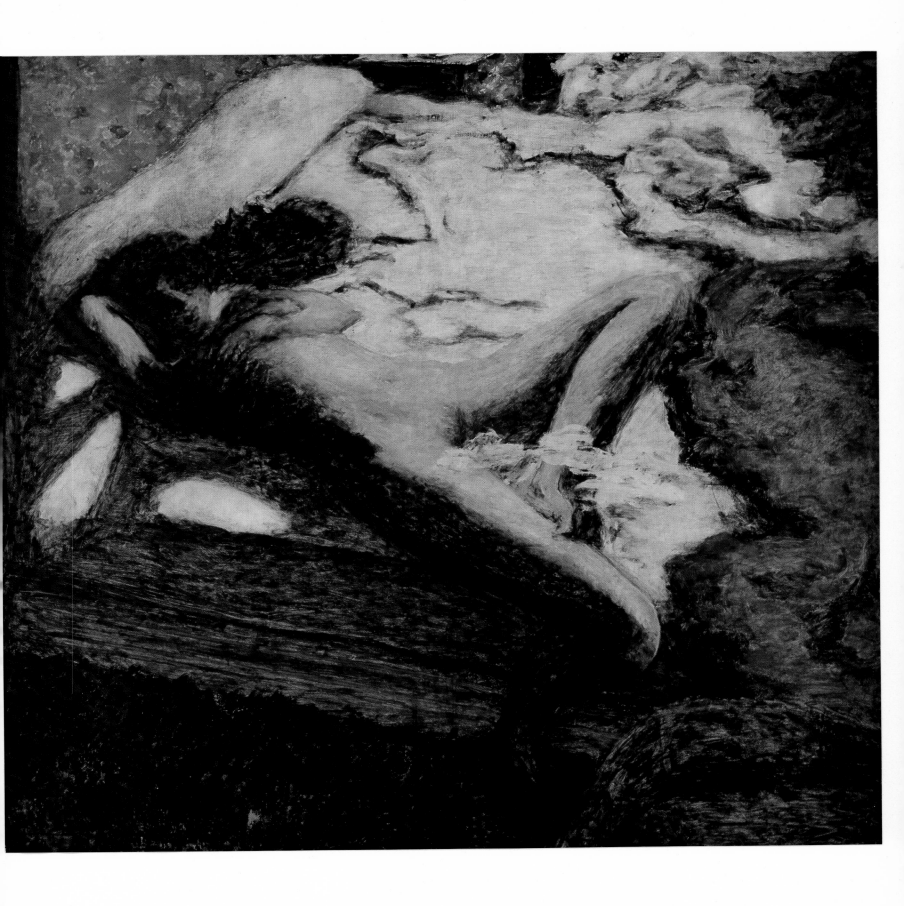

Painted 1900

MAN AND WOMAN

Oil on canvas, 45 1/4 × 28 3/8"
Musée National d'Art Moderne, Paris

The directness with which Bonnard treats this scene is actually rather rare in his work, especially in view of the fact that no evidence permits us to state that the couple is a lawful one; and even the hypothesis of a chance encounter cannot be discarded a priori. Even so, the painting has nothing of *L'Indolente's* erotic overtone and in fact appears decidedly matter-of-fact in spirit. Bonnard has stressed the couple's separateness one from the other, their indifference to each other, but in the manner of one reporting a fact without dramatic or philosophical commentary.

The painting's composition is remarkable for its naturalness, its absence of suggestive or moralizing overtones, the stress on the contrast between the two figures' attitudes, an opposition accentuated by strong contrasts in lighting. To the author's knowledge there is no other male nude in Bonnard's work, which is a pity, for this one has a quite remarkable physical and psychological truthfulness. One might imagine one's self looking at a figure from De Maupassant, and it would be hard to picture better, without vulgarity, the situation's relatively unpoetical nature. The man is in shadow but the young woman is bathed in the most exquisite light. Seated on the unmade bed, right leg folded under, two cats not far from her, she is one of the most adorable creatures Bonnard ever painted, a sister in her childish grace to the figures with which Bonnard illustrated Verlaine's *Parallèle-ment* in the same year.

Bonnard's inspiration in this case, as in that of *L'Indolente,* was probably not Edvard Munch, as Denys Sutton has proposed, but the Naturalistic drama and novel, with which Bonnard was well acquainted.

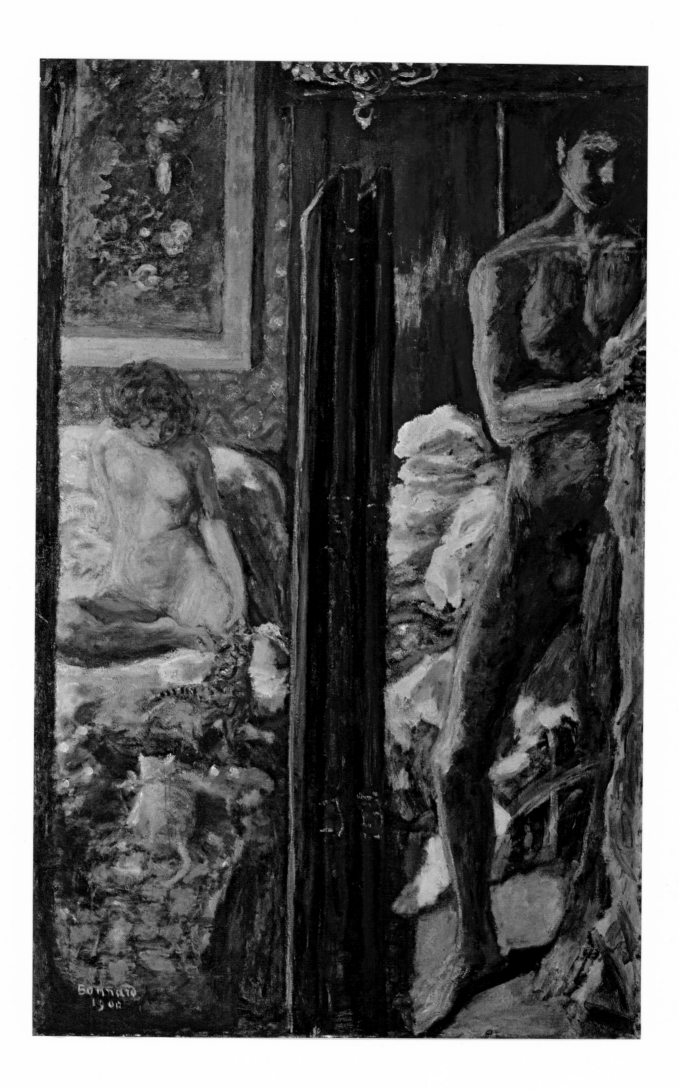

Painted c. 1900

YOUNG WOMAN IN LAMPLIGHT

Oil on cardboard, 24 1/4 × 29 1/2"

Kunstmuseum, Berne

Bonnard wrote to the critic Georges Besson in 1943 that all his life he had "floated between intimism and decoration." This painting, while very decorative with its tapestrylike background, is also a masterpiece of Bonnard's early intimist mood. After 1899 the artist painted many interior scenes, dark and moody, quite close in tonality and atmosphere to those of his friend Vuillard. The room floats in a mysterious twilight, illuminated by the glow from two lamps, one in the foreground and the other, lost in the background, casting several vividly colored highlights into the over-all subdued harmony. The room's actual shape is barely defined, the planes are not articulated with relation to each other, the objects difficult to identify. The background figures float in a kind of unreal but homely reverie, occupied with undefined but apparently routine tasks. Even the young woman offers to the lamp's clarity only a very small segment of her face. Everything is cloaked, secret, silent: "Never choose your words without some ambiguity," said Verlaine, and in this painting we feel all that Bonnard's sensibility owes to Symbolism, if only by the presence of the lamp, here charged with an almost religious value, an indispensable appurtenance of the poetry of the period and that upholstered, bourgeois world described in Gide's early tales. The painting might be an illustration for *Strait Is the Gate*.

From his admiration for Verlaine and Mallarmé, Bonnard acquired his lifelong taste for not etching reality too sharply, for presenting it with a certain coquetry, under a mysterious and unexpected guise, so as to make us study the painting before we can make out all its details.

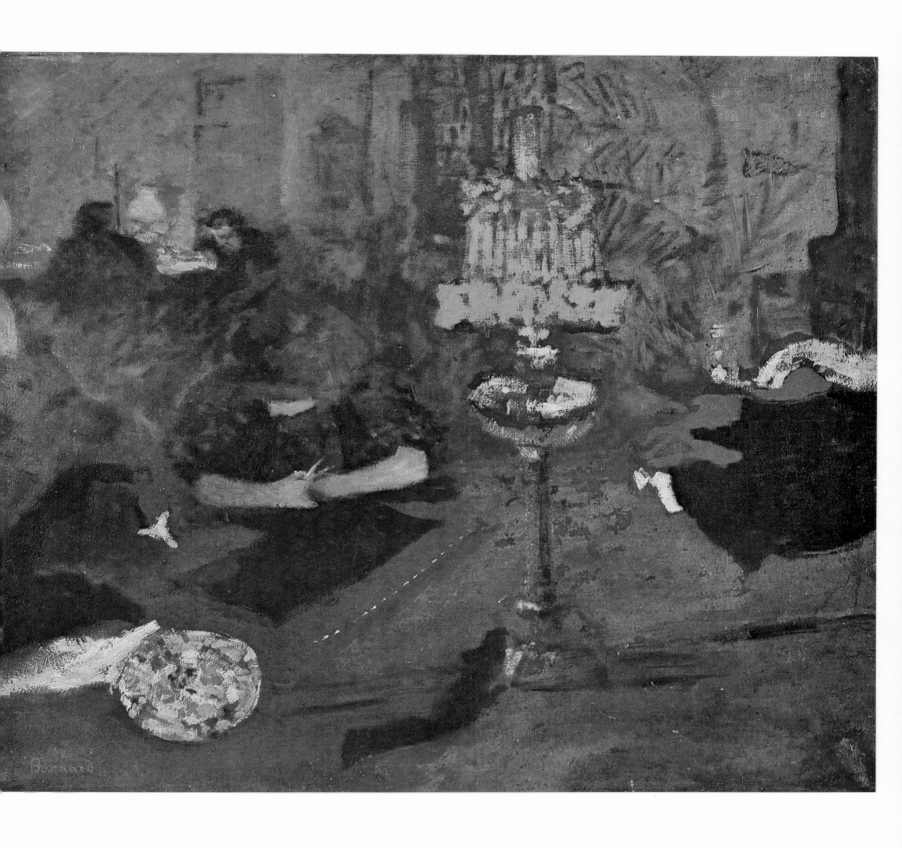

Painted c. 1900

PORTRAIT OF A WOMAN

Oil on canvas, 36 5/8 × 29 7/8"
Collection Katia Granoff, Paris

This type of portrait is rather rare in Bonnard's work. He himself was the opposite of social and worldly, and had no taste for the kind of Parisian bourgeois elegance in portraiture that at this time won fame for Jacques-Émile Blanche and the official painters, and that Vuillard, between the two wars, was so little able to resist. The sitter is a young American, Mrs. Singer, first wife of the writer Claude Anet, whose *Notes sur l'amour* Bonnard was later to illustrate. The pose seems oddly uncomfortable, but that was no doubt Bonnard's way of avoiding the formality of most portraiture. He has entirely refrained from stressing the luxury of the surroundings, the lacquered piece of furniture to the right of the composition having no other function than to provide gilded highlights (picked up again in the rug and the chair arm) that set off the rather obscure and veiled harmony of the whole.

All Bonnard's concentration is bent on the sharp, thin, melancholy face, on the young woman's glance, and perhaps most of all on her dress. The wide skirt, decked with little bows and shot through with gray, blue, and lilac hues, and the lacy sleeves of the blouse are brilliant virtuoso passages which make us forgive the picture's over-all feeling of emptiness. Around the beginning of the century Bonnard did portraits of a few other fashionable people, one in particular (1907), of the Princess Hélène de Caraman-Chimay, being most successful, as Bonnard nearly manages to give her the appearance of one of those nice, simple little bourgeois women who were his feminine ideal.

82

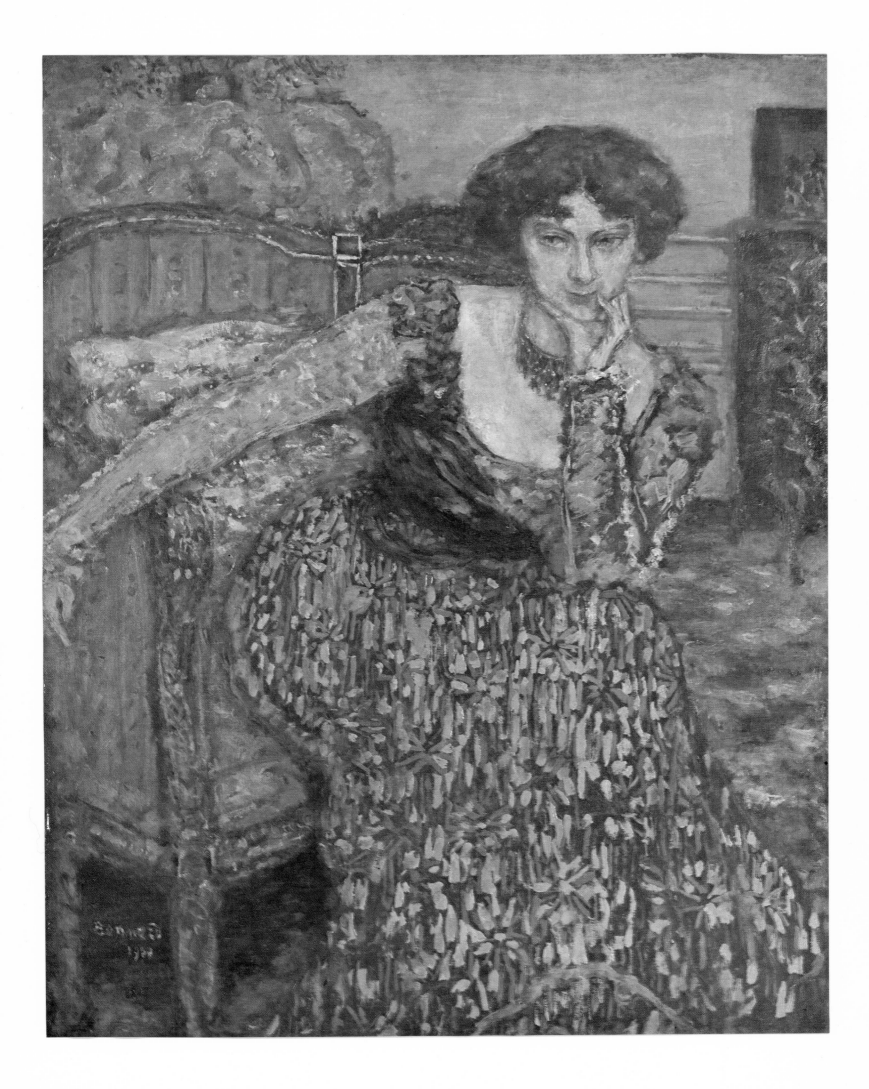

Painted 1902–3

THE TERRASSE FAMILY
(L'Après-midi bourgeoise)

Oil on canvas, 54 3/4 × 83 1/2"
Galerie Bernheim-Jeune, Paris

Represented in the painting is the artist's family at the house of his paternal grandmother at Le Grand-Lemps. It was situated in Dauphiné province, in the southeast corner of France between Savoie to the north and Provence to the south. In this house, to which he was strongly attached, Bonnard spent his vacations as a child and as a young man. It was here that he painted his first canvases, and the Grand-Lemps garden was the outdoor setting most often recurring in his work until the time when he bought a small house in Normandy. He concerns himself more with the garden than with the landscape, the open country appearing briefly in a rather timid and confused manner at the right of the composition. Around 1900 Bonnard was still a painter of domestic scenes: nature frightened him a little and it was to be some time yet before he embarked on a bolder study of landscape conceived otherwise than as a decorative background.

In the rear at the left, framed by the French window that appears to be guarded by the dog, is the painter's mother. The figure stretched on the bench with one ankle resting on the other knee is the composer Claude Terrasse, who in 1890 had married Bonnard's sister. Completing the scene are children, dogs, cats, and a table set with refreshments; the fat lady's hat and beribboned blouse show that she is a visitor; to the far right, perilously seated on a very small folding chair, is her husband, a family friend with the highly descriptive name of M. Prudhomme. Except for the pair in the foreground, who appear to be exchanging some interesting comments, the rest of the people in the picture seem prodigiously bored, especially the well-behaved child seated on the bench, and Claude Terrasse, whose posture strains the limits of good manners and suggests his being somewhat less than sympathetic to the simple joys of family life and the social etiquette of the provincial bourgeoisie.

The painting is light in tone, gray and white, a coloristic interpretation of the drowsiness that seems, after an overly enjoyable luncheon, to have overcome the participants, who are lined up in a row like strung onions. By multiplying parallel planes (the back of the chair, the table's edge, the bench, the steps), Bonnard seems to have been at pains to compress the scene and accentuate its frontality. The composition's intentional awkwardness and the stiffness of the poses give the picture the appearance of a family photograph or a "primitive" or "Sunday" painting.

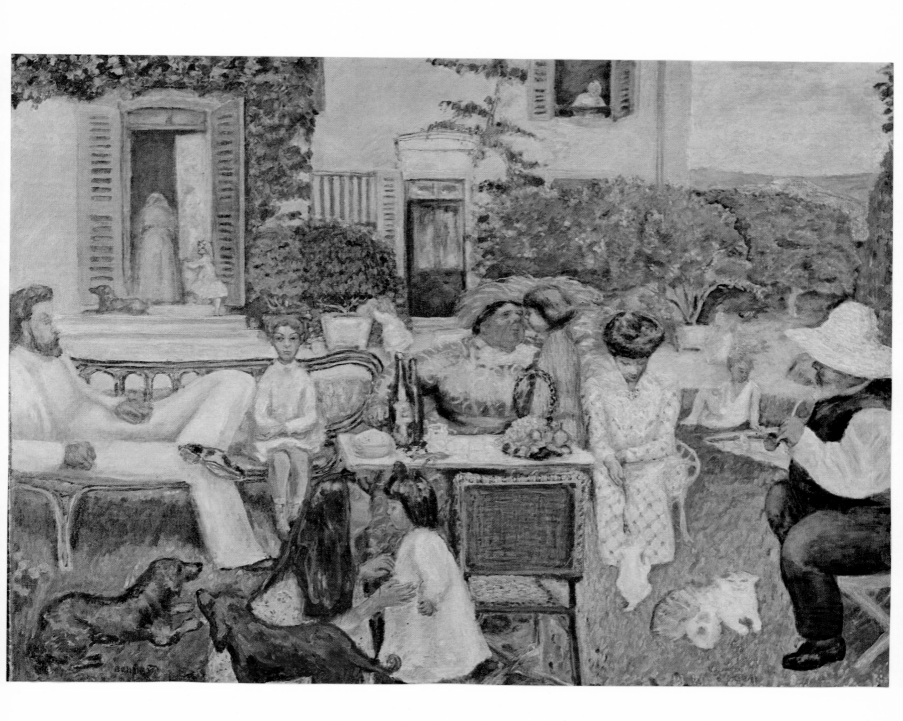

THE VOYAGE

Oil on canvas, 96 7/8 × 117 3/8"
Collection Mme. Kapferer, Boulogne-sur-Seine

This big composition is one of four decorative panels that Bonnard made for Misia Natanson's apartment: *Le Plaisir*; *L'Étude*; *Le Jeu*; and *Le Voyage*, exhibited in the Salon d'Automne in 1910. Misia Natanson was a young woman of Russian origin who, after having divorced Thadée Natanson, married first Alfred Edwards, founder of the mass-circulation daily *Le Matin*, and then the painter José-Maria Sert. Gifted with beauty and musical talent, Misia was advisor and confidante to the Nabis and Toulouse-Lautrec, and both Bonnard and Renoir made many portraits of her. She was acquainted with all of contemporary Parisian society, which she described in her book of memoirs, *Misia and the Muses*. Especially attractive in this book is the light, protective tone, natural enough in a woman of the world, with which she portrays the men of genius whom she knew.

Together with the "Mediterranean" series commissioned by the Russian collector Ivan Morosoff in 1910, these panels form the most important decorative group painted by Bonnard before World War I. Bonnard was at heart a decorator; he had a taste for broad surfaces, freely drawn and painted, backgrounds conceived like tapestries, freedom of fantasy evoking a mood of unreality, and the scope for broad and imaginative handling that decoration allowed him. The last big work that he undertook, toward the end of his life, was a decoration for a dining room commissioned by a Parisian artlover.

The panel here reproduced is deliberately presented as a tapestry. Monkeys and birds chatter and twitter in a curious orangey border surrounding the main scene, which is conceived in discreetly modulated hues no doubt intended to harmonize with the antique pieces that furnished the room in which the panel was to be placed. A bizarre inventiveness rules the subject matter of the central scene. Bonnard quite departs from the story-telling episode traditional in decorative panels, amusing himself by grouping together, apparently at random, whatever exotic and marine motifs he imagined might evoke the pleasures of travel and the magnetism of faraway lands. The composition is in truth not organized quite satisfactorily, but as Lucie Cousturier wrote so charmingly in 1912: "*The Voyage* brings together all those images that throng our Parisian daydreams: the ship with its proud bulk, the mermaids with their sensual wavelike shapes, the wondrous city, and, on the far shore, that Chinese with his box of tea—all larger than life, like our own appetite for the exotic."

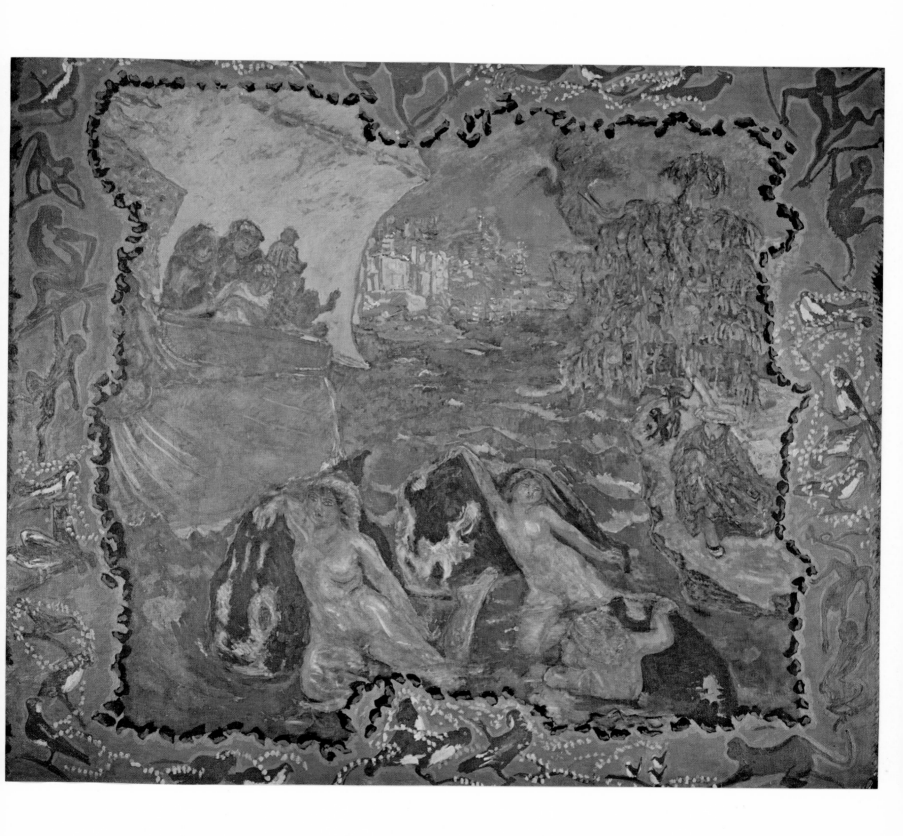

Painted 1907

EMMA THE SEAMSTRESS

Oil on paper, 27 × 23 1/4"
Ny Carlsberg Glyptotek, Copenhagen

Like Vuillard, the young Bonnard frequently offers us a view of typically domestic and feminine occupations, but with thoroughgoing selectivity: the care for person and attire is the hardest task that Bonnard's fragile creatures ever undertake. There are no ironing boards, no laundry tubs in his work. However, there are seamstresses and milliners, observed by the painter with a tender simplicity reminiscent of Pissarro.

Here the scene is a little more complex, and the anecdotal element has entirely disappeared. The young woman is doing nothing. She has come to take measurements or deliver a dress, has laid her hat on a chair and is posing for the painter. As he often did in these years, Bonnard has pushed the figure into the near foreground of the composition, leaving the middle ground more or less empty. He was fond of saying that a good painting must be constructed around a hole, an inert or unimportant element. The painting's composition, rather vague and uncertain despite the firmness of the geometrical elements, is quite odd, and rather exceptional for Bonnard. Depth is clearly suggested and the arrangement of planes in the background recalls certain Matisse paintings of around 1911.

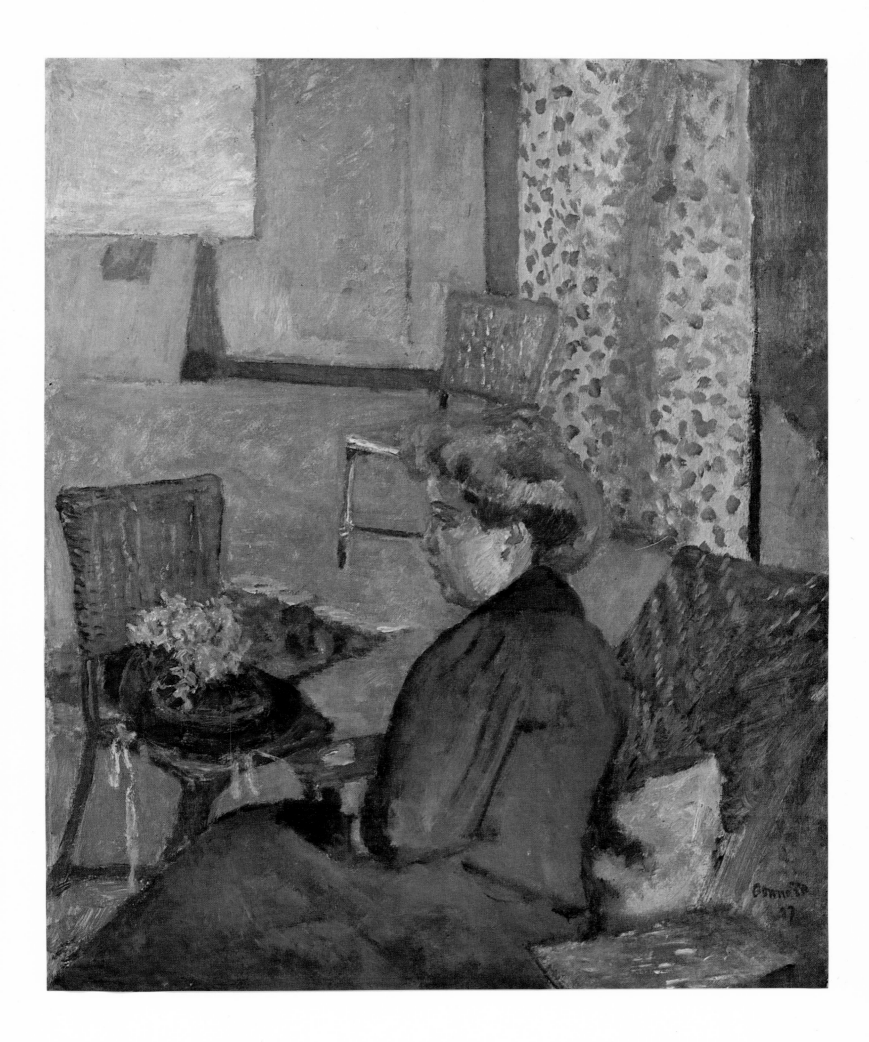

Painted 1908

THE LOGE

Oil on canvas, 35 1/2 × 47 1/4"
Collection Bernheim-Jeune, Paris

This picture, showing the Bernheim family in a box at the Paris Opéra, was painted by Bonnard at the request of the persons portrayed: Gaston (later Gaston Bernheim de Villers) and Josse (later Josse Dauberville) Bernheim, with their wives.

Gaston and Josse Bernheim were the sons of Alexandre Bernheim, whose art gallery first opened at 8 Rue Lafitte, the street where Paul Durand-Ruel and Ambroise Vollard also had their galleries. The Bernheim Gallery later moved to Boulevard de la Madeleine, and finally, in 1933, to Avenue Matignon, where it is still to be found. At the beginning of the century Bernheim's was one of the most active galleries in Paris. Alexandre also had a daughter, Gabrielle, who in 1899 married Félix Vallotton, and it was through Vallotton that the Nabis came to the gallery. With them came Bonnard, who, after a one-man exhibition there in 1906, remained loyal to the gallery throughout his life.

Bonnard has conscientiously carried out his task of portraiture: the persons are easily identifiable and the painter obviously took pleasure in dwelling on the two young women's fashionable dress—rather more pleasing to him, it appears, than their faces, whose rather mournful expression suggests an indifferent response to the performance they are witnessing. Though the painting may be one of Bonnard's most "Parisian" of the time, the manner in which the figures are enclosed in the box and the disciplined ennui their attitudes display suggest a satire of society rather than a parade of the pleasures it offers. Bonnard preferred the circus and the *café-concert* to the opera, and in treating the theme of the theater so dear to the Impressionists, handles it with that curious detachment, peculiar to himself, which always stamps his view of the human being. The painting is in fact the occasion for a contrast of particularly bold colors, the right side being plunged in darkness while the rear of the loge is illuminated by a warm glow, giving an ensemble of highly seductive lighting effects. The drawing is rather loose, almost awkward, the arm of the young woman at the left seeming broken. Bonnard multiplies his paradoxes by grouping the figures in a manner at once natural and arbitrary, and by his unexpected way of composing a scene which might logically have been expected to unfold horizontally, but which in actuality is brutally pulled up to the vertical by a standing foreground figure, the upper half of whose face is cut off by the top edge of the picture—something which, it is said, much displeased the model.

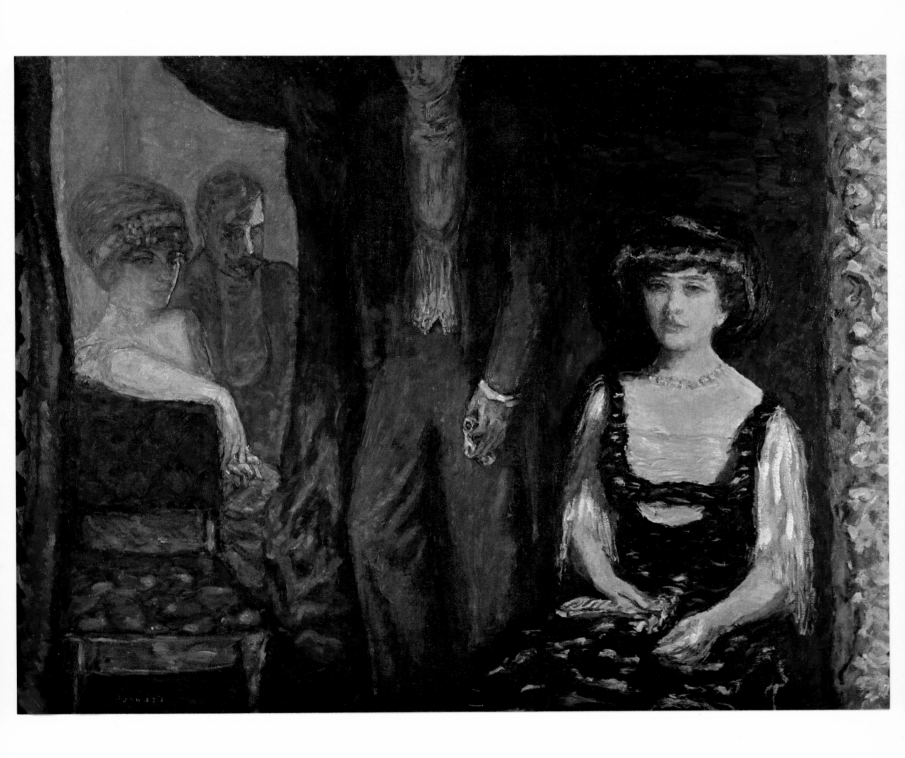

Painted 1908

THE CHERRY TART

Oil on canvas, 45 1/4 × 49 5/8"
Collection Peter Nathan, Zurich

In this big composition Bonnard accomplishes one of his most felicitous treatments of a favorite subject: tea (or lunch) in the garden, with a big table casually set up and in general quite frugally spread. One gets the feeling that the Bonnard family subsisted solely on fruits and cakes, and that their diet must have been quite circumscribed. The scene has an entirely ordinary appearance—the young woman is in a dressing gown, the crockery is quite everyday, the tart still reposes in the pan in which it was baked. Bonnard never had a taste for fine objects, either to own or to paint. Luxury intimidated him, and the décor in his works is of the most modest, the most banally petit bourgeois imaginable. By comparison, Monet's picnics and luncheons have a worldly and prodigal air.

The theme clearly has Impressionist origins, but Bonnard, faithful to his bent toward a close-up view, has compressed the scene and blocked off the horizon. The landscape appears only timidly through the foliage, and solely to enclose the table's perspective. But what the composition loses in atmospheric lightness and mood, it gains in power and authority. If we compare this painting to Monet's *Picnic*, which remained in its author's hands for some time and which Bonnard perhaps knew, we can see what discipline and firmness Bonnard, so often accused of loose formlessness, could bring to bear upon such a scene. The three trees that in the Monet force the recession into depth are here reduced to a single one, powerfully asserting itself at the right of the composition and balanced at the left by the bottles of syrup. The foliage, setting up a kind of screen between the landscape and the table, is treated with a breadth and lyricism, a power in the luminous accents, which are clearly the work of a major talent. Great authority is equally displayed in the three-color contrast on which the painting is based: the green of the branches; the blue of the table and horizon; the red of the tart, the fruits, the dressing gown, and the flowers in the background. Nor should one overlook the dog, whose eyes bright with covetous greed count among Bonnard's most piquant inventions.

92

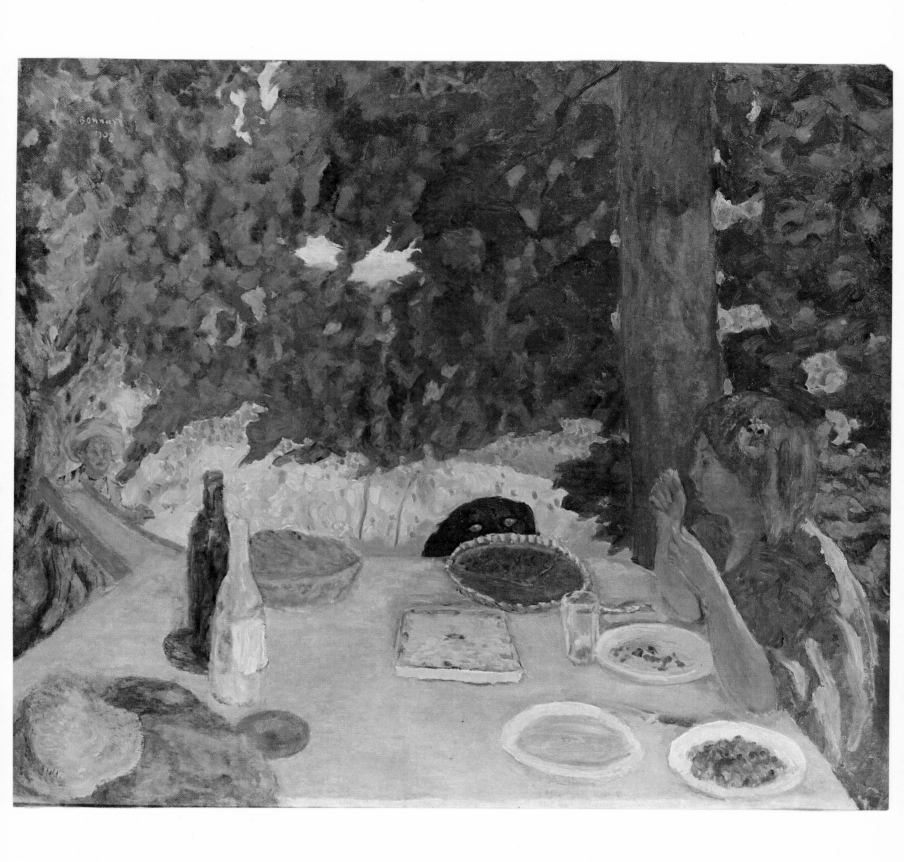

Painted c. 1908

NUDE SEATED ON THE EDGE OF A BED (Les Bas noirs)

Oil on canvas, 22 3/4 × 17"

Collection The Earl of Rosslyn, England

Seated on a bed, a young woman is taking off her chemise and will no doubt soon roll down her black stockings. The room is fairly dark, lit only by a lamp shedding a warm light on the front part of the bed and on the girl's torso and upper thighs. It is more than a trifle "1900" and "gay Paree," and the subject could have caused the picture to fall into that erotic tradition which, after the eighteenth century, perhaps no longer partook of what was most noble and emotionally high-minded in French painting. However, Bonnard's picture is thoroughly decent, and it is clear that he was mainly interested in the intimate mood, the contrast between blacks (which he relished at this period) and lighted areas, and the young woman's perfectly natural and everyday, almost comical, action, which causes her face to disappear altogether under her rucked-up chemise.

Still, it must be acknowledged that between 1900 and 1910 Bonnard was much interested in black stockings, and it is not for us to decide whether the reasons for his interest were of a purely plastic order or not. Here a quotation from Thádee Natanson, who devoted a whole chapter to this important question, is apposite:

In the eighties and nineties (and even later), the color of a woman's stockings could be none other than black. . . . Catulle Mendès declared that the nineteenth century could lay claim to credit for only two authentic inventions: cigarettes and black stockings. In the case of the black stocking, none of the painters who tried to treat it as an attribute of licentiousness achieved anything worthwhile. Fragonard was the master of the chemise. . . . As master of the black stockings, I know, besides Lautrec, only Bonnard who could treat them not simply as accessories, but in their dignity as objects, as Chardin did a goblet or a chocolate pot. Black stockings not only allow us to glimpse, between the fastened garters, a half-moon of thigh. Abandoned to themselves, in the evening, they curl up from having been so long stretched. Or they shape, on the floor, the meanders of a rivulet. Awaiting their mistress's awakening, they represent at the foot of her bed the indecision of her dreams—even such of the night as will linger in her eyes when she rubs them. When stockings are pale and imitate the color of the legs, Bonnard loses interest, or perhaps prefers the bare legs themselves whose hue they counterfeit.

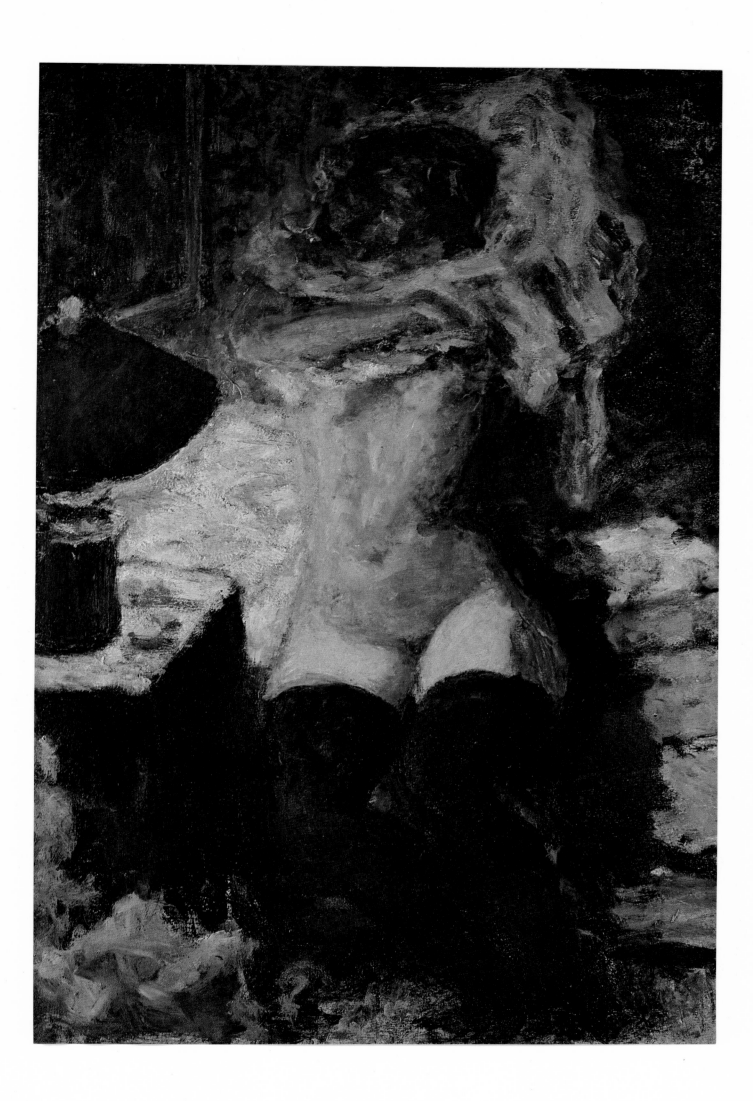

Painted c. 1908

NUDE AGAINST THE LIGHT

Oil on canvas, 52 3/8 × 34"

Musées Royaux des Beaux-Arts, Brussels

The year 1908 is of special importance in Bonnard's development. It marks, in effect, the end of his intimist period, and he may be observed at this time returning to a clearer-hued kind of painting, discovering light, moving rather rapidly from a decorative conception of landscape to a more impressionistic and atmospheric feeling for nature, and, finally, beginning to work out his very personal vision of the female nude. To be sure, as he himself said, he was always to be something of an intimist, and he was still to paint some dark pictures; but the year 1908 marks the beginning of an evolution which comes to full fruition around 1920.

In this evolution the Brussels picture is a work of prime importance, even though one would hardly be justified in calling it the first of those *nus à la toilette*, those female figures absorbed in bathing or dressing, which were to occupy so large a place in Bonnard's production over the course of twenty-five years. For the source of Bonnard's attitude to this theme one must look to Degas, although the theme itself was generally a very popular one around 1900. Of course, Degas did not invent the theme of the feminine toilette in art; but unquestionably no one before him had treated it with such straightforward naturalness, such exacting, often cruel realism, so much disdain for what was merely "pretty" or conventional in the genre.

When Bonnard had his first one-man exhibition at Durand-Ruel, he showed a painting entitled *The Tub*. In the present painting, however, he appears as a thoroughly original artist already working toward his most personal manner. This is, of course, an oil and not a pastel, and is more greatly elaborated than would be usual for a Degas. Nor was Bonnard, though obviously not in a class with Degas as a draftsman, content with simply capturing the gesture or attitude; what interested him especially was the relationship of the figure to its surroundings: the objects, and especially the light. For Bonnard, air was not simply an empty element with forms set about in it, but a medium through which the forms are penetrated by the light and through which each shape and color reverberates against the others—as the curtain and table edge, for example, are reflected in the tub, or as the sunlight filtering through the curtains caresses with bluish accents the young woman's body seen against the light, or the fabric covering the divan, in turn, casts reddish notes into the flesh tones. The coloristic harmony of the painting is a subtly restrained lyricism. The composition is remarkably dynamic, the young woman's body forcefully modeled and described in an attitude of offering itself, without rhetoric but with a passionate, almost ecstatic movement, to the light.

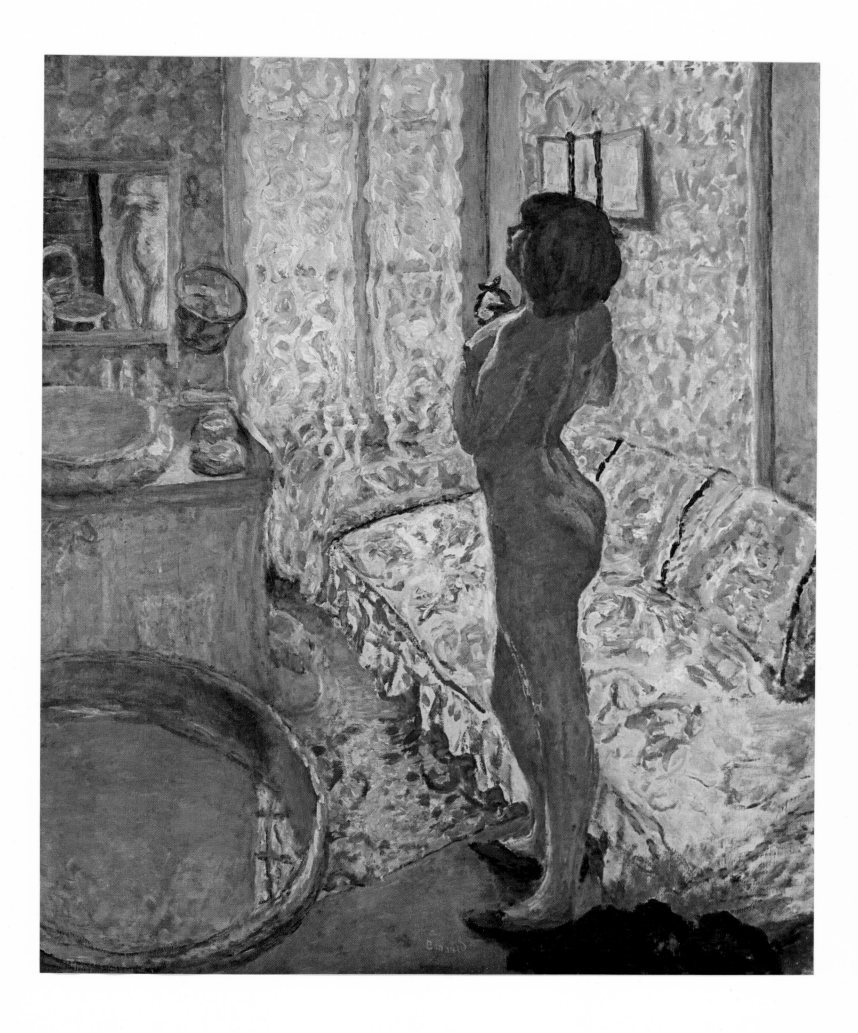

Painted c. 1909

COFFEE IN THE GARDEN

Oil on canvas, 20 3/4 × 29 1/2"

Ny Carlsberg Glyptotek, Copenhagen

Up to 1910 Bonnard's landscapes are rarely anything but Parisian. Yet he painted countless garden scenes at Le Grand-Lemps and around and about the Paris suburbs. The enclosed, luxuriant, intimate world of the garden better suited his sensibilities at this time than did vast horizons in which the eye might wander freely, but in which he might have had difficulty in placing his accustomed dramatis personae. There is virtually no sky in this painting and the perspective is deliberately falsified (the animal, even if it is a cat, is too small in relation to the distance separating it from the young woman looking at it), and Bonnard has been at great pains to evoke, with considerable power and lyricism though without the slightest prettification, the sparkling, sunlit profusion of plants and mounds of flowers. It is apparent from this painting that, in his own fashion, Bonnard has resumed his dialogue with Impressionism, with Monet and Berthe Morisot. But the interpretation is nonetheless very personal: a faintly Symbolist aura still hovers about the scene, the intention is more decorative than naturalistic, the vision less broad and direct. The still life in the foreground is beautifully firm. The wonderful blues in the young woman's dress and, especially, in the table top, bespeak Bonnard's joy at rediscovering color after the gray period of 1900.

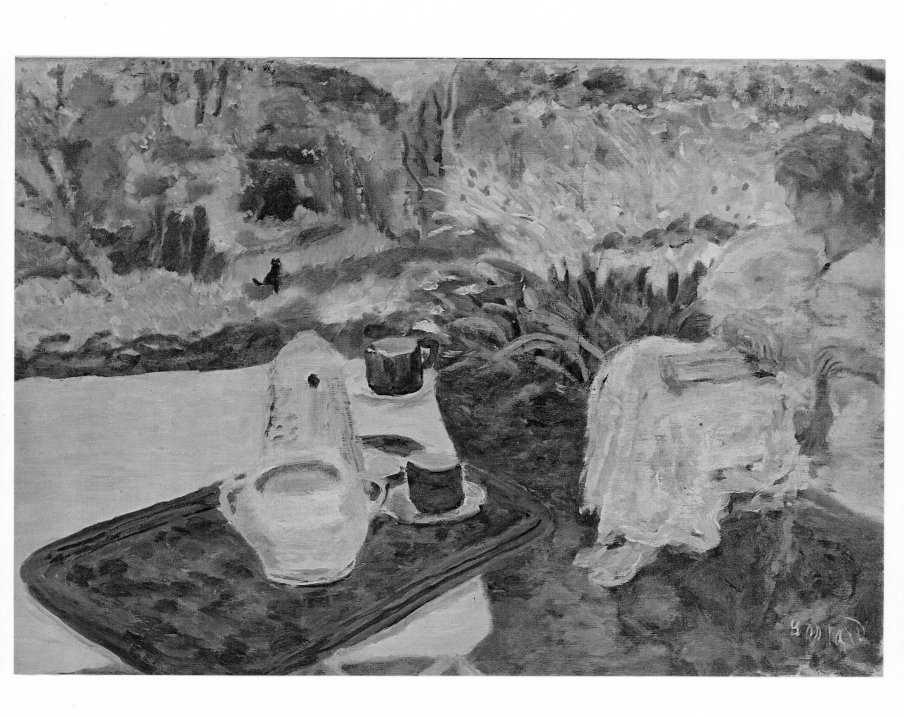

Painted 1910

VIEW OF SAINT-TROPEZ

Oil on canvas, 21 1/8 × 24 3/4"

Collection Professor Hans R. Hahnloser, Berne

Before becoming a world capital of international *dolce vita*, Saint-Tropez was a little fishing port entirely isolated from the rest of the coast. Paul Signac discovered it at the beginning of the century and, won over by its beauty and solitude, bought a house and set up his studio there. His presence attracted to Saint-Tropez a number of painters, among them Marquet and Henri Manguin; it was in the latter's house that Bonnard stayed when he made his first trip to the South of France in 1909. This painting, representing the garden of Manguin's villa, may therefore be said to mark Bonnard's first contact with the Mediterranean landscape. But he approaches it with many precautions; its full exuberance and luminosity are not to appear in his work until some years afterward. Professor Hahnloser recalls that as late as 1933 Bonnard told him, "I cannot paint in the Midi. There are no colors."

So, landscape is reduced to a garden and the open scene appears only as a vividly colored band in the background, to the left of the tree rising at the composition's center. As Hahnloser notes, "Bonnard withdraws to the shadow of the house and trees to paint"; and, again, Bonnard "delicately tests out [his subject] like the cat perched high on his velvet paws in the shadow in the foreground." Despite this hesitation, despite the branches that veil the distance, allowing only a few orange roofs to gleam through them, the painting has a luminous intensity that accurately captures the atmospheric feeling of the South of France, where it is better to remain in the garden's half-light than in the open sun.

Bonnard repeated the theme of this painting in the decorative panels commissioned from him a short time later by the Russian collector Ivan Morosoff, which were exhibited in the Salon d'Automne of 1911.

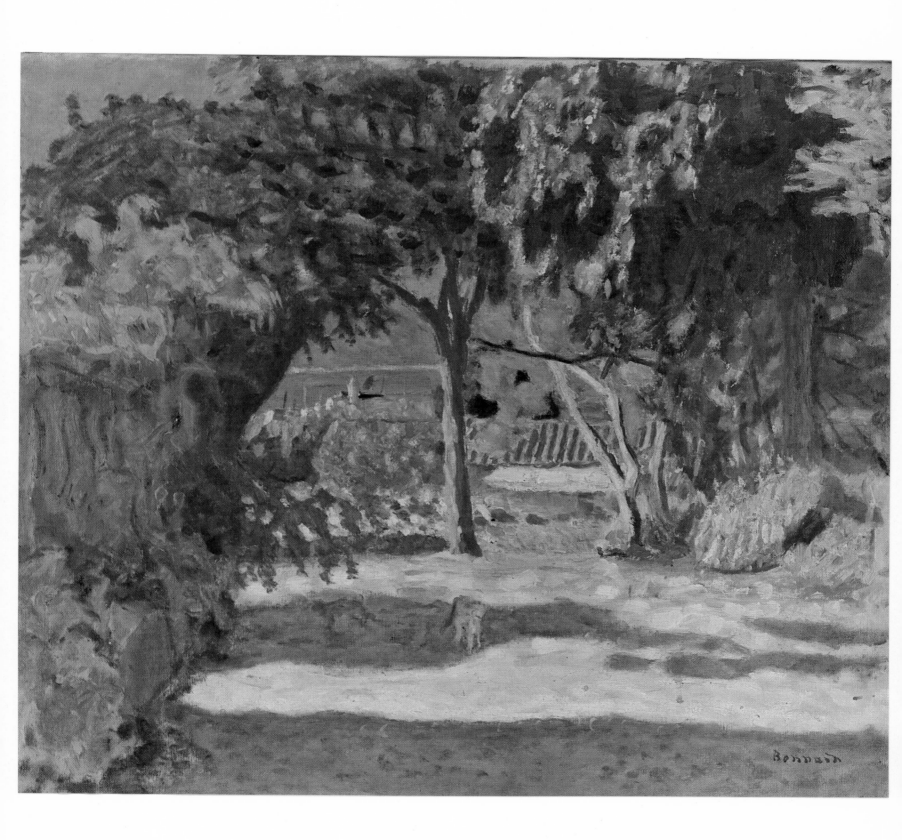

Painted 1910

THE RED-CHECKERED
TABLECLOTH

Oil on canvas, 32 5/8 × 33 1/2″

Collection Professor Hans R. Hahnloser, Berne

This painting, executed in 1910, is among those in which the originality of Bonnard's poetic and pictorial vision of the period is most clearly apparent. Yet it also shows him drawing upon contemporary experiments.

Though solidly constructed, the whole scene appears to lean a little toward the right, as though to make us follow the movement and the glance of the dog, whose dark muzzle contrasts with the light falling over the objects from the right, gilding the young woman's neck and face, laying upon them lovely mauve reflections and, at the level of her nose, a vivid pink accent. The objects in the foreground are so arranged that they trace out a gentle arc which follows an opposite line to that described by the table's farther edge. This last is raised curiously high in the picture; though Bonnard in some ways respects normal perspective tradition in allowing the movement of lines perpendicular to the horizon, the scene, brusquely limited by the wall in the background, seems almost without depth. Finally, in accordance with what is soon to become a usual principle with Bonnard, the objects are not all seen from the same angle. Thus, the young woman and the coffeepot are presented at about the spectator's eye level, the table seems distinctly below it, and a plate in the foreground appears absolutely vertical. It is hard to resist the thought that Bonnard had been looking at Cézanne. In his work on Cubism, John Golding wrote of that master: "He generally studied the objects in his still lifes from slightly above eye level. . . . This high viewpoint was probably assumed largely in order to limit the pictorial depth and ensure the unity of the picture surface. . . . Cézanne very often goes further and tilts up the top of an object even more towards the picture plane, so that it appears sometimes as if seen almost directly from above. . . . It is impossible to say to what extent Cézanne was aware of the fact that he was doing this, and in the process breaking the laws of scientific linear perspective, but it seems likely that it was a part of a natural desire to emphasize the two-dimensional aspect of the canvas while continuing to explain the nature of objects and also insisting on their solidity by modelling them as fully as possible." In this last respect Bonnard, who as a true Nabi had always had a certain aversion toward modeling, stands at a great remove from Cézanne. But, for the rest, it does seem as though he must have reflected on the teachings of the painter of Aix as interpreted in the first Cubist canvases, and thereby been encouraged to take great liberties with linear perspective.

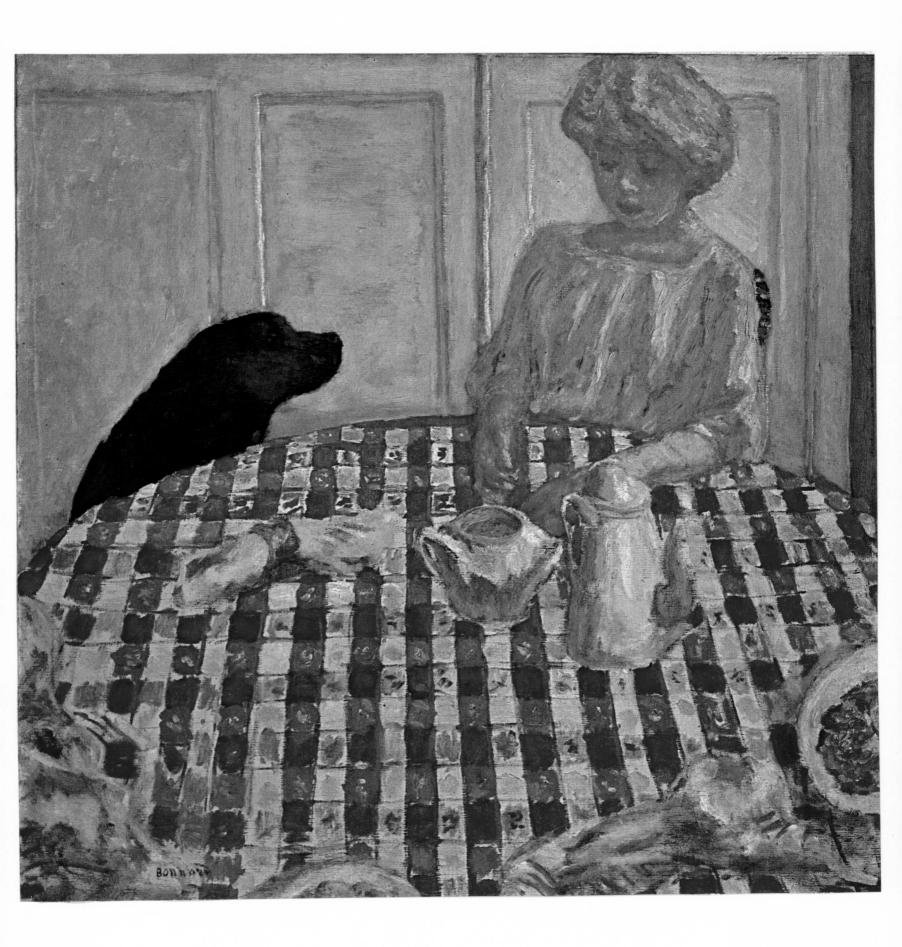

Painted 1910–11

NUDE IN LAMPLIGHT

Oil on canvas, 29 3/4 × 29 1/2"

Collection Professor Hans R. Hahnloser, Berne

One of the most attractive qualities of Bonnard's nudes is that they never seem to have been posed by a professional model. "Not one of them ever seems to have taken off her chemise more than a moment ago," wrote Thadée Natanson, adding: "More than one of these women making her toilette has reminded me of Renoir's complaining in mournful tones that models, even the youngest of them, who had seemed most supple and re-laxed, at the end of two or three weeks . . . had lost all their freshness and their unselfconsciousness, had already become unusable." This young wom-an, who is still undressing, is clearly the opposite of an academic nude. The drawing is perhaps a little lax, for there is no temperament more unlike the classicist Ingres' than Bonnard's, and he always underplays the figure's articulations—which he considered graceless—but bathes their forms in light. Lamplight here models the torso in strongly contrasting lights and shadows with warm reflections. All Bonnard's nudes at this period are about the same physical type: very young women, petite, slenderly built but robust. The source for his physical type is hard to determine—some of the eighteenth-century nudes might spring to mind, or Maillol's early statuettes. However that may be, if we apply here Sir Kenneth Clark's distinction between nudes of the *Venus coelestis* type and those of the *Venus naturalis* type, it is clear that Bonnard leans toward the *Venus naturalis* and the nineteenth-century Realist tradition, although with a less aggressive carnality and sensuality than we find in Courbet or Renoir.

Bonnard's nudes are in fact always gently depicted and seen in terms of intimacy. This no doubt explains the fact that he rarely introduced a nude into his landscapes, and that when he did, the results were rather mediocre. For him, bedrooms and dressing rooms, warm, cozy, and tranquil, were woman's natural habitat, and the *joie de vivre* type of theme, expressing the physical inebriation of dance or running, so favored by Matisse or Picasso, never interested Bonnard.

104

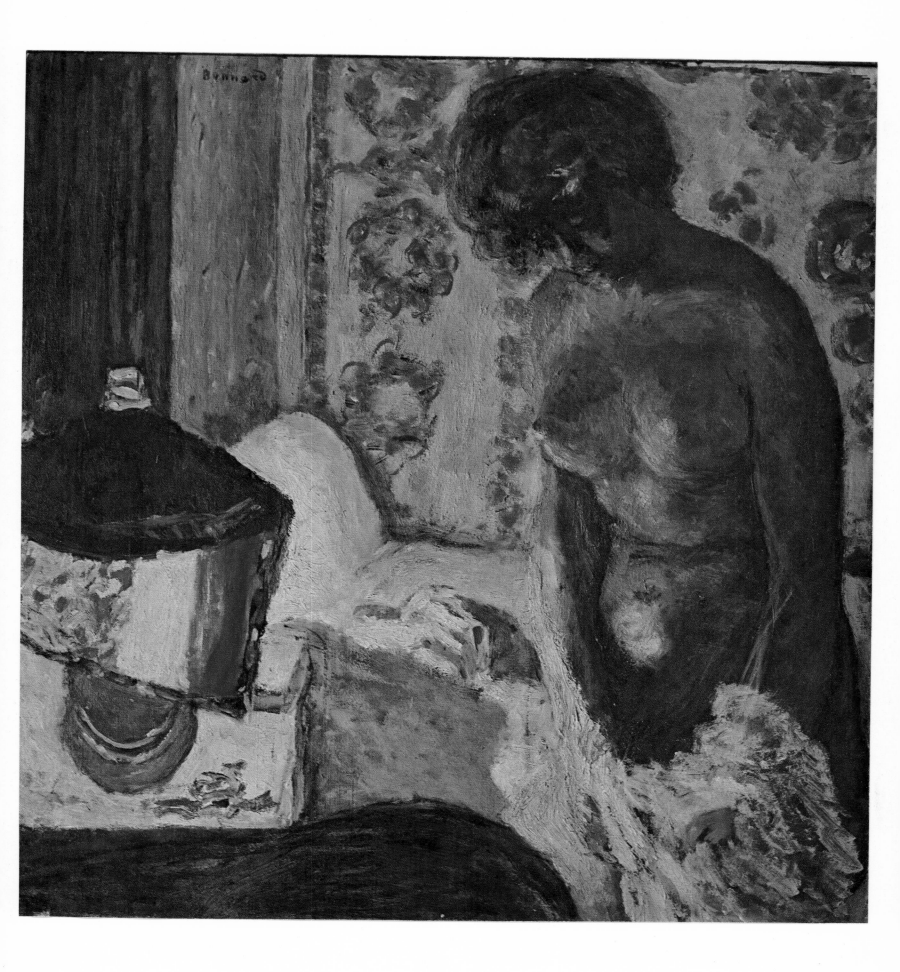

Painted 1911

NUDE WITH COVERLET and
NUDE WITH TOQUE

Oil on canvas, 49 1/4 × 22 1/2″ and 49 1/4 × 19 5/8″

Private collection, Berne

These two nudes were painted at about the same time, but they were not conceived as pendent to each other and their dimensions are not exactly the same. Bonnard here returns to the tall, vertical format he had often used before 1900, which indicates his decorative intentions in these two paintings. In these paintings the plastic and emotional intensity of the preceding nudes is altogether absent. In drawing and modeling they are somewhat sketchy, and both of them appear a trifle facile or superficial. But certain details, such as the coverlet, are beautifully handled, and the over-all radiant, almost joyous luminosity shows that Bonnard had cast a glance toward Renoir and the Impressionists and that he was capable of the most diversified kinds of expression. The attempt may have been premature, but the fact that these nudes could have been painted but a few short months after the *Nude in Lamplight* displays the artist's range of pictorial resources.

Bonnard paints what he sees, but he never paints before the model, and what he paints is only the memory of what he saw, based on which the picture becomes an autonomous construct. He liked to repeat a statement of Renoir's: "Bonnard, one must embellish!" That is to say, one must heighten the color, rearrange the forms, arrive at expressing a purely poetic vision of nature. However, Bonnard never forgets reality. Angèle Lamotte (*Verve*, no. 17–18, August, 1947) relates a few remarks Bonnard made before a bouquet of roses that he was trying to paint "directly, scrupulously," and forgetting that he was Bonnard:

"The presence of the object, the subject itself, is an embarrassment to the painter at the moment when he is painting. The point of departure for a painting being an idea, if the object itself is there at the moment when he is working there is always the danger that the artist will allow himself to be taken in by the specifics of the immediate view of it and in so doing lose the initial idea. . . ."

"But then you never work before the subject?"

"Yes, but I leave, I go back to check, I come away, I return some time later; I don't allow myself to be absorbed by the object itself. In sum, there comes to be a conflict between the initial idea, which is the good one, the painter's, and the variable and varied world of the object. . . . In the first inspiration or idea the painter achieves the universal. It is this inspiration that determines the choice of the motif and corresponds exactly to the painting. If this inspiration, this first idea is effaced, then there is nothing but the motif, the object, which has invaded and dominated the painter. From that time on, he is no longer making his own painting."

106

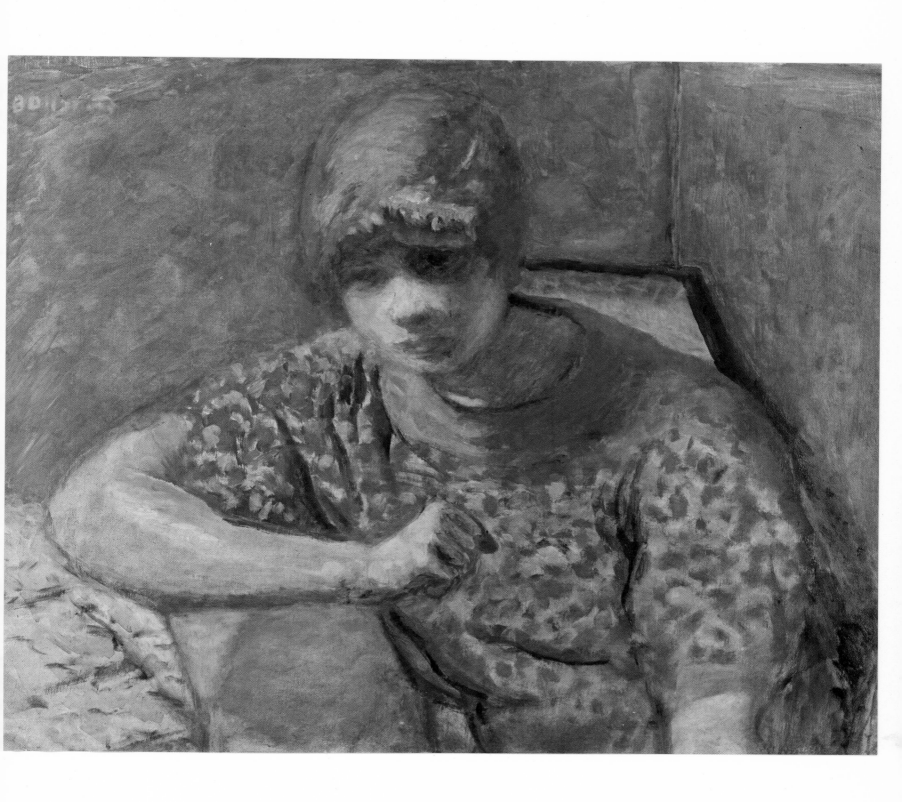

Painted 1913

DINING ROOM IN THE COUNTRY

Oil on canvas, 63 × 80"

Minneapolis Institute of Arts

This huge canvas, one of Bonnard's most famous, represents the dining room of Ma Roulotte, the country house on the right bank of the Seine that he bought in 1912. It was situated at Vernonnet, where the Île-de-France borders on Normandy. The dining room was located on the ground floor, while along the upper story ran a gallery that looked out over the whole valley of the Seine. In later years this gallery furnished a foreground for more than one of those big, decorative compositions in which Bonnard attempted to encompass all the verdant luxuriance of the landscape before his eyes. But here, in 1913, Bonnard has stopped with the ground floor, his landscape appearing only timidly as a backdrop glimpsed through the door and the wide-open window. A lover of the intimate, and psychologically somewhat cool, Bonnard made his first overtures to nature in prudent steps, seeing it from indoors; but one day, as Thadée Natanson writes, "the landscape, entering by the windows of the little house, will take possession there with a charming naturalness, diffusing within the four walls all its diversity and coloristic wealth."

The composition of *Dining Room in the Country* is based on the contrast between the outdoors and the interior: in the landscape a rustling freedom, with vividly modulated and contrasting tonalities; in the interior the more rigid architecture, the more intimate and muted color, laid on in broad areas. Accentuating the contrast, Bonnard has posed a particularly frail tree to the right of the composition as a balance to the sharply geometric design of the door; but the painter also links his two contrasting picture zones by carefully worked-out transitional devices, such as the green reflections that the landscape casts into the blue of the door, the breeze-stirred curtains slightly lifted into the interior of the room, and, especially, the charming presence of the young woman (Marthe).

Obviously Bonnard is already much engaged with those problems of structure which were to become his major concern in later years. The interrupted diagonal composition might have been suggested to him by recollections of Japanese prints, but it is here very rigidly treated, reinforced by the presence of the chair and the manner in which the window is thrown back against the wall. Any trace of schematic dryness, however, is effaced by his inclusion of various small tasteful details (the bouquet of poppies, the cats, the plates of fruit), and especially by the form, bold and unexpected in such a composition, of the table, the color of which picks up that of the distant sky and in its lyricism contrasts with the still somewhat "Nabi" tonality of the interior.

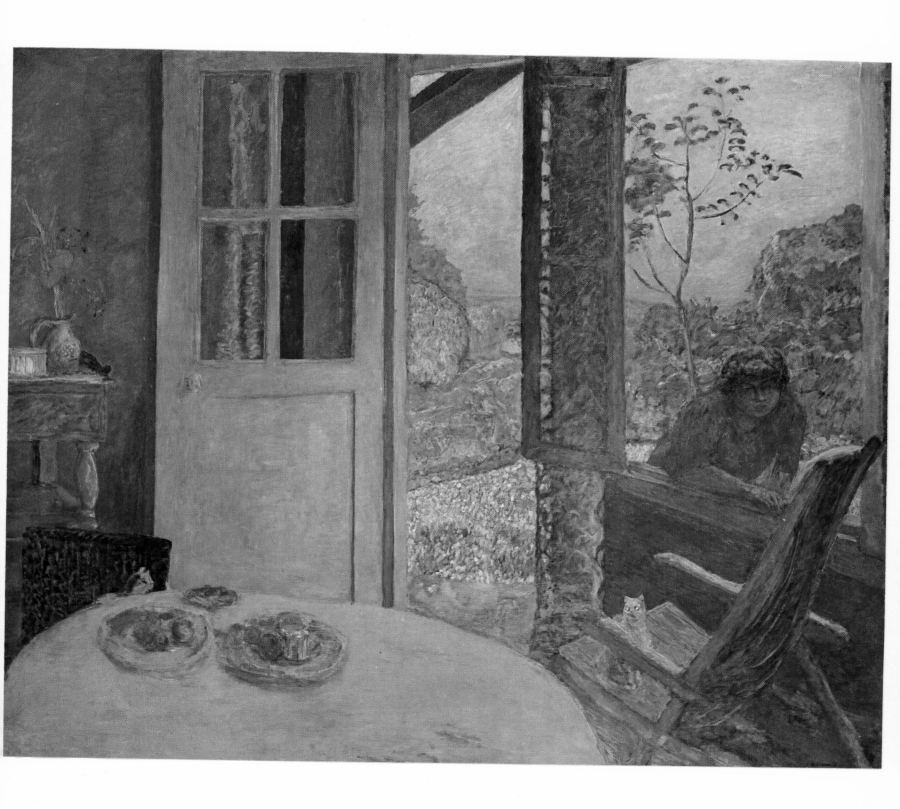

Painted c. 1914

SIGNAC AND HIS FRIENDS SAILING

Oil on canvas, 48 7/8 × 54 3/4"

Kunsthaus, Zurich

Bonnard does not seem to have been a very bold sailor. He never owned a boat, and according to Thadée Natanson the yachts that cast anchor at Cannes and Saint-Tropez appealed to him less than the round-bottomed rowboats in which he went out on the Seine when he lived near Vernon. However, he loved boats, seaports, and the light over watery horizons, whether on the Mediterranean or the English Channel. He painted beach scenes, too, often with a humorous touch, and he was not at all averse to whiling away the hours afloat with friends.

As in most of his works of this kind, Bonnard frames the scene in a decidedly original manner. Careful always to bring us close to the objects and place us squarely in the picture, he shows us here only the after part of the boat, which seems to sweep forward under the spectator's feet, while its central bulk reaches across the entire foreground. Recognizable under his little linen hat is Paul Signac at the tiller. From the time when he first came to the South of France, Bonnard had been quite friendly with Signac, who had owned a house at Saint-Tropez since the turn of the century. The forms of the other figures are quite generalized and even droll; they are less easy to identify, although the woman on the left is no doubt Berthe Signac. It does not take the eye of an experienced sailor, however, to see with what accuracy Bonnard has drawn the scene and suggested the prevailing atmospheric conditions: the sky shot through with mauve lights, the dark sea, the evenly parallel waves—all this shows us that the mistral was blowing on this day's sail.

The painting has often been dated 1924–25, no doubt because of the resemblance of its composition to that of another picture, *The Sea Trip (The Hahnloser Family)*, whose date has been established by the persons represented. In actuality, this painting would have had to be painted in 1913 or 1914, for the boat, according to Mme. Ginette Signac and Dr. Charles Cachin, is the "Sinbad," which Signac bought in 1912 and sold in 1914. Signac himself, furthermore, remembered the day and the trip well: Bonnard was seated forward in the boat and was drawing the scene before him on pieces of cigarette paper that he had suddenly taken from his pocket when the theme for the picture occurred to him.

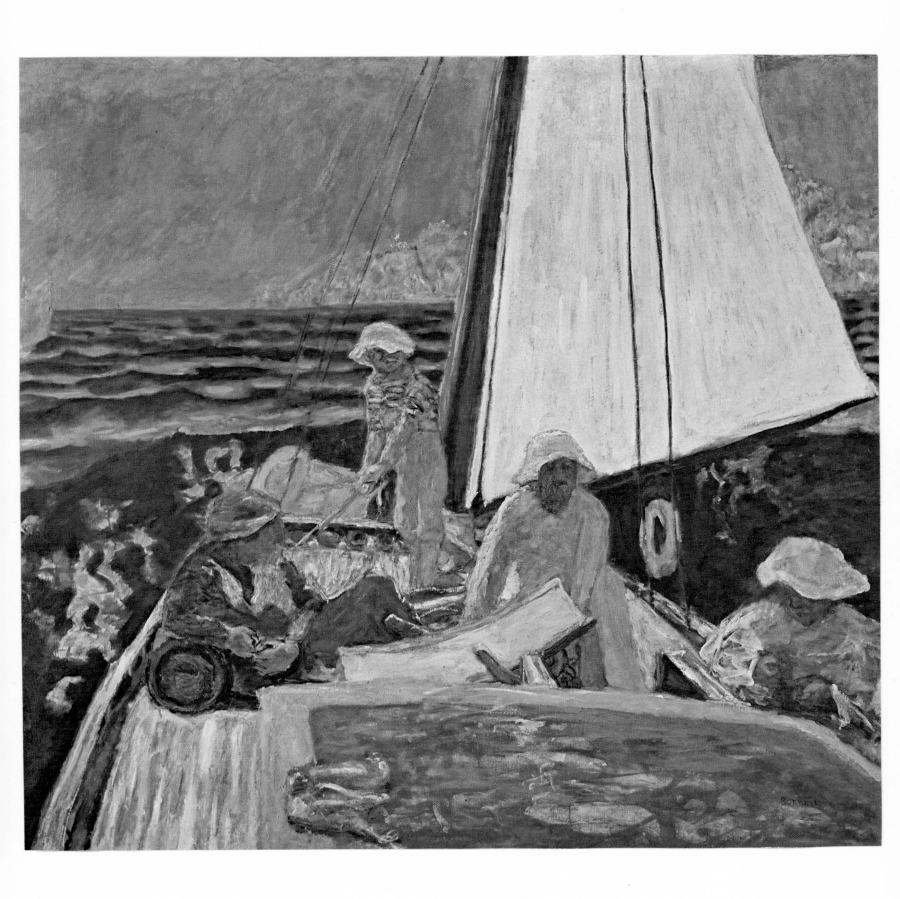

Painted c. 1915

THE TUB

Oil on canvas, 28 3/4 × 33 3/8"
Private collection, Winterthur, Switzerland

This is without doubt the most captivating and audacious of Bonnard's mirrors. The setting and the objects from the Brussels and Moscow paintings reappear here, but this time the painter has reflected the whole composition within the mirror. Since the glass is slightly tilted, and also seen from a diagonal view, the basin and tub receive an exaggerated importance; it was evidently this imbalance, this outsized place occupied by objects so inert and insignificant, that Bonnard chose as the true theme of his painting. The figure is pushed back to the left of the picture, and the curve of her body balances those of tub and basin. In the mirror's rectangle, to create depth and keep the tub from obstructing the composition, Bonnard has inscribed a triangle the two sides of which, one formed by the bed, the other by the towel rack and the model's profile, lead to the chair and the breakfast tray with which the composition terminates. The rhythm of the composition is underlined by the brush and bottles placed on the table, which clearly denote the level of reality as against that of the reflected world. Flavorful and paradoxical as is the arrangement of the picture, it is at the same time perfect in logic and discipline; in this Bonnard is second to none of his most austere contemporaries.

Now it is no longer, as it was around 1900, a search for style, poetic whimsy, or humor that is at the source of the distortions, the unexpected perspective angles, and the unusual relations between objects which can be noted in this composition. The image that the spectator derives from the mirror is in no way dimmed, and Bonnard has not sought to create an atmosphere of mystery or of poetic strangeness. Bonnard's painting is the least literary possible, and the metaphysics of the mirror, as expressed by Jean Cocteau or Paul Valéry, is quite foreign to him. At most the mirror allows him to thicken the atmosphere of withdrawal and silent intimacy which were suited to his temperament. Bonnard's world was for a long time to be one without solidity or relief, one that seems to slide easily onto the picture plane, the objects never striking us commandingly. He cherished diagonal and oblique views and dislocated volumes. His way of modeling was always closer to the Impressionists than to Cézanne and the Cubists. Once again he reports only what he sees; and if he had the conceit here of painting a view from floor level, he was forced to get assistance from the mirror, for no one has ever managed to paint while lying flat on his stomach.

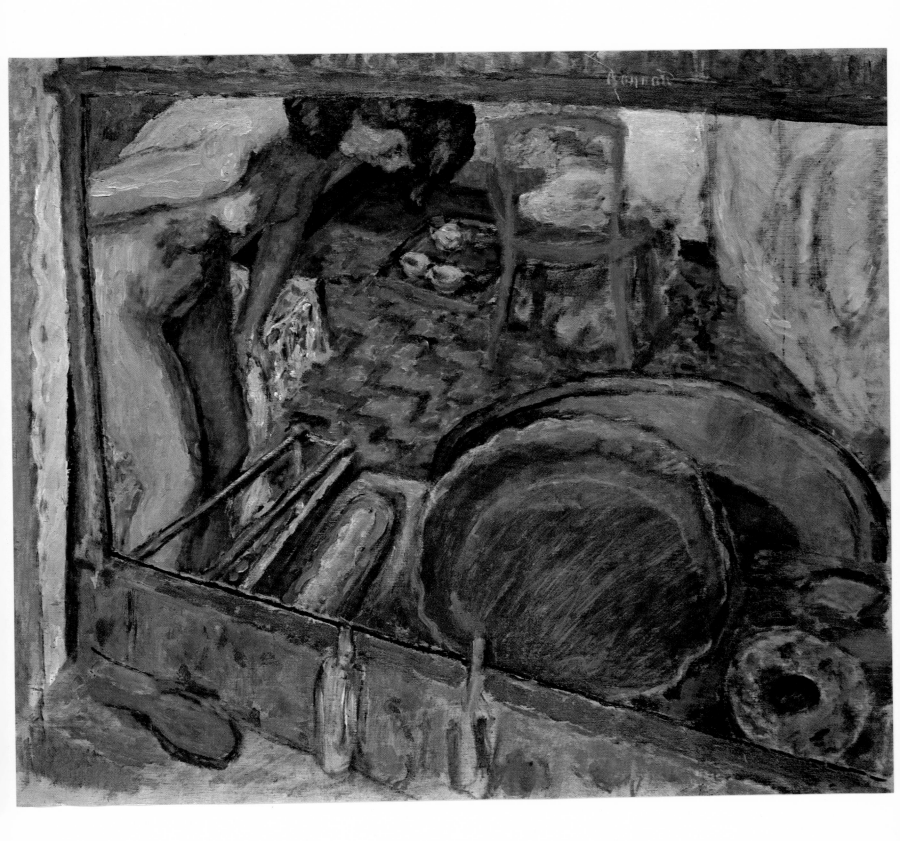

Painted c. 1915

LANDSCAPE NEAR VERNON

Oil on canvas, 15 × 21 5/8"
Private collection, Paris

After 1912 Bonnard spent most of his life at Vernon, or rather at Vernonnet, and Monet was one of his closest neighbors. Wrote Thadée Natanson: "Giverny is only a few kilometers from Vernonnet. Ma Roulotte often saw Monet's auto arrive, Monet asking to see Bonnard's recent paintings and considering them attentively. Of the two Bonnard spoke rather more, but that was hardly at all. Bonnard needed only a gesture or a smile from his great senior in order to be happy. And off Monet would go with his daughter-in-law Blanche, who accompanied him on all his outings. The Bonnards in turn would go to Giverny, sometimes being treated to a very fine luncheon. Monet would take them for a walk in his magnificent garden with its profusion of freely growing and varied flowers, between the great trees and along the walks of his remarkable water garden. Giant treetrunks and tufts of bamboo surrounded the pond where water lilies bloomed."

It is clearly not the Monet of the *Water Lilies*, however, that this landscape recalls, though Monet's influence seems close, as it does in a number of the paintings from this time. The work is modest in size and intent. The colors, despite the predominance of blues and greens, are nonetheless not so natural as one might imagine at first sight, and the orangey accents in the foreground are perhaps more Symbolist than Impressionist. But if one compares this landscape to some of his earlier ones, it may be clearly seen how many steps Bonnard has moved toward reality. The landscape is no longer at all decorative; the sky is calmer, the horizon vaster, the vision broader and more direct, and air seems to circulate through the moving masses of the trees.

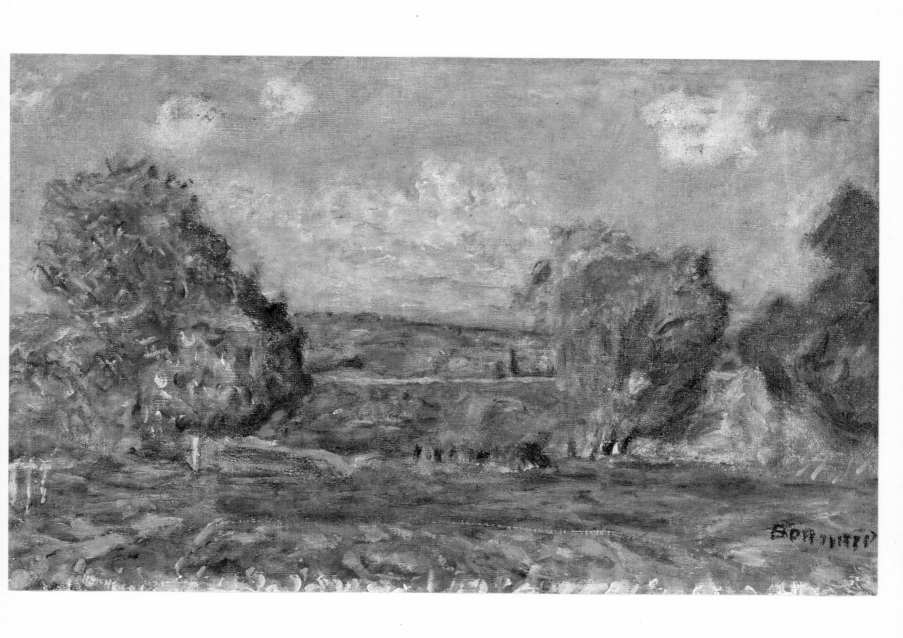

Painted 1917

TEA or THE BLUE TOQUE

Oil on canvas, 26 × 31 1/8″
Private collection, Winterthur, Switzerland

This delightful picture, which might well have been one of those banal genre scenes in which French painting of the time abounds, shows how very far Bonnard's art actually is from the facility and superficial hedonism of which he has sometimes been accused. The work has no anecdotal element, except perhaps on the level of a very restrained irony. Bonnard wryly underlines the mildly ridiculous contrast between the attitudes of the two principal figures: the young woman in red serving tea (Marthe, no doubt), assiduously bent with zeal and amiability, a trifle intimidated by her friends, and the personage with the hat, rather stiff, occupying the composition's foreground with such authority that she is the perfect picture of a "lady out calling."

The painting is so gay, so lively in tone, that Bonnard appears to have put the crisis of the years 1913–15 well behind him. He has, however, taken into account those critics who, on the eve of World War I, had accused him of not knowing how to construct and of being the symbol of Impressionism grown decadent. "His enemies," wrote Leon Werth, "said, 'He has assurance only in his feeling. How rudderlessly he floats, how he seesaws according to the hour, how he vacillates according to his caprice! This is the art of a child!'"

In point of fact this picture is rather rigorously constructed on the basis of horizontals formed by the chair and the lower part of the veranda, and verticals formed by the woman in the toque and the veranda column. Bonnard remains faithful to his custom of presenting the main figure close up in the foreground and seen from the back. If the red worn by the young woman serving tea is still a trifle "Nabi," Bonnard's palette here is for the most part light, of a slightly acid freshness that announces the very individual coloring of his paintings between the two wars. Bonnard once more uses color without constraint and in a deliciously arbitrary manner: the visiting lady wears a blue toque with a green dress—that is her affair; but, under the black hair, her neck is lilac-hued. Fantasy has reclaimed its place in the scheme of things.

118

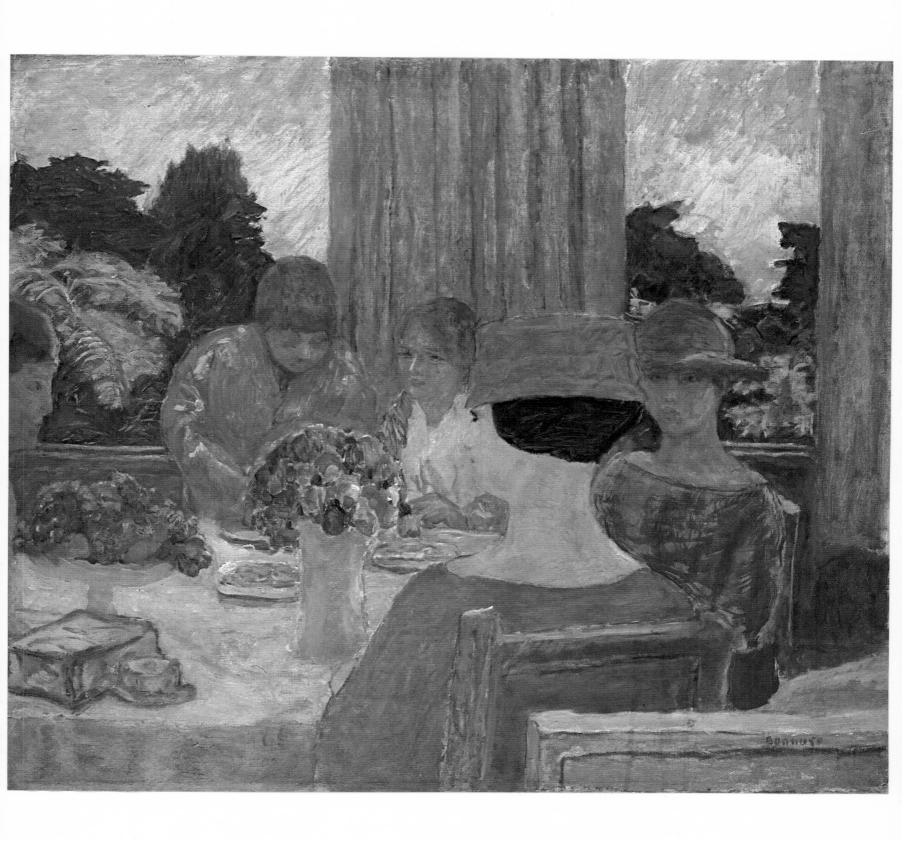

Painted c. 1924

SAINT-HONORÉ-LES-BAINS

Oil on canvas, 20 1/2 × 30 1/2"
Private collection, New York

Saint-Honoré-les-Bains is a small spa situated in the Morvan, to the south of Burgundy, where throat ailments are treated. It is a cool, green, quite primitive and hilly region, and one wonders whether it was its resemblance to the countryside of Brittany, seen in so many of Gauguin's landscapes, that led Bonnard to paint this one among his works in which Gauguin's influence is most clearly felt. Without Gauguin there would probably have been no Nabis, and what Maurice Denis, Sérusier, or Ranson owe him, even to quite literal borrowings, is clear; but Bonnard's case is more complicated, for he always showed a certain reserve in relation to the master of Pont-Aven. When Bonnard said in 1891 that he was "of no school," he meant that he was not of Gauguin's school. K.-X. Roussel together with the other Nabis had bought a Gauguin landscape, and they used to hang it in each of their houses in turn. "But," said Thadée Natanson, "when Bonnard's turn came he did not always remember to take it, and had to be reminded."

Bonnard must owe to Gauguin (as, in part, to the Japanese) a certain conception of painting, of space, of color, but no direct comparison can be made between their works until we come to those of 1924. The *Saint-Honoré-les-Bains* landscape is in fact remarkably close to one of Gauguin's Brittany landscapes, *Farm at Pouldu*, which Bonnard in all probability saw, since it belonged to Vollard, and which perhaps remained in his memory. That painting, it is true, shows Gauguin making some concessions to Impressionism, while Bonnard's colors are even more arbitrary than those in the Brittany landscape; but the general atmosphere, the drawing of the houses, the opposition of colors, the striking blues and greens in the two paintings are quite similar.

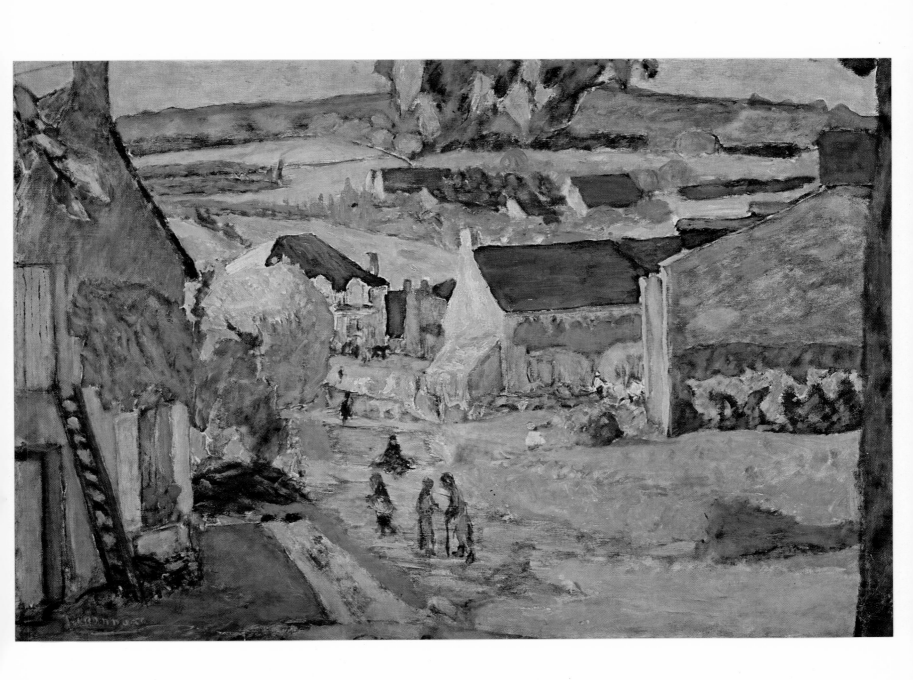

Painted c. 1925

THE RED CUPBOARD

Oil on canvas, 32 × 25 1/2"
Collection Roger Hauert, Paris

This large still life, which represents the cupboard in the dining room at Le·Cannet, is an example of the way in which Bonnard manages to confer on the most trivial furnishings of daily life a kind of unexpected and poetic nobility. On the shelves stand glasses, a pitcher, trays, apples, grapes, and a few anonymous objects that Bonnard has obviously not wanted us to identify more exactly, so evident is his desire to give these homely objects an attraction other than that of gluttony or the classical theme of preparing a meal.

Charles Sterling has very aptly written in regard to this painting: "Bonnard has re-invented the most ancient themes of the still life: the *xenion* arranged in a cupboard, the medieval niches and cabinets." In this respect Bonnard's still lifes are, in any case, always ascetically and resolutely vegetarian, but here it is not a question so much of foodstuffs as of color and light. The painting glows in a remarkable conflagration of reds and violets, shot through by a blue shadow in the foreground, orchestrated with an almost Expressionist vehemence. "His colors," Sterling adds, "are colors free of all convention, poetically arbitrary colors justified only by some inner vision. In his spirit of bourgeois happiness Bonnard joins the sensuous tradition of Monet and Renoir. Like theirs his still lifes are groups of fruit on tables or in cupboards visited by the sun; but with his departure from the Impressionists' literal naturalism they take on a fairytale quality. His objects seem as though penetrated by the sun's rays and by its heat, which appear to melt his fruits, leaving only the colored essence of their flesh and their taste."

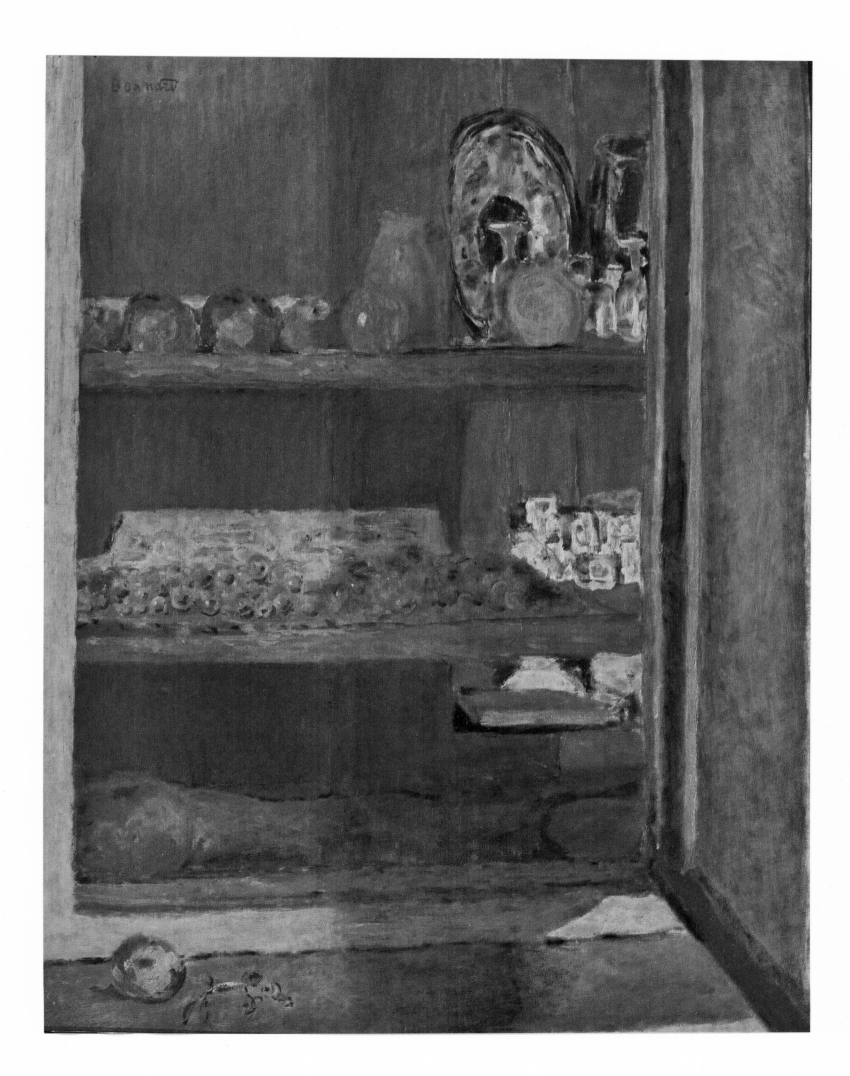

Painted c. 1925

THE DINING ROOM

Oil on canvas, 50 1/2 × 74"

Ny Carlsberg Glyptotek, Copenhagen

We are still at Vernon and this painting takes up again the theme appearing in the 1913 *Dining Room in the Country*. The door is still blue, the serving table is in the same place, and if the wall of the room seems a little less red it is probably because the light, by the will of the painter, enters more freely into the room than before. Only the hair styles and the dresses of the two young women show us that the years have passed. This attachment to a familiar setting changeless in its modesty is altogether characteristic of Bonnard's peculiar sensibility.

And yet the atmosphere has changed a little. The scene is even simpler and more everyday, if that is possible, than in the painting of 1913. One woman is looking at another who is giving the dog something to eat. No one is posed. It is a kind of snapshot, a family photograph in which the people have been caught unaware by a visiting friend (the influence of photography has often been adduced to explain the accidental and unexpected character of some of Bonnard's compositions). The landscape is much more natural than in the earlier picture, and without the slightest decorative element. It has shrunk in relation to the interior, but the light enters more generously into the room, causing the delicious patterns and folds in the two women's dresses to rival in brilliance the sunlit sparkling of the trees and garden. The composition is less rigid, much broader and more harmonious than in the *Dining Room in the Country*. The great blue table (less blue now—is it light or time that has faded it?) grandly occupies the painting's foreground. Its curve seems to echo the graceful arc of the woman bending down, which is in turn taken up by the round basket and the plates of fruit placed haphazardly here and there. It is hard to imagine a more relaxed and simple evocation of daily life with its "monotonous and easy tasks"—or fewer concessions to bourgeois sentimentality. Yet the mere presence of the figure seen in the windowpane endows the scene with sharply felt emotion. It is an instant, both unique and prosaic, of life going by.

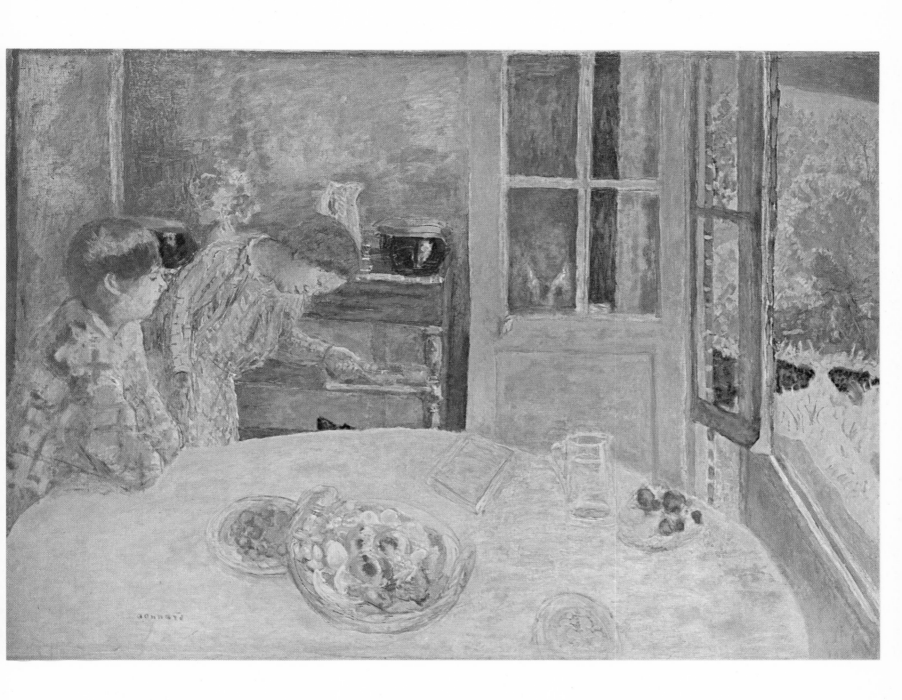

Painted 1925

THE BATH

Oil on canvas, 33 7/8 × 47 1/2"
Tate Gallery, London

Bonnard never goes very far in search of his subjects. His work recounts his life, and the theme of the bath, which provided the occasion for some of his finest masterpieces, must be credited to his wife. His wife, in fact, who evidently had hydrotherapeutic requirements rather unusual for the France of the period, seems to have spent her life between a tub and the mirror of her dressing room, or later in a bathroom. Bonnard was indeed fortunate to have had at his side this woman whose slender and charming body he so often depicted with modesty but also with evident pleasure—more fortunate in this matter than Cézanne, whose wife could not have overwhelmed her husband in this respect, and whose rather bony nudes show how hard it must have been around 1900 to find presentable models among the austere Provençal bourgeoisie.

The white of the bathtub, the iridescent luminosity on the bather's body, the water and tiles of the bathroom offered Bonnard a pretext for variations of infinite charm and subtlety. They gave him an opportunity for seizing light at its purest level of mobility and transparency and color at its most tremulous, when it ranges through swift and unexpected nuances. Bonnard places himself rather high above the model and tilts the bathtub up toward us to set off the whiteness of its side. The model's head and bust, seen from the front, are normal in proportion and rather clearly modeled, while the rest of her body, escaping the painter's head-on view, stretches out and disappears in the water as the forms lose their roundness. *The Bath* is surely one of the high points in Bonnard's art, and it is rare to see an impression of such naturalness and simplicity arising from so much insight, subtlety, and refinement.

The canvas is not quite rectangular. Bonnard did not paint with his canvas mounted on stretchers, and did not like regular formats. He would pull a piece of canvas from his roll, tack it up on the wall, and cut it out according to his pleasure, often marking out the picture's limits with horizontal colored bands.

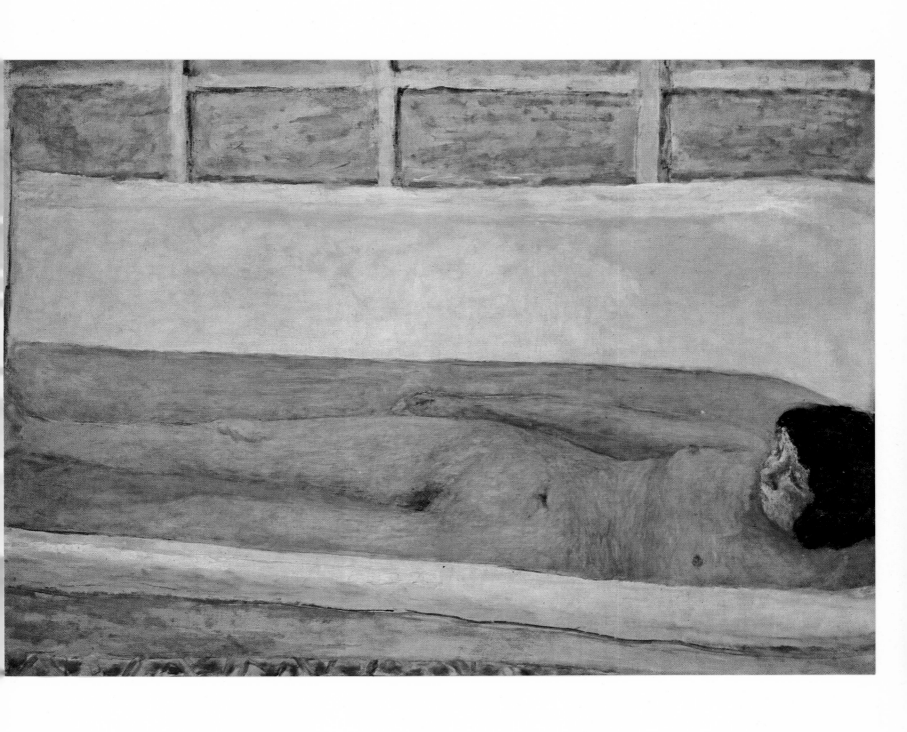

Painted c. 1926–34

THE JETTY (Le Débarcadère)

Oil on canvas, 16 7/8 × 19 7/8"
Private collection, Winterthur, Switzerland

The scene is at Cannes on the quay of La Croisette, the promenade going along the sea. Some young women and a delightful little girl are looking out. The shining rays that light up their faces cross the parapet in the foreground, while the one that stretches horizontally across the middle of the painting is echoed in the distance by the mauve and bluish lines of the Île Sainte-Marguerite. A mast balances the silhouette of the little girl. It would be hard to imagine a more harmonious, solid, and logical composition, and one at the same time offering such a faithful Impressionistic vision of the subject. As so often in Bonnard, the scene has the truth of a snapshot, and anyone at all familiar with the Midi can recognize the hour of day, the season, and what wind it is—the *Ponant* (or West wind)—that imparts to the blue-and-green sea its dark reflections and ruffles the little girl's dress. The mauves, yellows, and lilacs, which were to become Bonnard's favorite colors, he saw, as anyone can, in the lights and distances along the Mediterranean shore.

According to the recollections of Mme. Hahnloser-Bühler, related by her son, Professor Hans R. Hahnloser, in Annette Vaillant's book, Bonnard began this canvas in 1926 or 1928, but in order to be allowed to buy it "we had to wait at least seven years for it: he was always finding something he wanted to put right. Then one fine winter day in 1935 he said casually: 'If you still want to have *The Jetty*, it's ready. I have found out what was throwing it out of true. I have heightened this yellow effect; everything is in balance now. It is small, but I think it is quite a successful piece of work.' These seven years had not changed the price of the picture; he remembered the exact terms of our agreement and kept to them although the prices of his pictures had risen considerably in the intervening period."

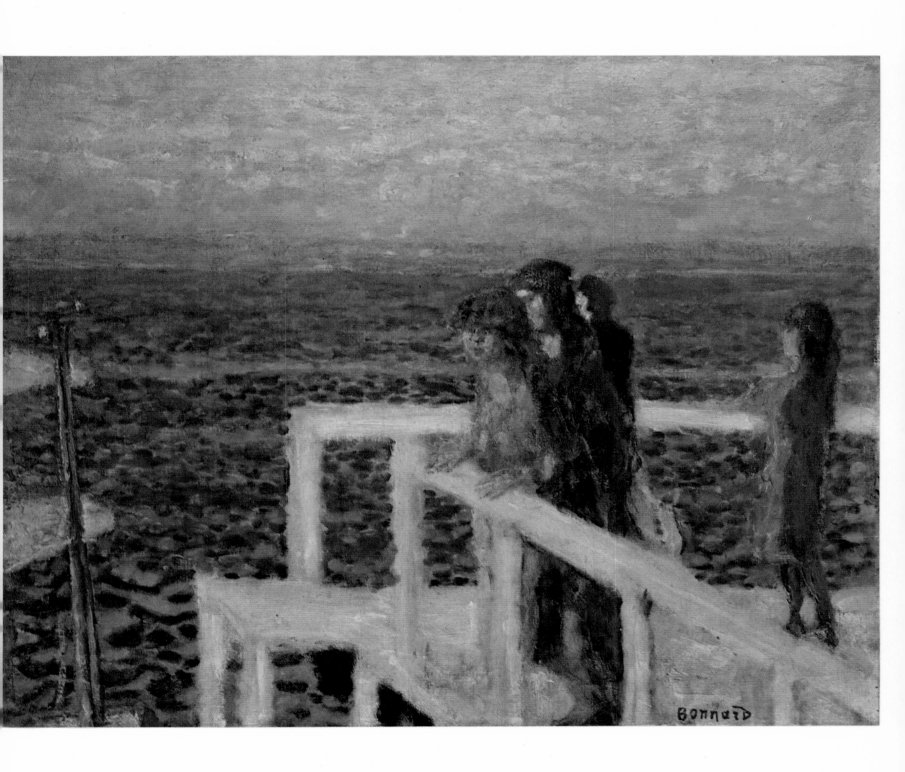

Painted c. 1928

MARTHE IN A RED BLOUSE

Oil on canvas, 28 3/4 × 22 1/2"
Musée National d'Art Moderne, Paris

Marthe's red blouse seems to have especially pleased Bonnard, for he repeated it in several paintings. To her right in this picture sits Reine Natanson, Thadée Natanson's second wife. Ever since the time of the *Revue Blanche*, Thadée had kept up his friendship with Bonnard; and although he was obliged to sell the works of his favorite artist along with the rest of his collection in 1900, after World War I he was once again able to buy paintings from Bonnard, most of which his widow bequeathed to the Musée National d'Art Moderne in Paris in 1953. Of all the writers on Bonnard, Natanson is without doubt the warmest and most perceptive, as well as the most gifted in literary expression, even though his prose may be somewhat precious, retaining as it does a savor of post-Symbolist bizarreness. In his book he describes this painting as follows:

"Two ladies, their faces described in some detail, have just lunched in the open air. The one is all blonde, of a blondeness in which the light plays, in a red blouse more than vivid, striped with white, a necklace of costume jewelry about her neck. The other is dark, her hair a chestnut brown with bluish overtones, seen full profile. In the distant background a servant comes, a cat stalks; in the foreground, on the near-gilt tablecloth in one of the earthenware plates, two plums, just suggested. Tree trunks, foliage, and sky form the setting for the outdoor restaurant.

"The harmony could not be more daring: an astonishingly powerful red, successfully harmonizing with pale yellows, barely livened with greens and violet blues. Between them, a pale lilac. The contrast of the vivid tints, of their vivid tones, the reds and lemons barely accented, accompanies the opposition of the faces, one in profile, one full face. . . .

"Nothing quiescent. All reverberating. The sum of dissonances, of unexpected harmonies, of resolutions, of powerful accords, of tones graduated in delicate tints, so many instruments of a polyphony masterfully disciplined so as to sustain the melodic line above a *basso continuo*."

130

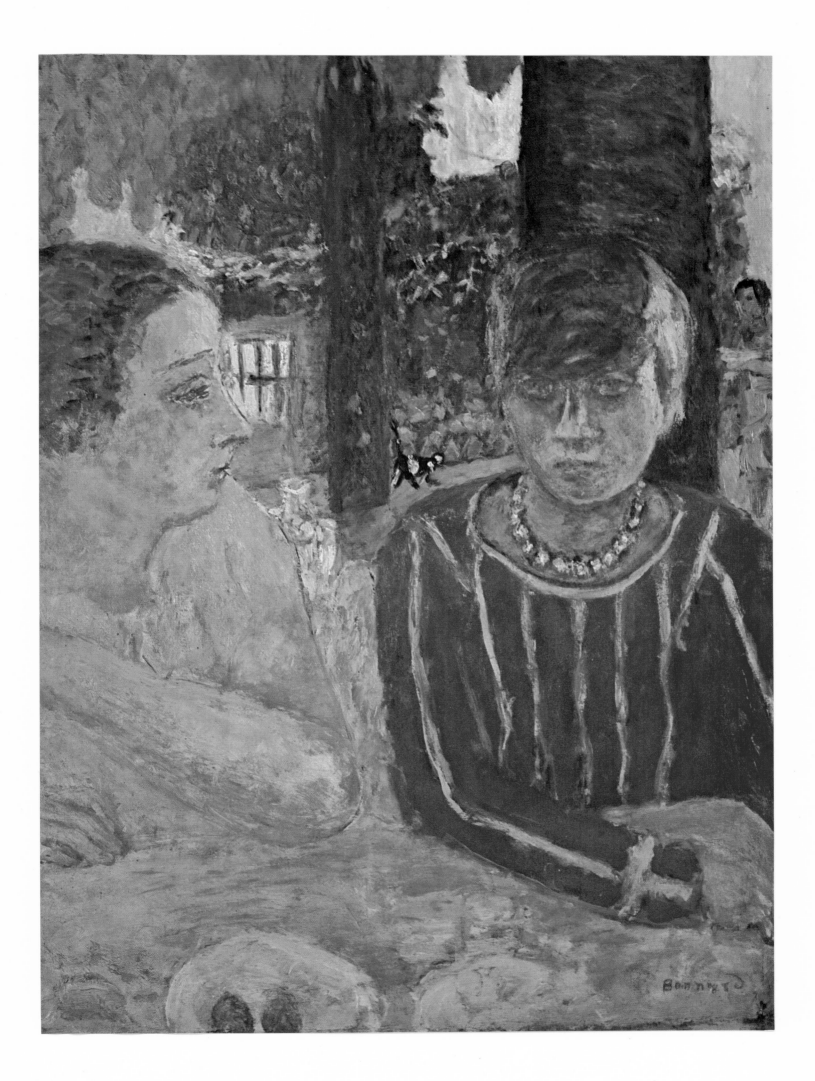

Painted 1930

THE PROVENÇAL JUG

Oil on canvas, 29 3/4 × 24 3/8"
Private collection, Berne

Contrary to what might be imagined, Bonnard's still lifes are relatively
nondecorative in spirit, and it is in this area of his work that the modesty
of his artistic intentions and his indifference to painting in the grand manner
may best be sensed. For Matisse, Picasso, or Braque, not to mention Cé-
zanne, a still life was the occasion for a composition sumptuous in color and
form, for brilliant resolutions of the most challenging plastic problems, and
for conferring monumentality, mystery, or emotion on the world of the
inanimate. No such thing in Bonnard: this Provençal jug might have been
quite grand but, by showing it not quite straight, pushing it back into a
corner, drawing its handle poorly, he has in no way tried to hide the fact
that it is simply a very ordinary jug. He has not pointed up the central ele-
ment of the composition, but rather cluttered it with various elements which,
though highly refined as to color, detract a little from the balance of the
whole: the shadow of the jug on the wall; some sort of bowl at the left; and
especially the woman's arm and hand, which because of the shadow appears
to have six fingers, and whose disengaged presence results from the painter's
cherished habit of cropping the picture abruptly so as to give the impression
of a scene extending beyond the limits of the canvas. The drawing is so
unsolid and the forms so oddly inexpressive that the effect is somewhat
disconcerting. On what is the jug resting? A table top? A mantel? Or simply
on the base of the fireplace, the foreground showing us the floor? But in
that case in what position is the person whose arm we see? Bonnard adored
offering this kind of visual riddle, the solution of which is by definition not
to be found. In any case, if one compares the sculptural density of Cézanne's
table edges to the looseness with which Bonnard has drawn what might have
been the composition's architectural element, it can be understood that
Bonnard wanted only to note in this painting the poetry and mystery that
color and shadow confer on the most insignificant of objects.

132

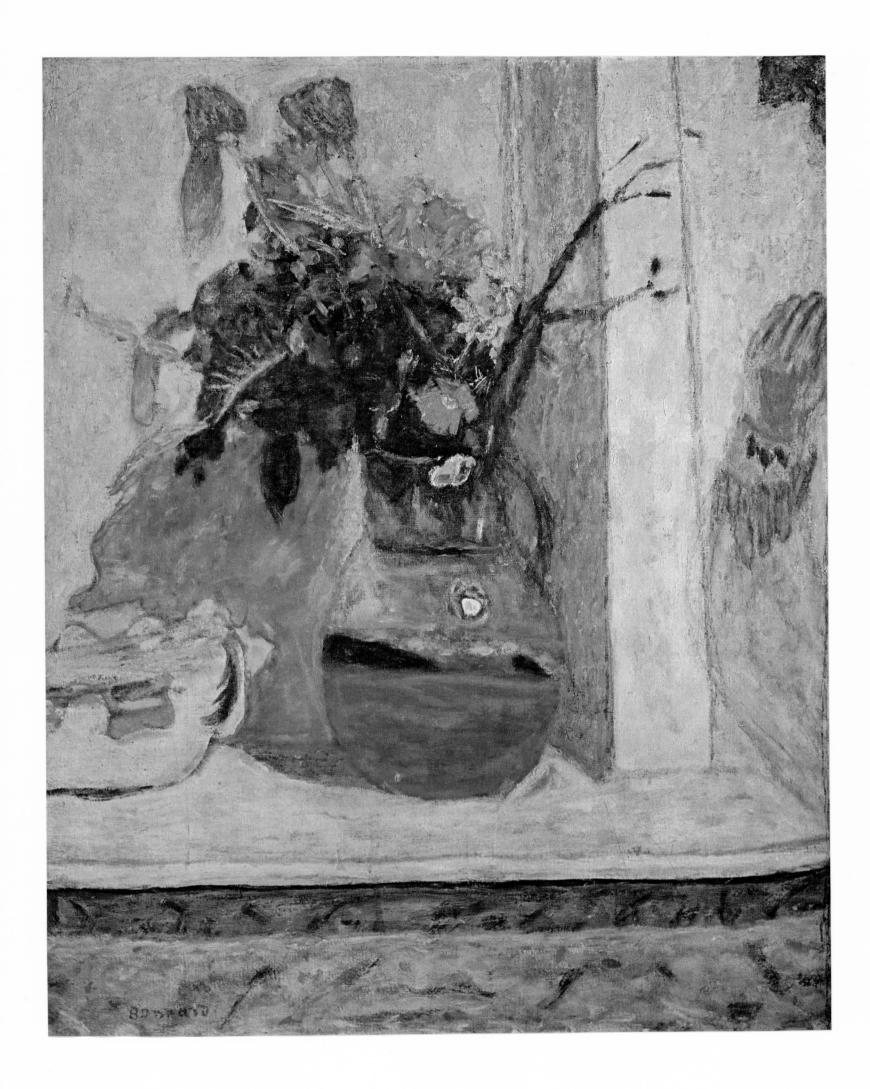

Painted 1930–32

PORTRAIT OF A CHILD

Oil on canvas, 20 1/8 × 24 3/4"

Collection Antoine Terrasse, Fontainebleau

Portraits of children are frequent in Bonnard's early years, the painter often amusing himself by observing the children of his sister and his friends playing and going about their daily occupations. The Terrasse family, in Paris or at Le Grand-Lemps, was among the favorite subjects of his youth; and if childhood appears more rarely in his later works it is simply because his friends' children had grown up and the Bonnards remained childless. Children appear now and then nevertheless, and one sometimes sees their little forms planted in the foreground of a landscape or trotting along the edge of a beach. The portrait reproduced here shows what freshness Bonnard could bring to the most conventional kind of subject, which is the most dangerous kind. Picasso turns his children into fairytale creatures or frightful little monsters ferociously intent on lollipops; Bonnard, without poetic disguise and with a minimum of distortion, has made of this little girl a symbol of childhood remarkable in its lyrical power and intensity of expression. It is one of the rare faces painted by Bonnard on which can be read a positive feeling: the joy of living, of being seated on the bench warmed by a ray of sunshine, of smelling the garden's aromas, of having her dog beside her, of sensing, in a kind of pleasurable ecstasy, light, freedom from care, and ease. The splashes of color around the bench are quite characteristic of the evolution of Bonnard's landscapes after 1930.

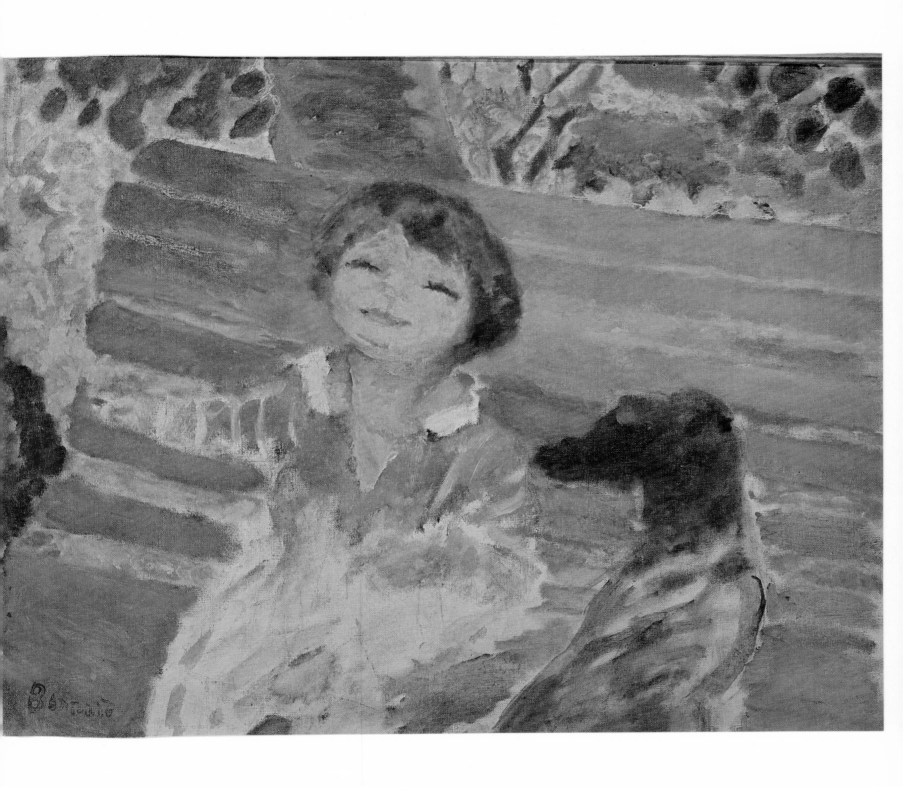

Painted c. 1932

LE CABINET DE TOILETTE
(Nude in a Bathroom)

Oil on canvas, 47 1/2 × 46 1/4"

Collection Mrs. Wolfgang Schoenborn, New York

Light streaming in the window of the bathroom illuminates the left side of the composition and the right part consequently appears a little darker. Although the slats of the shutters through which the sunlight falls break up the light and make it iridescent, nothing, from the point of view of ordinary visual logic or plain observation, can explain Bonnard's extraordinary license in the handling of color. The tiled bathroom floor is blue to the left, orange at the right, separated by a passage (which, to cap the climax, is a white shadow!) corresponding to the white of the stool and the linen on which the dog is sitting. The forms are rather confused, save when they represent geometrical elements, and the painting is a mosaic of colors assembled patiently and shrewdly, and with evident enjoyment of the refined variations in blues, mauves, lilacs, and orange-pinks which are from this time on the basis of Bonnard's palette. One could imagine nothing more sumptuous and more dazzling, nor more evocative of the spirit of feminine illogicality and disorder: this dressing room is an incredible jumble, a profusion of tumbled linens and more or less identifiable utensils in the middle of which the alarm clock appears, like an ironic and helpless recall to precision. As for the young woman, she does not seem aware that it is shod feet she dips into the basin (unless it is a shadow). Her position is altogether charming and original. Bending forward and turning her head, she sets up a diagonal opposing that marked by the bathtub and the dressing table, thus creating a particularly animated space; for at the left the eye is drawn back toward the window, while at the right it is pulled out toward the foreground again, the composition being firmly pinned in the center by the edge of the curtain, the stool, and the dog. To the left, straight lines and stability dominate, while, at the right, curves and movement create a subtle, asymmetrical balance.

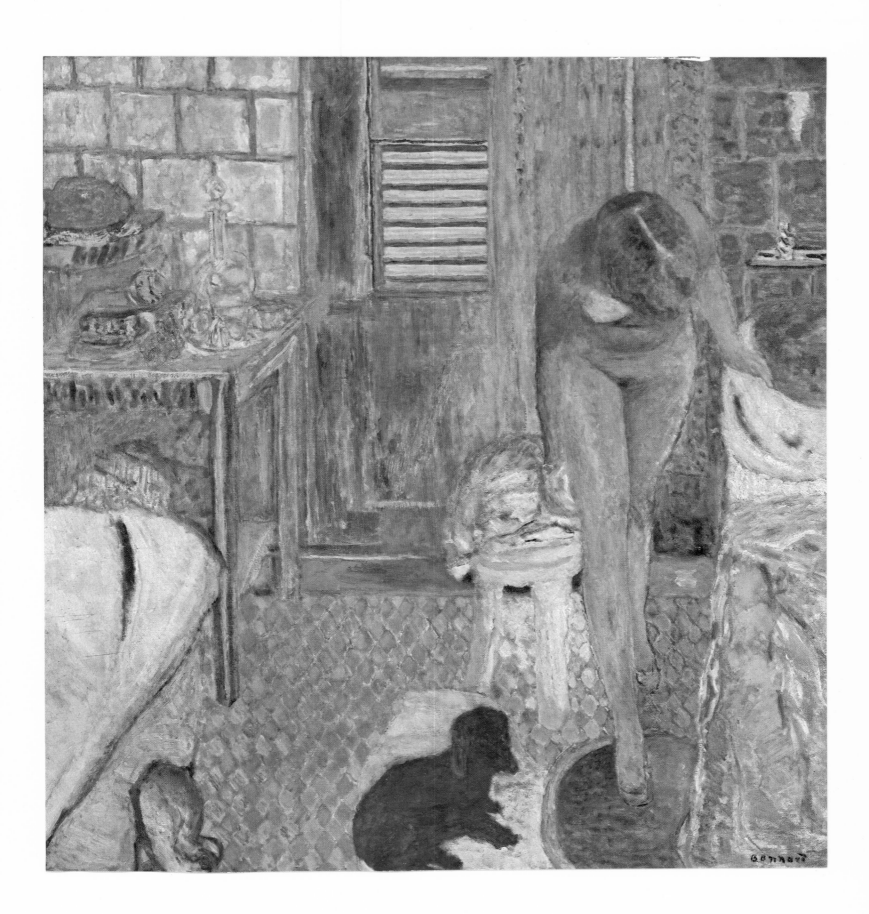

Painted c. 1933

NUDE BEFORE A MIRROR

Oil on canvas, 59 7/8 × 40 1/8″

Galleria Internazionale d' Arte Moderna, Venice

With the years, Bonnard's figures grow bigger, as do the mirrors in which they look at themselves. Despite its crowded and in certain parts almost indecipherable character, this composition gives a remarkable impression of ease and even of monumentality by the play of verticals scanning it (the mirror, the yellow area of the wall) and the *élan* of the big nude standing in the center. At the same time, since Bonnard was not fond of facile solutions, he contradicts this ascending movement by offering various horizontal elements, and by weighting the composition toward the bottom with the armchair in the foreground and the abnormal elongation of the young woman's hips and legs in relation to her upper torso. The eye is thus drawn simultaneously to the top and bottom of the painting, while the mirror and window enlarge the room. With the reflection of objects in the mirror Bonnard sets up a particularly complex movement, giving the sensation of a mazy rhythm pulling the eye in all directions at once, only to bring it back at last to the strong light caressing the young woman's back, her body seeming to have absorbed into itself all the colors in the room.

Corresponding to the dispersal of the forms is the scattering of color, one justifying the other. Even at the end of his life Bonnard rarely went so far as he does in this picture in analyzing received impressions, scooping up, one might say, the least highlight, the most fugitive nuance, in order to give it consistency of form and density of color. There is no area in the painting that has not been subjected to a most searching exploration, though we are unable to discover whether Bonnard's first desire here was to translate into pictorial terms a specific sense impression, or whether he aimed at elaborating the logic of colors as such, since he considered this to be "more severe than that of form."

138

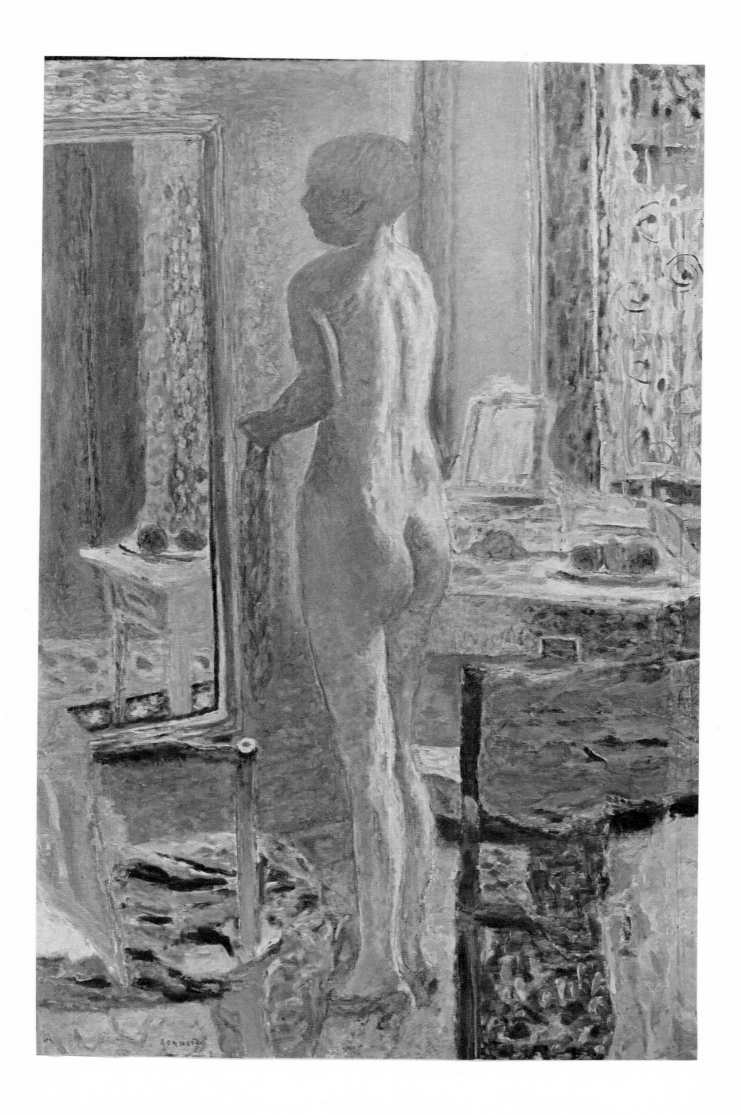

Painted c. 1934

DINING ROOM ON THE GARDEN

Oil on canvas, 50 × 53 3/8"

Solomon R. Guggenheim Museum, New York

The theme of a still life set out before a window through which may be seen a fragment of landscape is one of which Bonnard, like Picasso and Matisse, never tired. But while Matisse simplifies and brutally opposes one form to another, Bonnard seems to approach objects almost shyly, exploring them one by one, lingering over even the most modest of them, in no way disturbing what chance has brought together under the light. Even though one may descry some purpose in the way the objects are arranged on the table, as for example in the placement of the two pitchers which set up a diagonal leading the eye back into the landscape, the composition gives the impression of total freedom and exquisite naturalness. The two frail and slender compotes seem to spring a little slantwise from the table, like two mushrooms, giving the picture something unstable, fleeting, on-the-move, despite the window frame's clearly established geometry.

Few of Bonnard's paintings are as difficult to date as this one. But if Bonnard's chronology is often hopeless, each of his works yet quite distinctly bears the stamp of the place, season, moment in which it was conceived, if not entirely finished.

Bonnard allows himself to take liberties only with the color, which he exploits both for the delectation of the senses and to ensure the composition's over-all balance. The colored bands cutting across the table are clearly quite arbitrary and correspond to his first intention, though each of them is taken up again at one point or another in the painting. But what subtle counterpoint is established between the light coming into the room and the colors that the room itself projects into the landscape! Through the window at the left appears a light patch that seems to echo the tints of the bouquet; to the right a ray of light brightens the wall's hues, and these in turn reverberate in the foliage of the tree. Bonnard thus abolishes any question as to the continuity between the interior and the landscape, the crux of the problem posed by a composition of this kind. But he seems to have been at pains to complicate its solution by also accentuating the disjunction between the two compositional zones, placing the chair back squarely in the center, and giving much greater importance to the table than to the landscape. At the same time, however, the circle described by the table's edge expands first to that formed by the backs of the chairs, then toward that, already less clearly affirmed, suggested by the position of the woman's figure and the light ray that seems to gouge out the wall (although the room is rectangular), and it is finally dissolved in the grand luminous accord closing the composition. Color gathers together what form has sundered—until the day when form is to be absorbed by light.

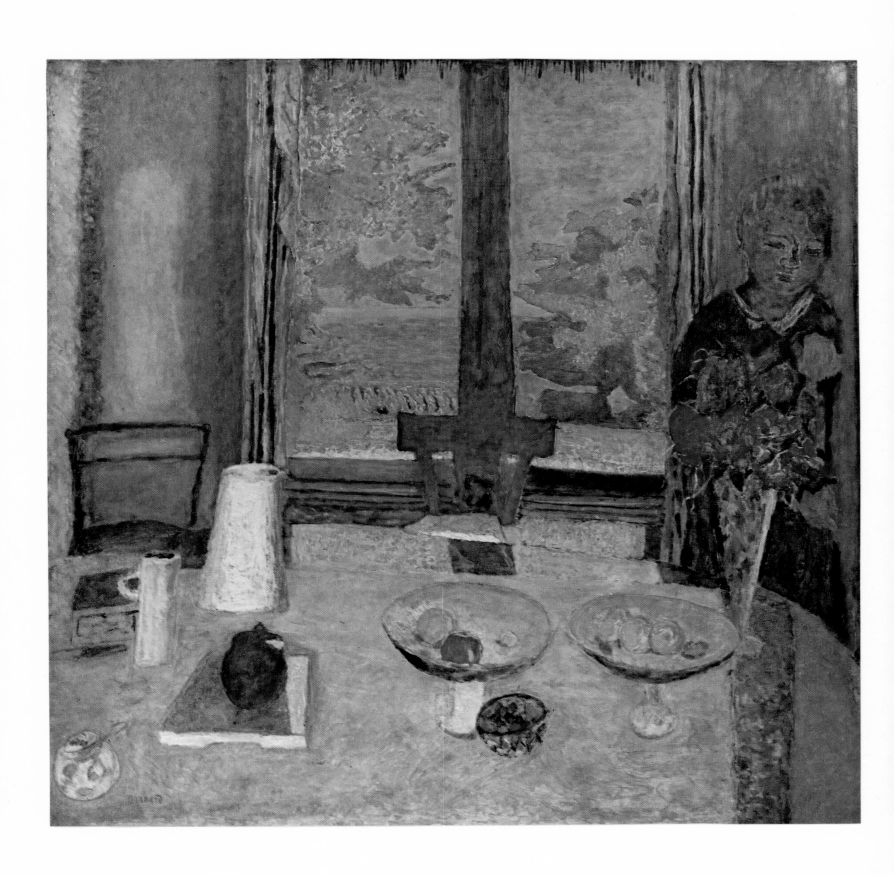

Painted c. 1935

STILL LIFE (Le Coin de table)

Oil on canvas, 26 3/8 × 25″

Musée National d'Art Moderne, Paris

Such a sumptuous still life as this shows to what point Bonnard's favorite notion of the "mobility of vision" can be rendered complex and sophisticated. The fact of presenting the table on a diagonal, running it across the composition, is not in itself astonishing: Monet had already done the same in, for example, *Les Galettes*. Nor is the manner in which the table is tilted up to the vertical: the procedure is familiar in Bonnard, and Matisse also employed it often, as in his *Oysters* in the Basel Museum. It is one way of not immobilizing the composition, of suggesting in a very dynamic manner that it continues outside the limits of the frame. But while both Matisse and Monet, in each case with the presence of a knife laid on the table, emphasize the movement into depth along a diagonal, Bonnard busies himself with contradicting it in all possible ways. The superb red band edging the table narrows suddenly just at the top of the composition, behind the basket; the fruits and plates are presented frontally and piled one above the other, while their shadow is cast horizontally so as to interrupt the ascending movement in the painting. As for the chair at the left, which plays the same role, it is really one of Bonnard's most curious inventions, and it is hard to understand in what position the painter could have got himself in order to see it just so. The objects, rather difficult to identify, seem weightless, barely resting on the table, their shadows in fact seeming to raise them above it. The result is a sum of paradoxes and caprices which might suggest a rather uncomfortable mannerism, were the color not so powerful and so joyously affirmed.

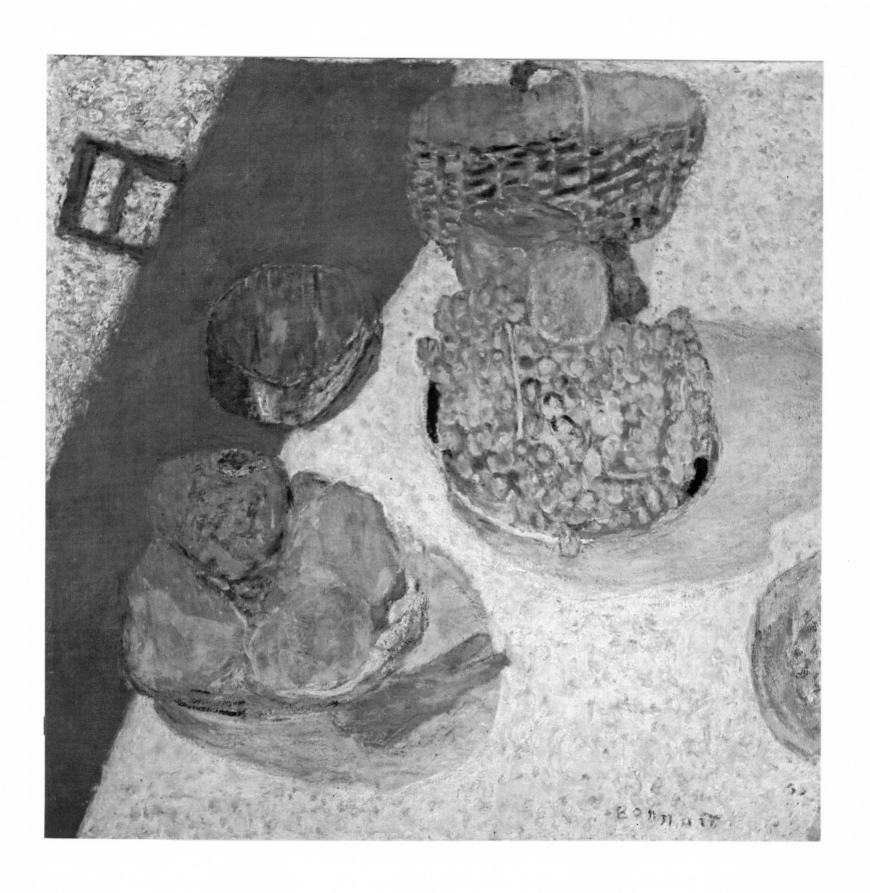

Painted c. 1935

THE GARDEN

Oil on canvas, 50 × 39 3/8"
Musée du Petit Palais, Paris

Open nature and broad horizons always appealed less to Bonnard, the painter of the intimate and the solitary, than the familiar world of gardens: a setting for tea, for dreams, or simply for allowing the hours to pass. It is there that he most willingly sets his figures, rather than in broader landscapes where they always appear somewhat lost. But Bonnard's gardens have nothing at all of that moving symmetry and compulsive regularity that all French petits bourgeois seek with such passion. The painter's friends often described the extraordinary jungle of greenery surrounding the house at Le Cannet.

A landscape is traditionally more or less structured and perceived in an analytical manner. It inevitably implies distinct masses, planes tiered in depth, at least a minimum of perspective (though Bonnard often reduces this as much as verisimilitude allows him to). In this garden there is nothing of the kind: here one perceives nature not as a spectator at all, but right from her midst, with the sense of being in the center of abundant and confused growth. And though Bonnard had always tried to express landscape in such a way as to give us the feeling of being close to it, of moving amid the trees and flowers, the extraordinary lyricism of this painting is without precedent in his work. All the elements of the composition are confounded, piled up, not distributed in depth but brought forward to the picture plane, as in other works the table tops or faces seem to move forward and press themselves against the canvas. There is present, to be sure, a perspective device—the road ending with the orange tree; but the device is negated by the orange tree being much too small, and the path seems to run through the canvas rather than to penetrate into the garden. The forms are difficult to identify, merging one into another and becoming confused masses hatched with patches and strings of color, apparently incoherent and juxtaposed with obvious awkwardness. The painting has no center, seems but barely composed, goes off in all directions, and, what is perhaps most remarkable, the canvas is entirely covered with spots and shapes through which no air circulates. One may guess at a sky behind the foliage, but when the sky actually makes its appearance at the top, to the right, it appears as a zone of color set on the same level with all the others. Space here already seems abstract, and one might no doubt discuss abstraction in connection with this painting. But it is Bonnard's desire to express not the appearance of things but the urgency of organic life and the emotion that it arouses in us, which have here caused all the principles of classical composition, which Bonnard knew (and respected) as much as anyone, to explode.

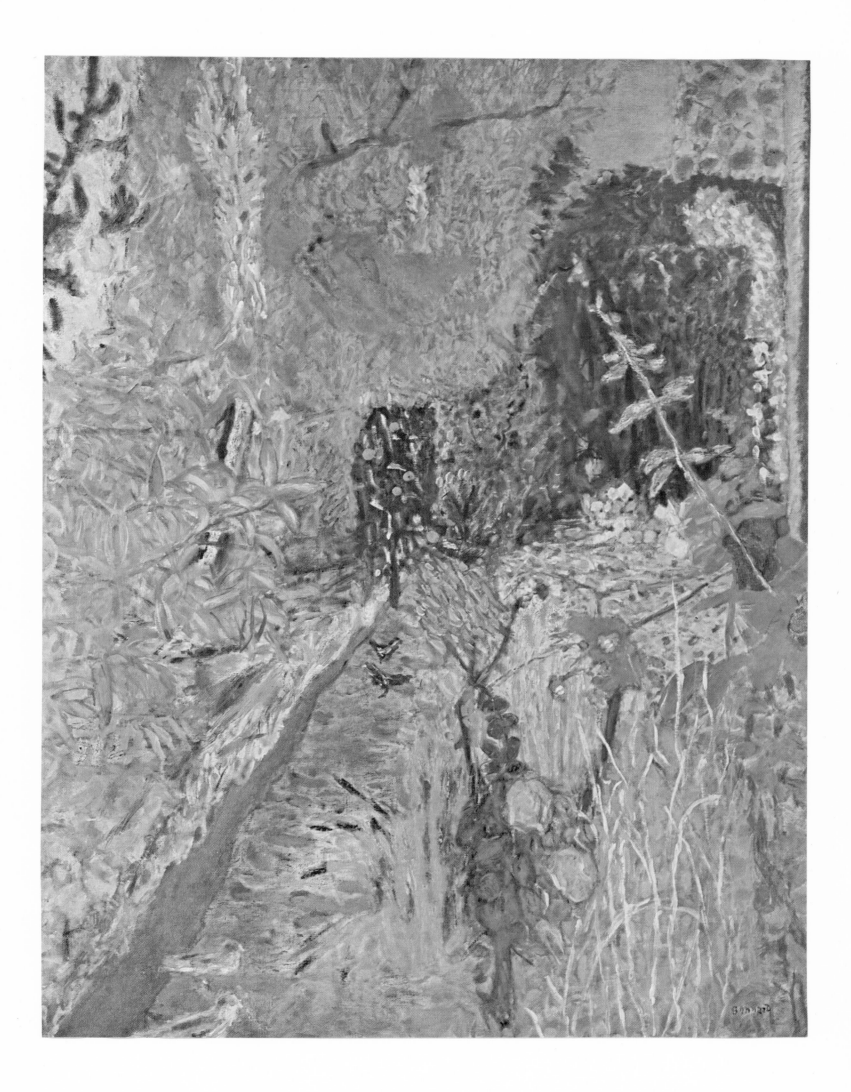

Painted 1936–37

THE LITTLE BRIDGE

Decorative panel
Palais de Chaillot, Paris

The structure that arose on the Chaillot hill at the time of the 1937 International Exposition, replacing the old Trocadero, can certainly not be set down as a credit to the artistic perspicacity of the Third Republic's leaders. Its architecture (a Perret design was, alas, turned down) is extremely ugly and the decoration a triumph of confusion and banality. To ornament its interior, a group of artists was selected, each very different from the next, most of them mediocre and some distinctly bad; neither Matisse nor Picasso, nor Braque, Léger, or Delaunay were called upon for a contribution. The officials in charge limited themselves to Dufy, Maurice Denis (who appears there at his most uninspired), Roussel, Vuillard, and Bonnard—no doubt because these were the artists least disturbing to the academic soul. (Maurice Denis decorated a number of public buildings and was to bring Vuillard into the official Institut de France behind him in 1937; as for Bonnard, there was never the least suggestion that he be admitted.)

Amid the over-all mediocrity of the décor, Bonnard's piece is striking for its originality and its almost aggressive bizarreness: one might imagine the painter to have been enchanted at the idea of paying off those responsible for such a reprehensible building. Beyond the delightful little bridge in the foreground the composition, all tilted up vertically, is almost entirely incomprehensible. Trees of a kind that never existed save in the painter's imagination surround a prairie or a river (it is not quite clear which) where lambs, ducks, a cow, and an ass are sporting, while under the bridge appear various figures in the most extraordinary poses, defying all laws of gravity and balance. There is no ground plane, no perspective, and Bonnard probably never went so far in the intentional awkwardness of his drawing, the lack of order in his composition, and the arbitrariness of his color. However, set down as it is with the methods of a primitive, the idyllic vision has a great deal of charm and freshness. The blue tree at the right, the child radiating happiness who opens wide her arms in a gesture recalling Marino Marini, the gentleman who seems to be reading the newspaper in the foreground— all of that is as unexpected as it is amusing and flavorful.

Bonnard was apparently not entirely satisfied with his work (he never was, to be sure). When Sam Salz congratulated him, he replied, "When for once I had a chance to work on a big surface, I couldn't take advantage of it . . . as usual!" For once, indeed! For *The Little Bridge* represents the only commission with which the State ever honored Bonnard.

146

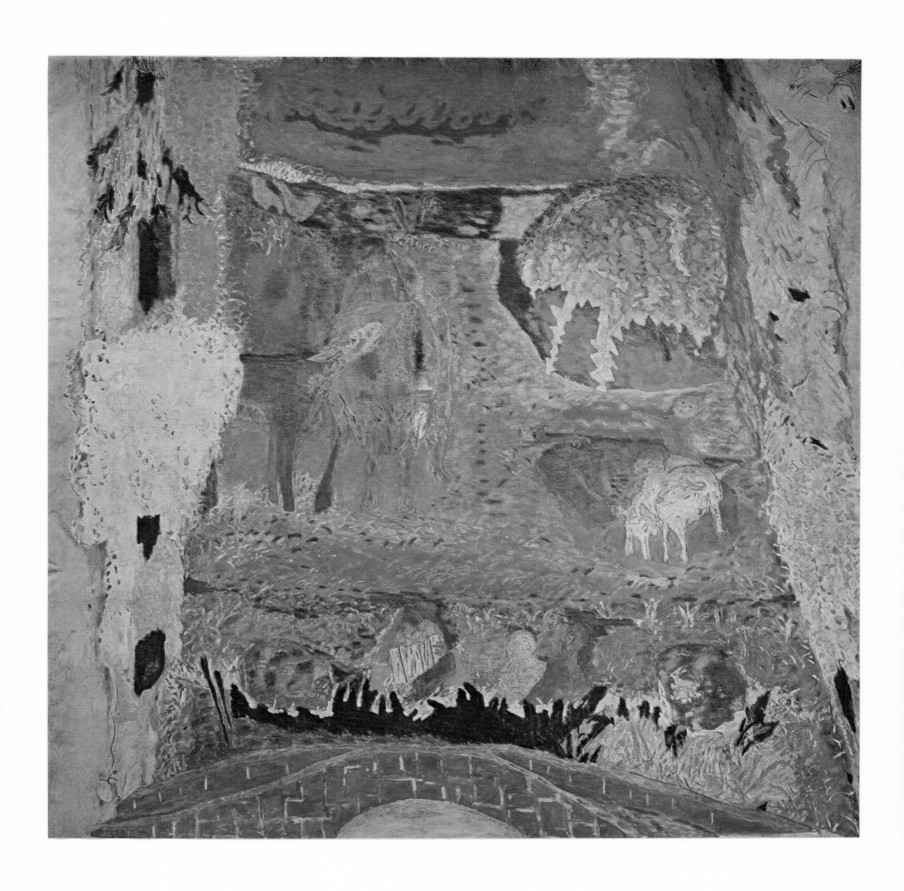

Painted 1937

NUDE IN THE BATH

Oil on canvas, 36 5/8 × 57 7/8"
Musée du Petit Palais, Paris

Between 1925 and 1938 Bonnard made a number of paintings of this subject. He never stopped exploring the potential formal and luministic variations to be derived from the theme of the nude in a bathtub.

In the present picture, color is distributed according to its own logic and in an entirely arbitrary manner. The painting is constructed around the relationship between two colors: blue and yellow, with all the nuances and transitions that can result from contrasting and mingling the two. In the lower part blue dominates; above, in conformity with the logic of the light traversing the room, it ought to have been yellow, but the composition would then have been in danger of falling into two horizontal parts. So Bonnard cuts the upper part with the blue tone of up-and-down bands which, with the accent provided by the bathmat in the center of the foreground, stabilize the structure vertically and merge into the darker mass of the water. The composition is further animated by the fact that the bottom end of the bathtub leans out of the left edge of the painting, and that the light circles from left to right in an elliptical movement, laying gold highlights on the upper edge of the tub and on the young woman's hair, and coming to an end most harmoniously in the blue and gold spotting of the floor tiles. This movement is taken up by the diagonal of the bathmat and the side of the tub, below which the floor mounts up and expands the composition along a longitudinal line that is already suggested in the model's right leg.

But where do these colors come from? From a gold highlight, from a blue highlight, and from the color of the water that Bonnard saw reflected on the wall at the back: these he has exploited with great boldness. He has succeeded in resolving the problem that Maurice Denis had posed: to identify color and light, while sacrificing nothing on the level of density and transparency. Few paintings cost him so many pains: "I should never again dare engage upon such a difficult theme," he said. "I can't make it come out as I wish. I have been at it for six months and I have still several months' work to do" (quoted by Antoine Terrasse). The result, at any rate, is worthy of the effort invested, for if the painting is a sum of just about all of the pictorial investigations Bonnard had ever made, it is also one of the most immediately attractive of his works, perhaps the most delectable he ever painted.

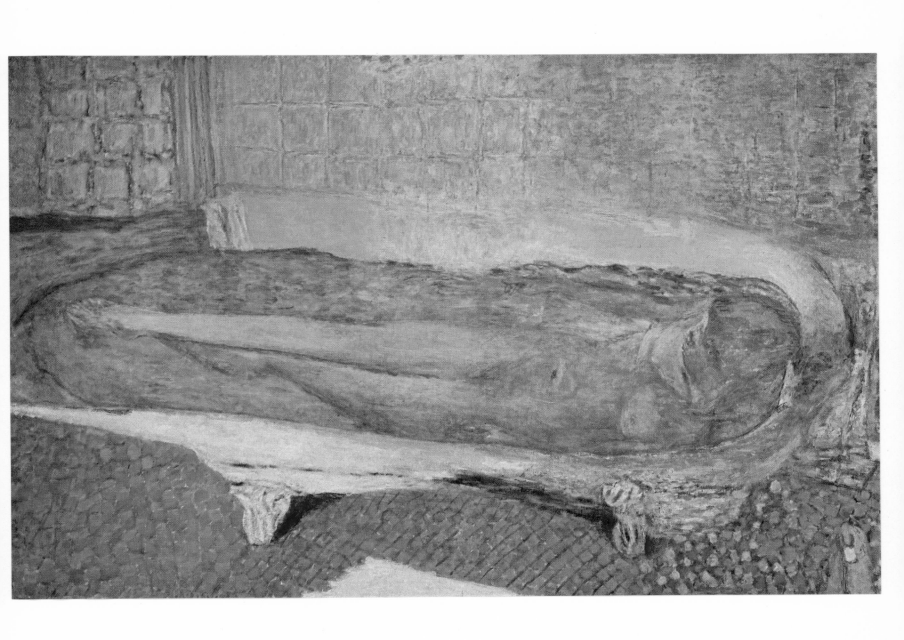

Painted c. 1938–40

NUDE IN YELLOW
(Le Grand Nu jaune)

Oil on canvas, 67 × 42 1/2"
Private collection, New York

The room, the furnishings, the curtains are the same as those surrounding the *Nude Before a Mirror* we saw earlier. The model's position has hardly changed either: Bonnard once more shows her near the window, her body swept by a diagonal light. But here everything has become yellow, both the light and the shadow, which tends toward orange. The composition has been simplified and it appears that, rather than analyzing the relationships between color and light, Bonnard sought here to give a kind of synthetic expression, a poetic equivalent arbitrary in itself and no longer referrable to a realistic visual impression. The light has become a sort of imaginary environment which Bonnard renders plausible by very carefully indicating the shadows, the highlights, the differences in the colors' intensities, and by providing the composition with certain elements, such as the curtain and the gray-blue piece of furniture, or the linen striped in red, in which local color is more or less maintained. The result is of a surprising freedom and charm; and in fact the scene has an almost Rococo grace and elegance which Bonnard rarely allowed himself. The young woman's gesture is exquisitely intimate, yet it would take but little to bring the picture close to the deliberately risqué, or even over the borderline into an eighteenth-century licentiousness. The high-heeled blue shoes might also provoke such a feeling, and it calls for all Bonnard's tact, all the humor with which he draws the model's body and head, to keep our minds on nothing but the painting.

The work is an example of Bonnard's tendency at this time to unify the painted surface (a tendency especially evident in some of the gouaches and watercolors) as well as to indulge the predilection for yellow that gives so curious an appearance to some of his last works. Jacques Rodrigues, one of Bonnard's most faithful friends and one of his dealers, recalls that when one day, while looking at a Signac watercolor, he commented to Bonnard, "There is a lot of yellow in it," Bonnard replied, "One can't have too much" (quoted by Annette Vaillant).

150

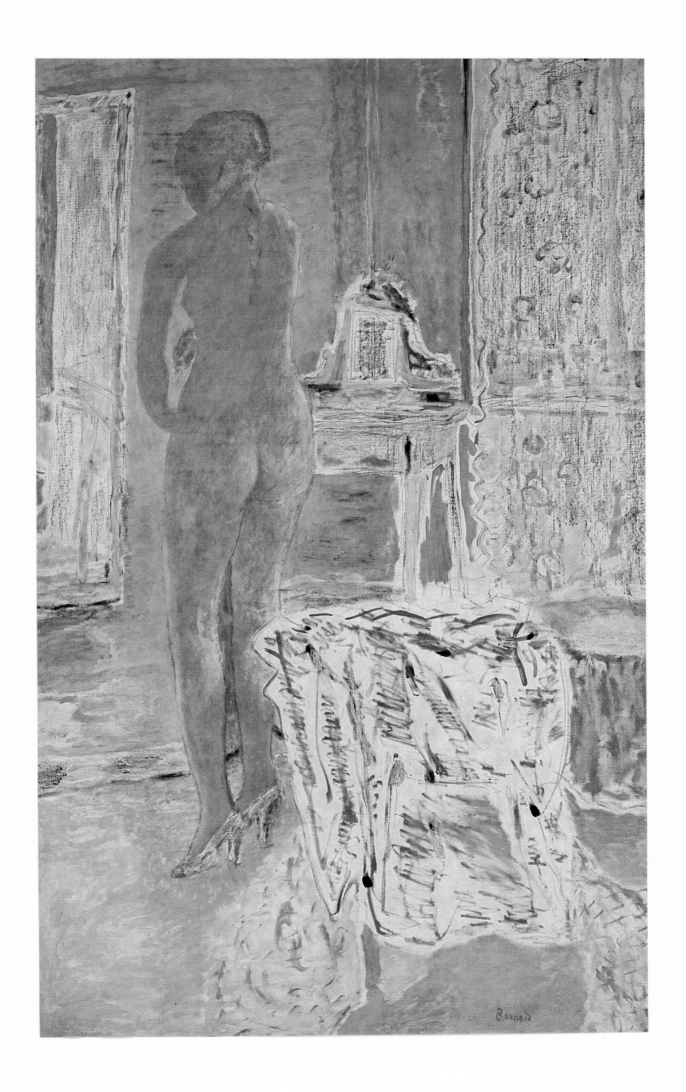

Painted c. 1940

LANDSCAPE: LE CANNET

Oil on canvas, 25×21"

Private collection, Paris

Though Bonnard evinces but a lukewarm taste for farflung horizons, he has given us several panoramic views of Le Cannet, generally in pictures of modest dimension and intent. The painting reproduced here is difficult to date exactly. It was probably done around 1940, even though it looks earlier than the 1935 *Garden* in the Musée du Petit Palais. Nothing is more unwise than to date a Bonnard painting on the basis of a supposed stylistic evolution, for his works do not show a logical development and it often happened that he took a step backward, picking up again a picture or theme abandoned much earlier.

The view of Le Cannet that he gives here is exceptionally broad, for it embraces the whole bay of Le Cannet, and in the distance appear the blue and mauve mountains of the Esterel. Bonnard for once has not interposed an architectural screen between spectator and landscape, but he does show us the view through a crown of foliage constituting a highly animated foreground. Beyond certain rather arbitrary colors (one of those blue trees so beloved of Bonnard), the landscape possesses over-all a grand atmospheric unity and a delightful accuracy of observation. In these respects the painting may be linked with the Impressionist tradition, but it appears that Bonnard wanted to go even further than the Impressionists in trying to express an immediate sensation that has not been filtered through the intelligence nor reworked by stylistic manipulations. The most fluid Impressionist landscape seems nobly and majestically constructed in comparison to this one. Not only does Bonnard not try to impress order on nature or structure on vision, but he even tries to eliminate (unlike Monet, for example) all species of focal "motif": the various elements of the painting are all placed on the same plane and the only ones that escape the floating unity of the whole (the yellow trees vividly lit by the sun, the green patch in the center) are such as might have been considered most meaningless by way of "motif." Despite the breadth of the scene represented, the landscape seems singularly modest and slight, an impression reinforced by the thinness of the pigment and the lightness of the execution. Its charming poetic sincerity, its delicate proportions show that, despite his aversion for realistic minutiae, Bonnard yet possessed something of the candor of a fifteenth-century miniaturist.

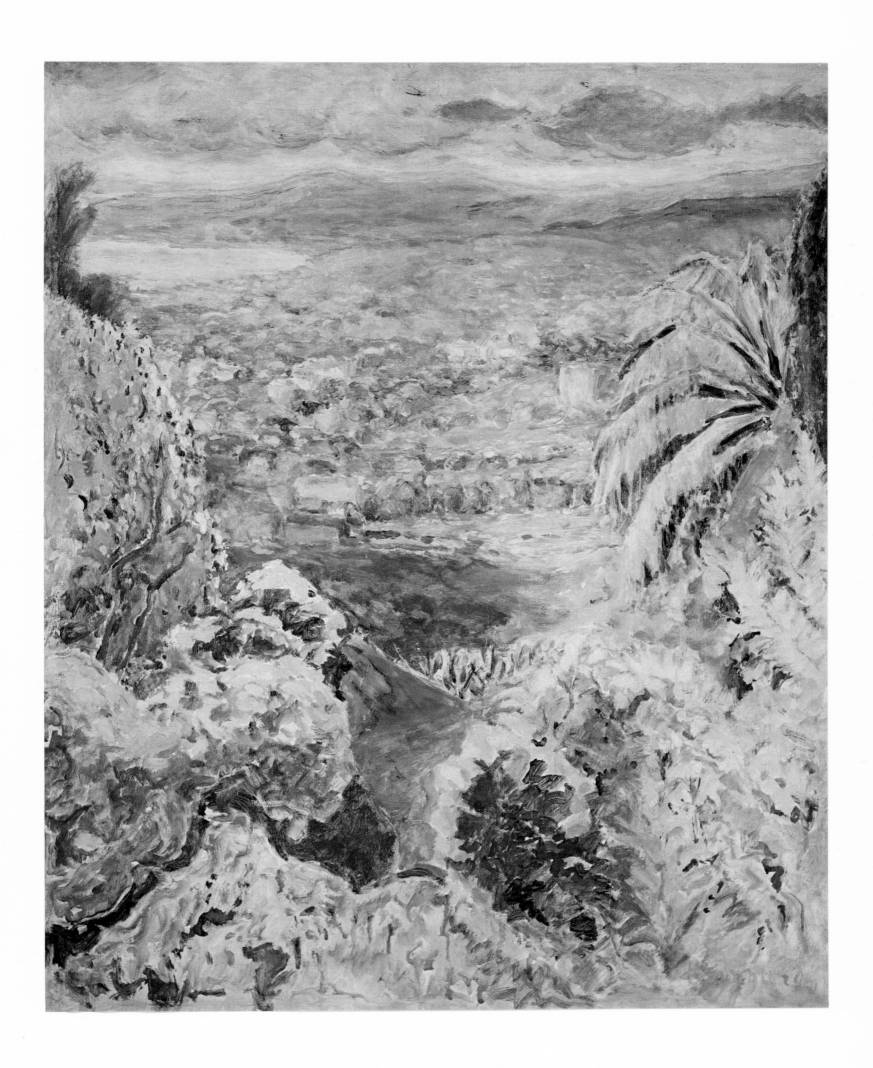

Painted c. 1938–46

THE STUDIO AT LE CANNET, WITH MIMOSA (L'Atelier au mimosa)

Oil on canvas, 50 × 50"

Collection Charles Terrasse, Paris

Seen through his studio window at Le Cannet, an immense mimosa hides three-quarters of the landscape that Bonnard so often painted. Here occurs once again the structure of opposed diagonals which was frequent in Bonnard's pictures after 1913, and which also indicates that the painting was begun before World War II, probably in 1938, for the painter afterwards composed his landscapes with greater and greater freedom, eliminating both foreground and architectural elements. The painting was retouched in 1946. The opposition between the luminous brilliance of the natural scene and the more withdrawn and sheltered intimacy of the interior is gone. Light has come into the studio, brightening the walls with colors fresh to the point of acidity, as brilliant as they are arbitrary, laid in long vertical bands, while at the left appears a face whose barely suggested forms seem to dissolve in the atmosphere. Red-roofed houses can be seen through the masses of foliage and the horizon is closed in the distance by the bluish mountains of the Esterel.

Le Cannet is a village situated just above Cannes. In 1925 Bonnard bought a villa there called Le Bosquet, in which he lived until his death. "It is," wrote his nephew, Antoine Terrasse, "a little house with pink walls, all white on the inside. The garden, where bushes and flowers grow at will, slants down to the street. At a distance one can see the red roofs of Le Cannet, the mountains, the sea. The studio, on the second floor, is small. In it there are a stool, a chair, a narrow divan, one or two little tables, tubes of color, and the bottles of turpentine, the brushes, and rags. The light comes in through a glass bay and plays on the white walls where the canvases are tacked. 'I dislike elaborate installations when I am to paint . . .' said Bonnard. 'They intimidate me.' "

Bonnard was less rapidly conquered than Matisse by the light of the South, and he often said that he preferred the light of the North, "which changes ceaselessly." Yet in 1937 he confided to a Swedish journalist: "It was Boudin who called my attention to Deauville. He maintained that there was no place in France where the sky was so beautiful and varied. And I must agree with him." However, the landscapes from the end of his life show that Bonnard achieved complete mastery of the Southern light and expressed with incomparable lyricism all the exuberance and coloristic wealth of Mediterranean nature.

154

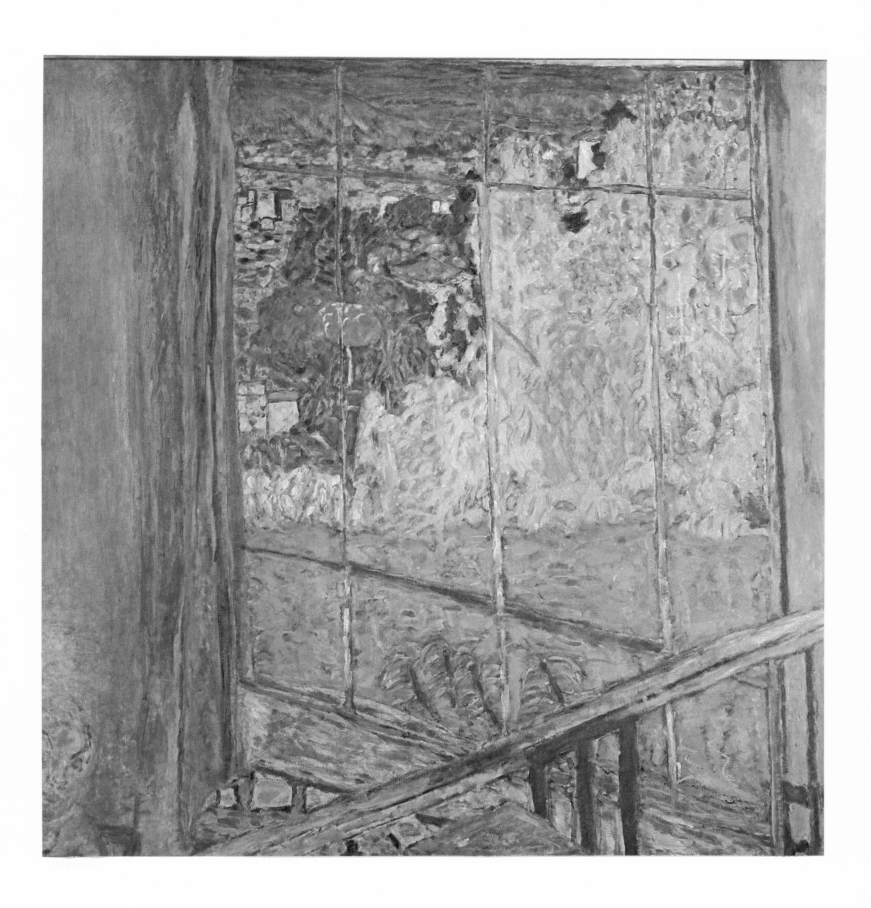

Painted 1941–44

SEASCAPE: THE MEDITERRANEAN
(La Méditerranée)

Gouache, 19 5/8 × 24 3/4"

Musée National d'Art Moderne, Paris

Despite its small size, this gouache gives a strong feeling of power and
poetic gravity, so well has Bonnard succeeded in concentrating the atmos-
pheric impression and giving the seascape maximum plenitude and solem-
nity. The painter rarely expressed with such truth the Mediterranean's
colors, the blue of sky and sea—not the blue of certain postcards or of
facile paintings, but the deep, almost somber blue of autumn or winter
days. The composition is of the utmost simplicity, Bonnard needing but
a few details—the clouds, the sails—to indicate reaches of sea and sky.
The play of horizontals gives the painting life beyond the limits of its frame,
suggesting an immense coastal panorama. The presence of some little figures
in the foreground adds to the sense of solitude, of austere and melancholy
restraint that makes the scene so moving, almost poignant in feeling, as is
so often the case in Bonnard's last works. The painter seems to have wanted
to capture here the very essence of light, but he has nonetheless noted with
great precision all the nuances and lights hiding at the heart of this dizzying
blue, and the color is in fact much less arbitrary than in some of the earlier
works. To the end of his life Bonnard remained faithful to reality: "Abstract
art," he said, "is one compartment of art," and "The abstract is its own
point of departure." To the day of his last work, *The Flowering Almond Tree*,
emotion before nature was Bonnard's point of departure.

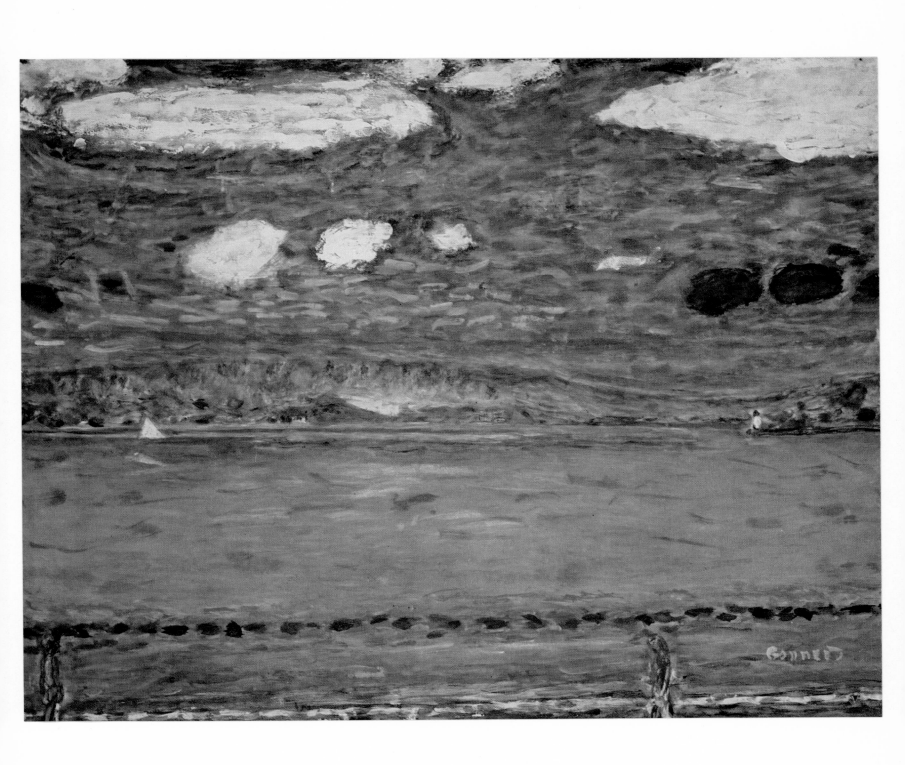

Painted 1942–46

INTERIOR: DINING ROOM

Oil on canvas, 32 3/4 × 39 3/8"

Private collection, Paris

This is very likely the last table, the last dining room, the last interior scene that Bonnard painted. In the final ten years of his life he devoted himself almost entirely to landscape (and, as a concomitant, to still life). Interiors become quite rare and figures disappear from his work, though after Marthe's death he painted a fine nude posed by Maillol's model, Dina Vierny. After Marthe died Bonnard lived in almost complete solitude, bearing as best he could the miseries, the sadness, and the privations of occupied France. This dining room, painted at Le Cannet, with the painter's òld radio visible on the mantelpiece, has a mood very different from that of earlier works of its kind. The room is somber and the light austere, almost lugubrious. Nowhere to be found is that sense of joyous animation, of domestic content and comfort that formerly characterized Bonnard's interiors. The young woman whose face can be seen at the right of the composition appears sunk in a kind of doleful torpor. No more tarts, nor fruits with bright colors: the plates are empty or contain food that is visibly insubstantial and uninviting. Even the color, of a tonality rather rare with Bonnard, is less than agreeable, and reinforces the slightly sinister impression conveyed by the whole. The composition, however, is striking in its strength and authority. Rejecting such distortions as would be unsuited to the psychological atmosphere he seeks to evoke, Bonnard pushes the table deeply into the canvas, broadens the foreground and weights it at its two lateral extremities, on the right by the female face and on the left by the particularly massive (at any rate for Bonnard) group of bottles whose verticality announces the colored bands scanning the composition's background. It was perhaps on a day like the one on which he conceived this picture that Bonnard wrote to Georges Besson: "Our life here is quite solitary and as routine as possible. Today is a bad day. It has been snowing since morning. The maid is sick, the electricity is not working, and the milk will probably not be delivered this evening. Apart from that [as the song says], tout va bien, Madame la Marquise."

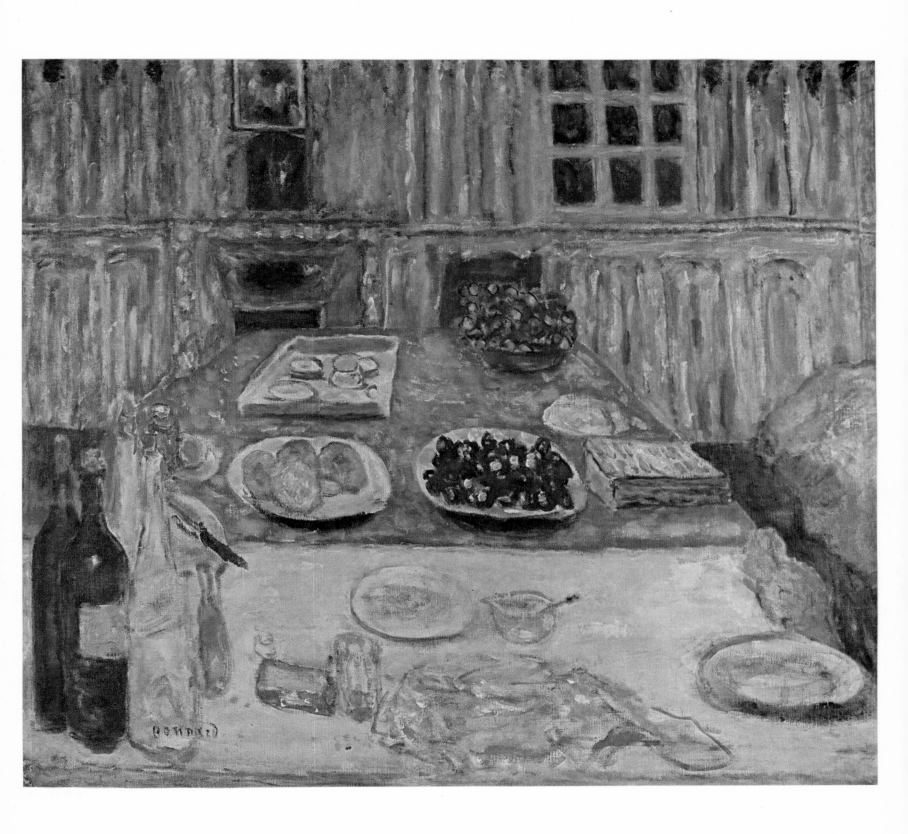

SELECTED BIBLIOGRAPHY

GENERAL WORKS

BARR, ALFRED H., JR. *Masters of Modern Art*. The Museum of Modern Art, New York, 1954.

BLANCHE, JACQUES-ÉMILE. *Les Arts plastiques sous la Troisième République*. Les Editions de France, Paris, 1931.

BULLIET, CLARENCE JOSEPH. *The Significant Moderns and Their Pictures*. Covici-Friede, New York, 1936.

CASSOU, JEAN (and others). *Gateway to the Twentieth Century*. McGraw-Hill, New York, 1962.

CHASSÉ, CHARLES. *Les Nabis et leur temps*. Bibliothèque des Arts, Lausanne, 1960.

CHENEY, SHELDON. *The Story of Modern Art*. Viking, New York, 1941.

COURTHION, PIERRE. *L'Art indépendant*. Albin Michel, Paris, 1958.

DENIS, MAURICE. *Théories*. Bibliothèque de l'Occident, Paris, 1913.

———. *Nouvelles théories*. Rouart et Watelin, Paris, 1922.

DORIVAL, BERNARD. *Twentieth Century Painters: Nabis, Fauves, Cubists*. Universe, New York, 1958.

FELS, FLORENT. *L'Art vivant de 1900 à nos jours*. Cailler, Geneva, 1950.

HUMBERT, AGNÈS. *Les Nabis et leur époque*. Cailler, Geneva, 1964.

JACCOTTET, PHILIP. *French Drawing of the Twentieth Century*. Vanguard, New York, 1955.

LHOTE, ANDRÉ. *Parlons peinture*. Denoël et Steele, Paris, 1936.

———. *La Peinture libérée*. Grasset, Paris, 1956.

LIBERMAN, ALEXANDER. *The Artist in His Studio*. Viking, New York, 1960.

MATHEY, FRANÇOIS. *The Impressionists*. Praeger, New York, 1961.

NATANSON, THADÉE. *Peints à leur tour*. Albin Michel, Paris, 1948.

NEWTON, ERIC. *In My View*. Longmans, Green, London, 1950.

RAYNAL, MAURICE (and others). *History of Modern Painting: From Baudelaire to Bonnard*. Skira, Geneva, 1949.

REWALD, JOHN. *Post-Impressionism from Van Gogh to Gauguin*. The Museum of Modern Art, New York, 2nd ed., 1957.

SERT, MISIA. *Misia and the Muses*. John Day, New York, 1953.

STERLING, CHARLES. *Still Life Painting*. Universe, New York.

VERKADE, DOM WILLIBROD, O. S. B. *Yesterdays of an Artist-Monk*. Burns Oates & Washbourne, London, 1930.

VOLLARD, AMBROISE. *Recollections of a Picture Dealer*. Little, Brown, Boston, 1936.

BIOGRAPHIES AND MONOGRAPHS

BEER, FRANÇOIS-JOACHIM. *Pierre Bonnard*. Editions Françaises d'Art, Marseilles, 1947.

BESSON, GEORGES. *Bonnard*. Braun, Paris, 1934.

BONNARD, PIERRE. *Correspondances*. Tériade, Paris, 1944.

COURTHION, PIERRE. *Bonnard, peintre du merveilleux*. Marguerat, Lausanne, 1945.

FOSCA, FRANÇOIS. *Bonnard*. Kundig, Geneva, and Crès, Paris, 1919.

JEDLICKA, GOTTHARD. *Pierre Bonnard*. Rentsch, Erlenbach-Zurich, 1949.

LAPRADE, JACQUES DE. *Bonnard*. Braun, Lyons, 1944.

LHOTE, ANDRÉ. *Bonnard, seize peintures*. Le Chêne, Paris, 1944.

THE MUSEUM OF MODERN ART, NEW YORK. *Bonnard and His Environment*. Texts by James Thrall Soby, James Elliott, and Monroe Wheeler. Doubleday, Garden City, N.Y., 1964.

NATANSON, THADÉE. *Le Bonnard que je propose*. Cailler, Geneva, 1951.

REWALD, JOHN. *Pierre Bonnard*. The Museum of Modern Art, New York, 1948.

ROGER-MARX, CLAUDE. *Pierre Bonnard*. N.R.F., Paris, 1924.

———. *Pierre Bonnard*. Babou, Paris, 1931.

———. *Bonnard*. Hazan, Paris, 1950.

———. *Bonnard lithographe*. Editions du Livre-André Sauret, Monte Carlo, 1952.

SUTTON, DENYS. *Bonnard (1867–1947)*. Faber and Faber, London, 1957.

TERRASSE, ANTOINE. *Bonnard*. Skira, Geneva, 1964.

———. *Pierre Bonnard*. Gallimard, Paris, 1967.

TERRASSE, CHARLES. *Bonnard*. Floury, Paris, 1927.

VAILLANT, ANNETTE (and others). *Bonnard; ou Le Bonheur de vivre*. Ides et Calendes, Neuchâtel, Switzerland, 1965.

WERTH, LÉON. *Bonnard*. Besson, Paris, 1919; 2nd ed., Crès, Paris, 1923.

——— (and others). *Pierre Bonnard*. Les Publications Techniques et Artistiques, Paris, 1945.